W9-BFP-766

Complete Guide to
FLOWER PAINTING

by Ralph Fabri

WATSON-GUPTILL PUBLICATIONS New York

*This book is dedicated to artists
and students of art, who like to experiment
with subjects, as well as with techniques
and materials*

Paperback edition 1985

First published 1968 in New York by Watson-Guptill Publications,
a division of Billboard Publications, Inc.,
1515 Broadway, New York, N.Y. 10036

Distributed in the United Kingdom by Phaidon Press Ltd.,
Littlegate House, St. Ebbe's St., Oxford

Library of Congress Catalog Card Number: 68-12343
ISBN 0-8230-0801-0 pbk.

All rights reserved. No part of this publication
may be reproduced or used in any form or by any means—graphic,
electronic, or mechanical, including photocopying, recording, taping,
or information storage and retrieval systems—without
written permission of the publisher.

Manufactured in Japan

1 2 3 4 5 6 7 8 9/89 88 87 86 85

Acknowledgments

Special thanks to the Editors, Donald Holden
and Susan E. Meyer, whose ideally constructive
remarks and marginal notations made my work not
only easier, but a real pleasure as well. And
my appreciation to James Craig for the elegant
design of my book.

Preface

The aim of this book is to speak to painters; to discuss the visual appearance and the esthetic effects of what we popularly call flowers; to show the numerous possibilities of using flowers as pictorial subjects, not only by themselves, but in conjunction with other themes as well; to describe—in all necessary detail—the various media and techniques in this particular field of painting.

We aren't concerned with the Latin, or even with the English names of flowers; with their planting methods, life cycles, and the functions of their organs. Whether flowers live on the minerals they absorb from the soil, or by trapping and consuming insects, has no bearing on a painting. There's no reason why an individual artist shouldn't be interested in the science of botany. But a fine artist can paint beautiful, lifelike florals without any scientific knowledge, just as a sound knowledge of medical anatomy isn't at all needed for painting portraits or figures.

the popularity of flowers

Man has admired flowers since immemorial times. The word "flower"—at least in Western languages—denotes the finest, fairest, choicest part of any species, any specimen. This admiration is also manifested by the use of flowers in celebrations, festivals of all sorts. Beautiful maidens strewed flowers and petals in the path of triumphant kings in ancient civilizations. Garlands, crowns, necklaces of flowers were, and still are, employed by civilized as well as primitive peoples, at weddings, funerals, receptions, and at practically all official ceremonies. Flowers themselves are the central theme of many festivals, such as in the Tournament of Roses in Pasadena, California, and countless similar events in many other cities and countries. Flowers were employed in pottery, textiles, architectural, and other ornaments in all ages, in all parts of the world. They also were the perennial subjects of the poetry and songs of all nations.

In no other creations are the fantasy, the mysterious ways, the incredible diversity of nature better, or more beautifully displayed than in flowers. Except for the ice-covered polar regions, and high, barren mountain ranges, flowers may be found everywhere. Anyone who has ever visited a botanical garden knows that flowers can be strange, weird, formidable, or frightening as well as pretty or beautiful. They can be almost as complicated as certain fishes and insects. Whatever their names, wherever they grow, whatever odor they emit, flowers are a great source of inspiration for artists, designers, decorators in all corners of the earth.

do artists need this book?

Do artists or art students need a book to tell them about flowers? Couldn't they just set up flowers and paint them? What's so special, or difficult, about painting flowers? Flowers have no eyes, eyebrows, lips, nostrils, ears, and other features so difficult to draw and paint. Why not just buy the right colors, brushes and canvas, and start painting?

The fact is that you must have natural talent to be an artist in any field, but talent

isn't enough. Entrancing legends of India speak of knowledge and wisdom suddenly descending upon an illiterate shepherd, as the generous gift of the deities. In real life, however, you have to cultivate your talent by studying, training, experimenting. Knowledge and technical excellence have to be acquired, often through arduous toil, many misses before the first hit. An artist may be a dreamer, an idealist, a self-effacing person, not "fit for this commercial-minded world" but, when he practices his art, he must be in full command of his work. He must know what he's doing.

This book is planned to help any artist interested in one of the loveliest, one of the most inspiring subjects in art: the painting of flowers. This book should help him paint flowers in any medium, in any technique, and to paint them better, in a more esthetic manner, with more self-assurance, than he possibly could without the necessary fundamental knowledge presented in the following chapters.

Contents

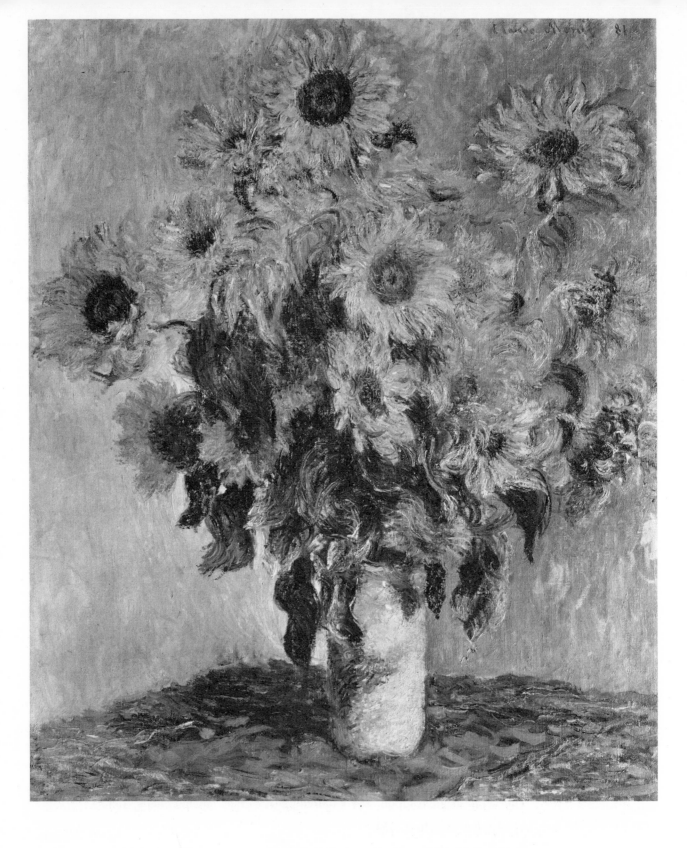

Sunflowers by Claude Monet, French, 1840-1926, oil on canvas, 39¾ x 32 inches. Monet shocked the world with the bold sketchiness of his flower picture in an age when photographic realism was expected. His crisp, soft flowers appear to be more alive than the painstakingly rendered florals of previous times. The Metropolitan Museum of Art, Bequest of Mrs. H. O. Havemeyer, 1929, The H. O. Havemeyer Collection, New York.

12

1 Why Paint Flowers?

Whether you paint strictly for art's sake, or for the sake of fun and relaxation, you have to study, at least to a certain degree. Anyone can boil an egg, but it takes experience to prepare a mushroom omelet, not to mention a chicken cacciatore. Many beginners appear to believe that copying the works of other artists, or working from photographs, is as good a way of studying painting as any. Like most professional artists, I think that paintings by accomplished masters, and good photographs can be an inspiration and help to any painter. At the same time, I am convinced that actual observation is the true mother of art. One painting, even if far from perfect, executed from your own observation, direct from life, is worth ten good copies done from paintings or photographs.

what to paint?

Personally, I painted everything I could find in our house: books, silverware, glass, porcelain, scarves, gloves, my mother's feathered or flowered hats. I painted fruits, vegetables, and flowers in all kinds of containers. Each subject was a new thrill as well as a new experience. Flowers inspired me with their symmetrical shapes, lovely colors. They also posed a challenge with their comparatively quick wilting. In my youth artificial flowers were not what they are today. Made of wax, they looked heavy, crude, truly artificial. Fresh flowers shrivel up, their colors fade or turn rusty within hours. I had to work faster than when painting nonchanging articles, which could be put away, and reassembled even days later.

**you ought to
try everything**

Not everyone wants to paint flowers, just as not everyone is interested in painting portraits, figures, or seascapes. You have to decide for yourself what subject gives you the greatest pleasure. How can you tell, though, without trying them all? Experimenting ought to include all subjects, and various media and techniques as well. For the sake of all-round experience alone, every artist should paint flowers. He owes it to himself to try his hand, his eyes, his taste, his talent at this particular subject.

**prejudice against
flower paintings**

No matter where we turn in life, we bump into prejudice. Certain artists consider flowers a feminine subject, as if there could be art subjects for men only, or for women only! The fact is that, at least during the second half of the nineteenth century, girls in fashionable private schools had to study painting in watercolor, and their subject was usually floral. This kind of work began to replace embroidery. Even where embroidery was practiced, the subject usually consisted of flower designs.

It's also true that several of the very few women artists of past centuries, whose works and names survived, painted flower still lifes because such a subject seemed eminently suited to the weaker sex, before the idea of emancipation began

to shake the Western World. A subject good for women, however, needn't be taboo for men. The concept that flowers are strictly for women is the same as the belief that cooking and sewing are women's tasks. Surely, some of the greatest chefs and tailors are men, and no woman would deny this. If you're a good artist, your work will be good, whether you're male or female. A bad woman artist paints bad florals; so do bad male artists. Nobody denies the feminine touch, of course. A woman might select soft-hued, sweet-smelling flowers (even though the sweet smell doesn't show in the picture), whereas a man might make a more dramatic, or exotic arrangement. But even here, don't bet your life that you can tell for sure whether a flower still life is the work of a man, or a woman.

flower painting with non-floral elements

A flower painting is not necessarily a vase or bouquet of flowers. The flowers are usually displayed in a container — which may be glass, porcelain, silver, and so forth — on a table, or some stand. They have a background, which may be anything, from a blank wall to magnificent scenery. Quite often, there are accessories, too, which may turn the picture into an impressive, dramatic work of art. Flowers are often employed in connection with portraits or figures, or with imaginary subjects.

there are many reasons for painting flowers

• Flowers are perhaps the most challenging subject in the realm of color. Delicate shades of all imaginable hues occur in flowers; these are surely worth rendering in any medium.

• Even the simplest flowers you pick alongside a dirtroad, or in a meadow, are lovely to look at. Anything so attractive in nature must be attractive in art, too, if it's well rendered.

• Fresh flowers are all round you in the country, and no farther than the nearest florist's shop, in the city. Street vendors sell flowers from baskets. Many towns have flower markets. Therefore flowers are always available.

• Today, artificial flowers are made in plastics, cast directly from fresh flowers. They're done with such amazing precision that, from a short distance, they look absolutely real. They last indefinitely, so that you're not faced with the previous problem of fast-wilting shapes and fading colors.

• You need no big studio for flower painting. Any quiet corner of your house will do, provided that you have enough natural or artificial light.

• Even people allergic to the odor of certain flowers love to see flowers. It's difficult to imagine a person who'd object to flowers as such, the way some people object to nudes, political, biblical, mythological themes, weird magic realist pictures, erotic, bizarre, or disturbing subjects.

• Just as much originality or individuality goes into a floral painting as into any other. A good flower painting is as valuable from an artistic viewpoint as an equally good painting on any other theme.

• Taste plays a starring role in flower pictures. The taste you develop in arranging flowers, in selecting colors, backgrounds, and accessories, will help you in other subjects as well.

• Flowers can be rendered in any medium, and in any technique, in any style, from the most traditional to the "farthest-out."

• Many artists paint flowers exclusively, but many more employ flowers in connection with other subjects. Thus, a knowledge of flowers is bound to assist you in your career as an artist.

• The observation, the technical control you practice in floral painting will be of help to you in portrait and figure painting, where delicate hues and shades are of extreme significance.

• Many exhibitions offer special awards for floral subjects. Don't take it for granted that you'll win such an award the very first time you exhibit a floral picture, or even with your second flower still life, but why not try to win sometime?

• It cannot be denied that many persons are more impressed by huge figure paintings than by small flower still lifes. Yet, it's unquestionably true that the same people would rather have flower pictures on their walls than more or less sumptuous nudes.

• The general public differentiates between art that's fine for museums and great private collections, and art which is fit for the home of a self-respecting, law-abiding citizen. Flower subjects are among the most salable, and perhaps *the* most salable, of all easel paintings. People who love flowers also love flower paintings. I am not telling you to paint flowers because you can sell such paintings. Nobody can give you a guarantee that you'll sell any of your paintings. I merely suggest that you paint flowers because they're nice to paint. But why dismiss the possibility of selling? I'm sure most artists would like to sell their works. Well, try flower paintings.

• And, above all, you ought to paint flowers just for the heck of it.

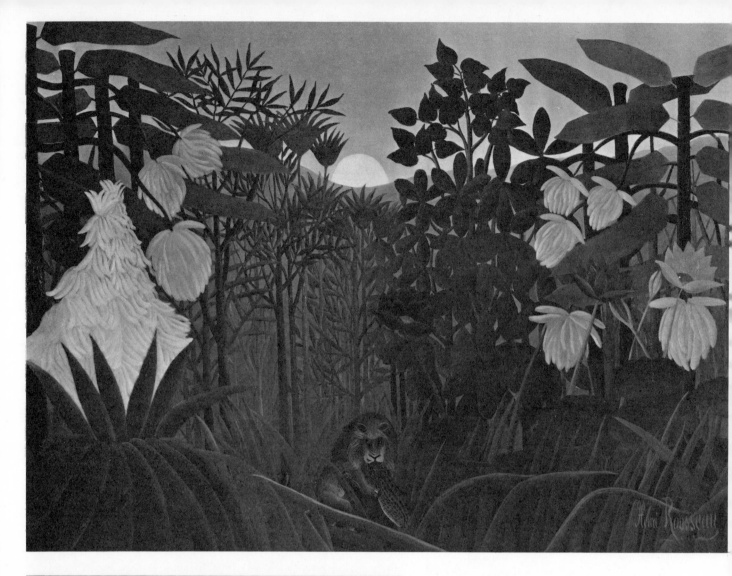

The repast of the lion by Henri (Le Douanier) Rousseau, French, 1844-1910, oil on canvas, 44¾ x 63 inches. The tall, vertical trees and huge, colorful flowers form a poetic as well as majestic setting for the lion devouring his prey. The Metropolitan Museum of Art, Bequest of Samuel A. Lewisohn, 1951, New York.

Detail

2 Some Historical Notes

We find renderings of flowers, trees, and plants all through the ages, in all parts of the world. Such renderings are usually stylized; that is, simplified, conventionalized. Stylizing almost invariably has a local or national pattern, so that the national origin of an object, or even of a fragment, is quickly recognized by an experienced person. We can tell at a glance whether a certain piece of artifact comes from Greece, Hungary, Germany, Japan, India, Mexico, Russia, China, and so forth.

Proportions, comparative sizes, fine details are of no significance in such renderings. A tree, for example, may be no taller than a man standing next to it, while a flower would be just as high as the figure. This naive approach was practiced all through the existence of great civilizations, such as Mesopotamia, Egypt, Persia, and through several centuries of Christianity in the West and in North Africa. It still prevails in the tradition-bound icons of Russia, Bulgaria, Greece, and other countries where Orthodox Christianity is the leading religion.

flowers in pottery The potter's wheel was seemingly man's first mechanical invention; pottery, or ceramics, in one form or another, may well be considered the first of all mass-produced articles. The plain, utilitarian earthenware soon had decorations. The invention of glazes enabled artisans to make ceramics more attractive as well as more durable.

Perhaps because they were nature-worshippers, Chinese and Japanese craftsmen decorated their ceramics with much more delicately realistic pictures than their Western counterparts did. Oriental artists applied gracefully outlined and colored pictures of flowers, plants, and other natural objects to their porcelain, and in their picture scrolls or lacquered panels. Although some features — such as clouds — were stylized, the floral items were as close to realism as the artists could make them.

mixing of styles The most famous pottery in the Western World developed in the Cretan civilization, and in its successor, the Greek (Athenian) civilization. Both contained realistic figures of animals and humans, intermingled with stylized floral designs. The famous Attic vases — done either in red on black, or in black on red background and, later, with the addition of two or three other colors — had rows of highly stylized plants, such as palm leaves, above and below the often superb pictorial figures and scenes.

Renaissance and Baroque ceramics in many parts of Italy, Spain, and Germany were also usually ornamented with realistic figures and scenes from mythology, from the Bible or history, mixed with conventionalized floral decorations.

Most esthetically trained people of our age believe that realistic objects should be turned into what we call "flat designs" — that is, stylized renderings — when used as decorations on a flat surface. Pottery is not literally flat, to be sure, but it's flat in comparison to the general concept in the pictorial arts. There's no absolute, final law in any branch of art.

**flowers
in rugs**

Rugs, too, have been of great importance to mankind for a long time. They came later than pottery, because they were already items of comfort and luxury, whereas pottery served a most important utilitarian need. In rugs as well as ceramics, Chinese and Japanese artists achieved as much realism as the craft of weaving permitted.

Whatever the woven materials may be, it's quite difficult, for example, to weave round forms and very small details. The nature of the materials and tools made stylizing inevitable. We find somewhat squarish, simplified, yet recognizable flowers in Turkish, Persian, and American Indian rugs and textiles, too.

**floral decorations
in architecture**

Roses, acanthus leaves, other flowers and plants, were incorporated in the architectonic decorations of ancient Greece and Rome. Floral patterns were especially popular in Muslim countries, where pictorial and carved representations of humans and animals were forbidden as idolatry. It's easy to understand that these are the countries in which we find the highest degree of stylization in flowers. Such nonfigurative designs were the sole expression permissible to Muslim artists and craftsmen, except for book illustrations, in which the surrounding text made the nonreligious meaning of each picture clear.

In countries where Christianity prevailed, realistic figures were needed to spread the religion. Flowers also became more realistic. A beautiful meeting of Islam and Christianity, in art, occurs in Gothic architecture, which is based on the pointed arch, an Arab invention. Many of Spain's cathedrals and churches were begun as Muslim mosques. They were finished, or changed, by the Christians after the collapse of the Arab rule in 1492. The Gothic cathedrals in France and in other continental European countries always had at least one large rosette window. Done in stone, the rosette window was completely stylized, but it was filled with stained glass windows showing representational scenes and figures. Inside and outside, you'll see hundreds of realistically carved flowers, too.

floral carvings

Nature makes the stem strong enough to support the flower or flowers growing from it. Flowers cannot be carved in-the-round, though, because the weight of the flower would be too much for the slender stem, in any material: wood, stone, or marble. Floral carvings, therefore, are made in reliefs — high or low — in which the forms are not separated from the background. Simplification and stylizing must be practiced even in such reliefs, so that the carvings are solid enough to survive the destructiveness of nature and of human beings.

The degree of stylizing depends upon the size and the material. A carving made of ivory or quartz, on a very small scale, may be quite delicate, as it is likely to be handled only by people who cherish it.

**flowers in
illuminations**

Floral decorations are common in illuminated manuscripts. Initials were usually embellished with floral and stem patterns. The custom continued after the introduction of printing. Diplomas and scrolls of citations are frequently ornamented with floral borders, either hand-painted or typeset. Monograms, the direct descendants of initials used in manuscripts, still often contain floral elements, whether the monograms are painted, embroidered, or made in some material and attached to an article.

realistic flowers

Truly realistic flowers, plants, and trees are also found in all forms of ancient art. As I mentioned before, Chinese and Japanese artists depicted such objects with the sensitive outlines and delicate colors so characteristic of their art. Their floral themes were often combined with insects, birds, turtles, drawn with equally unsurpassed

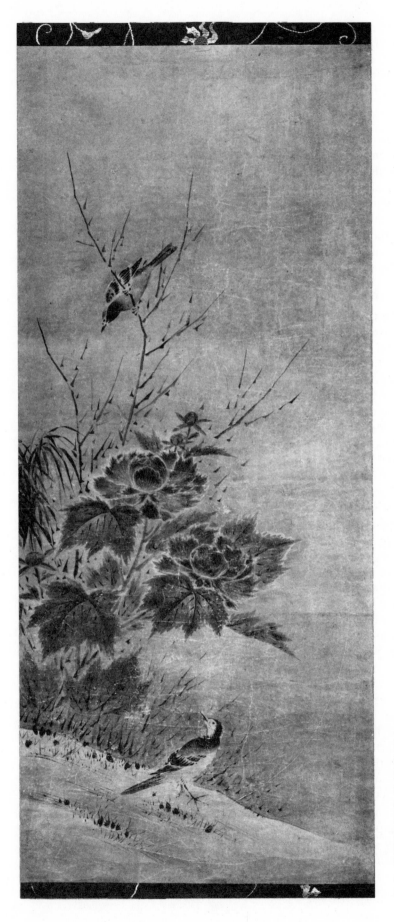

Birds and flowering shrubs a painting from the Ashikaga Period (1334-1573). Probably because they were nature-worshippers, Japanese artists rendered flowers with love, admiration, and unsurpassed delicacy. Painted mostly on solid-colored paper or silk, the flowers or sprigs seldom had pictorial background, but birds and insects were often added to the picture. The Metropolitan Museum of Art, Howard Mansfield Collection of Japanese Art, acquired in 1936.

skill and keen observation, though without shadows and often without any actual background. Flowers still play an important part in the daily existence of the Japanese people. Today, more than ever, Japanese flower arranging is an art admired and imitated in most sections of the Western hemisphere. Japanese flower paintings are extremely popular, too.

flowers in Mughal painting

When the Mughals (also called Moguls, originally Mongols) conquered a large part of India, and Muslim emperors ruled that vast country (1526-1857), they brought with them Persian-trained artists. Most of the paintings executed by these artists depicted and glorified elegant, romantic court life in fabulous miniatures. Muslim concepts were intertwined with native Hindu motifs. Done with the most childish perspective, but in exquisite details, these miniatures could hardly be imagined without flowers or without floral ornaments. The flowers are a delightful mixture of acute observation, a sincere effort at perfectly lifelike rendering, and a remarkable sense of the decorative.

realism in Roman flowers

Attractive, accurate renderings of flowers have been found on the walls and floors of houses in Pompeii, Herculaneum, and other parts of the ancient Roman Empire. Flowers have been used as religious offerings since the earliest times; certainly in the Cretan, Greek, and Roman civilizations, as seen in their paintings and sculptural works. The Christians continued the custom of placing flowers in wall shrines and on altars. In Christian art, flowers were always done in the same style as the rest of the pictures. They were crude, naive in the early centuries; more realistic and more sophisticated in later periods.

saints and flowers

Many Renaissance and Baroque paintings of saints contain flowers. An often recurring idea was to depict a saint, or some other religious personage, as if the figure were a piece of sculpture in a niche. The figure was painted to look like white marble, in a gray-buff stone niche. In front of or around the statue, the artist painted floral offerings, garlands in bright, natural hues. This kind of painting offered the artist certain advantages. He wasn't compelled to handle the figure realistically in color; it wasn't necessary for him to paint a complicated background, such as scenery related to a religious event, since the figure was supposed to be a statue, with a stone wall behind it. As a matter of fact, the artist could use an actual statue as his model, instead of devising his own figure. Even a mediocre artist could thus produce a satisfactory picture. At the same time, the flowers in front or around the niche were full of life and color. Furthermore, such paintings didn't demand much faith, religious fervor, or imagination.

artists don't live in a vacuum

At present, we are up against the erroneous, but very popular concept that artists are doing things for art's sake, for no detectable earthly reason. Actually, artists produce what their age demands, even if this may not be clear to the average layman, or to tradition-bound artists.

Not only the age, but the surroundings as well have an inevitable effect on art and artists. In Japan, for example, the most modest home seems to have had painted scrolls at all times. Such scrolls, however, weren't, and aren't, on permanent display. One scroll is rolled up and replaced by another, according to the season, or to some special occasion (an important event in the life of the country or the family). Well-to-do people own many scrolls, but show only one at a time; or even just a part of one scroll. This is usually the case with long, horizontal scrolls, which are opened at one particular scene for a while, then rolled on to another section, like the Holy Scriptures in a synagogue.

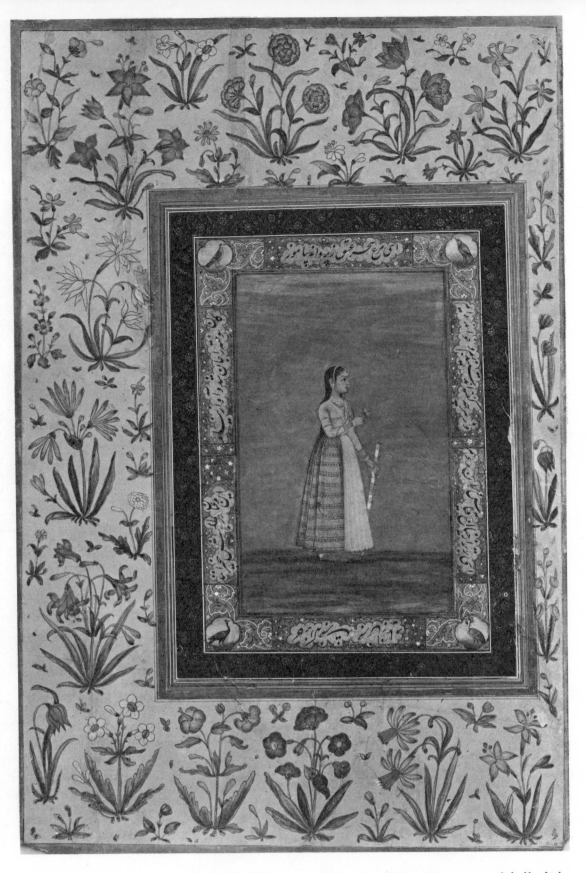

Portrait of a woman Indian Mughal miniature, second half of the seventeenth century. The arabic inscription around the lovely woman explains the nature of the painting. The flowers are a delicate mixture of acute observation, an effort at lifelikeness, and a sense of the decorative, typical of Muslim Indian Art. The Metropolitan Museum of Art, Rogers Fund, 1918.

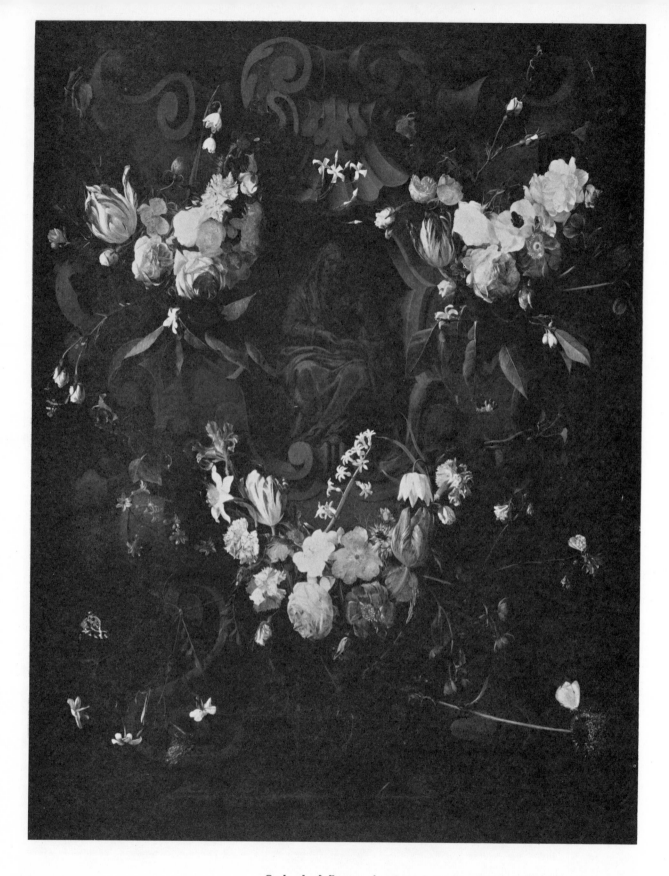

Garland of flowers by Daniel Seghers (1590-1661); the figure part ascribed to Erasmus Quellin II (1607-1678). Vivid flowers, in bouquets or garlands, surrounding the statue of a holy personage in a stone niche constituted a favorite subject of Dutch and Flemish artists of the Baroque period. The Worcester Art Museum, Eliza S. Paine Fund, 1966, Massachusetts.

**private paintings
in the West**

In the Occident, secular art first appeared in the fifteenth century, in the palaces of aristocrats, and the private residences of churchmen. Later, it reached the mansions of wealthy businessmen. It wasn't until the seventeenth century that middle class people also began purchasing paintings that weren't strictly religious. The Netherlands, with its comparatively large, fairly prosperous middle class population having its taboos and laws against religious subjects in art, may be considered the birthplace of still life in general, and flower painting in particular. Flower paintings suited the Protestant beliefs, the middle class taste, and the typically small rooms of Holland as well.

**small homes,
small paintings**

The idea quickly spread all over Europe, regardless of religious beliefs or disbeliefs. The number of small private homes grew everywhere as merchants, physicians, lawyers, architects, successful craftsmen increased their living standards after the Thirty Years' War. The French Revolution, about a hundred and forty years later, gave the middle class another big boost. The bourgeoisie had no use for complex biblical and historical pictures, or for the "shocking" nudes of mythological scenes. It wanted small, cheerful, inoffensive pictures. If fresh flowers made any room more attractive, flower paintings must have the same effect. And painted flowers wouldn't wilt, like fresh ones.

**demand
for variety**

As flower paintings became fashionable, the demand for variety, skill, and sophistication in the subject grew, too. It's true that absolute likeness in flowers cannot be of the same importance as in portraits. A rose is still a rose if you omit or add a petal or two. You cannot expect an artist to paint a daisy to such perfection that you should be able to pull its petals out, one-by-one, to see if someone loves you, or loves you not. But it's a mistake to think that flowers are easier to paint than other subjects.

Flowers have an anatomy of their own; they also have foreshortening. A good composition is as vital in this as in any other theme. Proportions, sizes, color combinations, spatial relationship, the selection of background, foreground, and accessories, the rendering of textural effects, are just as significant in florals as they are in painting figures and landscapes. As a matter of fact, flowers pose a real challenge to serious artists. Flowers are organic creatures, with fascinating, often voluptuous forms, an immense array of colors. You'll find real excitement, and esthetic satisfaction in creating good flower paintings.

Nor is there any restriction on style, technique, tools, materials, and artistic concepts. From the Japanese approach of depicting what might be called the essence of flowers, through the cold, botanically accurate images of classicist artists, to the dramatic flowers executed by contemporary painters in their own, distinctive — perhaps puzzling — styles, there's no limit to originality and creativity in this subject.

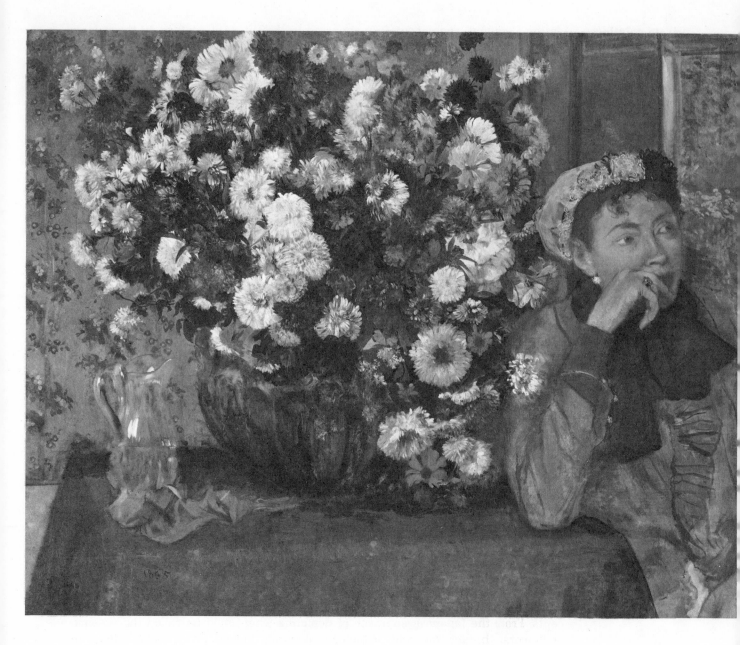

Woman with chrysanthemums *(Mme. Hertel) by Hilaire Germain Edgar Degas, French, 1834-1917, oil on canvas, 29 x 36½ inches, painted in 1865. One of the first Impressionists, Degas was a scion of a wealthy family, able to live without selling his paintings. This work is an unusual combination of a huge arrangement of flowers in a bowl with Mme. Hertel's almost inconspicuous portrait. The Metropolitan Museum of Art, Bequest of Mrs. H. O. Havemeyer, 1929, The H. O. Havemeyer Collection, New York.*

3 The Anatomy of Flowers

Yes, flowers and plants, have anatomy, too. Not as complicated as the anatomy of humans and other mammals, but the variety is great. You needn't know every little botanical fact to be able to paint flowers, just as you can paint a portrait or figure without being familiar with all the medical features of human anatomy. But a comprehension of the basic anatomical structure of flowers is important if you wish to paint recognizable flower subjects.

knowledge or observation?

The classic Greeks knew nothing about human anatomy, as we use the term. They were able to create statues of idealized beauty, of unsurpassed perfection, merely through keen observation. Oriental masters went even beyond that. They observed everything with the utmost concentration, then drew and painted from memory. You, too, can observe every detail of flowers, and paint them without any botanical knowledge. Certainly, the most accomplished botanist is not necessarily a painter. But, if scientific knowledge of botany doesn't make a flower painter, an artist without any botanical information is bound to be up against graver difficulties when painting flowers than an artist who possesses some fundamental knowledge in this field.

words have no bearing on art

One of the most boring experiences of my life was walking with a woman botanist, whose main conversation consisted in telling me the Latin and English name of every flower, plant, shrub, tree, and weed we passed in a city park, in the country, or in a florist's window. It was as if I had guided someone through the galleries of The Louvre, The Prado, or The Metropolitan Museum of Art, rattling off the names of all the artists, without giving any other information to my unlucky companion. There's much more to flowers than their scientific and everyday names. Just as there's much more to art than the names of the artists. On top of the bargain, my botanist friend could easily have fooled me by giving me the wrong names. I'd never have known the difference, nor would I have cared. And I could have told my companion that a certain painting was by Veronese, when it was a work by Tintoretto.

but words are helpful

Still, a knowledge of words denoting the main visible parts, or features of flowers is nothing to sneeze at. After all, we do normally know the names of various parts of the human body, and of animals as well, even if we don't know the scientific name of every bone, muscle, and ligament. Isn't it simpler to say "collarbones" than to describe them as "those two short bones under the neck, between the shoulders and the center of the throat?" It's also much simpler to say "calyx" than 'that green stuff, at the end of the stem, from which the petals of the flower stick out."

flower terminology

The following is an alphabetical list of those parts of flowers which are often, though not always, visible to the casual onlooker

Anther: the part of the stamen which develops, and contains, the pollen.

Axis: a straight line, real or imaginary, passing through the center of any object, including flowers.

Bract: a leaf from which a flower, or a floral axis, arises.

Bud: a protuberance on the stem of a plant, consisting of undeveloped foliage, or floral leaves.

Calyx: (plural: calyxes or calyces), the external, usually green, or leafy part of a flower.

Carpel: an ovary at the base of the pistil, the female sex organ of a flower.

Corolla: the petals of a flower, collectively. What we usually call the flower.

Cupule: a cup-shaped involucre, such as the well-known bottom part of the acorn.

Filament: the anther-bearing stalk of the stamen.

Inflorescence: the general arrangement of flowers on an axis; the pattern in which flowers grow.

Involucel: a secondary, smaller set of involucre.

Involucre or Involucrum: a whorl, or rosette of bracts, supporting a cluster of flowers, or a fruit.

Leaf: needs no explanation, except that each species has its own particular kind of leaves.

Petal: one of the leaves of the corolla.

Pistil: the ovary with its appendage, the female sex organ.

Pollen: the mass of spores, usually a fine yellow dust.

Raceme: an inflorescence in which flowers grow along a common axis, as in the lily of the valley.

Spike: an inflorescence in which flowers are sessile; that is, they are attached directly to the stem, without any noticeable connecting link.

Stalk: any supporting organ.

Stamen: the organ from which the male fertilizing cell rises in the flower.

Stem: any axis which develops buds and shoots, but not roots.

Umbel: an inflorescence in which the flowers spread from a common center, on nearly equal stalks.

significance of organic facts

Knowing the anatomy of flowers helps the artist as soon as he begins to paint any flower. It's easier to paint a human figure if you know where arms and legs grow out of the body; in which direction, and how far, legs and arms can move and reach; in what positions they cannot possibly be. It's equally helpful for you to know which way, and how far, a stalk or stem bends before it breaks; how the calyx grows from the stem; how the corolla grows from the calyx, and what those little things, the pistils and anthers are. You'll need to know where and how the leaves grow from stalk or stem.

No plant could long survive without all its parts. Flowers and leaves do not grow in a haphazard manner. Again, the basic fact is the same as in humans and animals: no two members of a species are ever exactly alike, but their organic, anatomical

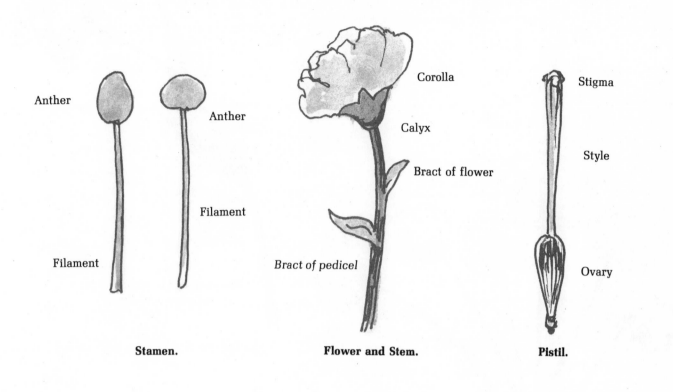

Stamen.　　　　**Flower and Stem.**　　　　**Pistil.**

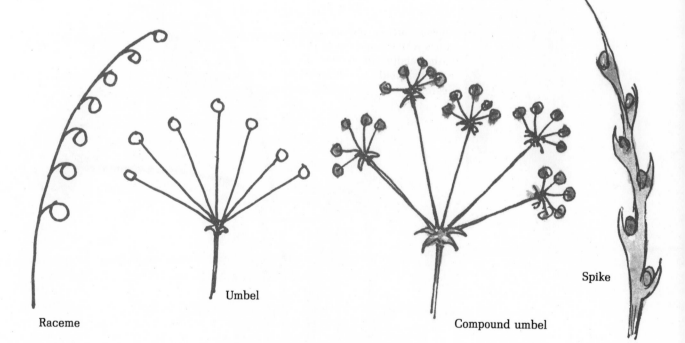

Inflorescence.

The stem bends according to size and weight of flower.

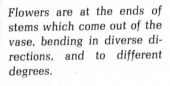

Flowers are at the ends of stems which come out of the vase, bending in diverse directions, and to different degrees.

Flowers cannot turn any old way. If a stem bends down, its flower cannot turn upwards. Observe organic formations and facts.

forms are identical all over the world. Thus, a species consisting of five petals will always have five petals, and they'll all grow from the same kind of calyx and stem, with the same types of pistils, stamens, and leaves.

avoid ludicrous
mistakes

Students often make the mistake of painting flowers in a vase or bottle without considering the simplest facts of organic life. They first paint the container, then the bright flowers (usually much larger than lifesize), before they indicate stems and leaves. When finally they try to paint the stems, the students find that many, if not all the flowers are in wrong positions. Stems coming from that particular container could not possibly reach those flowers, unless they were broken. Also, very often, the flowers seem to be facing wrong directions compared with their stems. For instance, a bloom turns upward, while its stem bends downward; or the flower seems to be dangling precariously at the end of a stem, instead of growing out of it in a natural way.

Looking at such errors, I think of a painting in which a man is depicted as running forward, but his feet point backward. Or I remember the many boat pictures in which the flags were blown backward by the same wind which blew the sails forward. An artist with sufficient experience draws the stems of the flowers first, as they "grow" out of the container. He then sketches the flowers to fit the ends and directions of the stems.

observe
and study

My eternal advice is: don't take anything for granted. Observe whatever you paint, and your work will be infinitely better than it would be otherwise. Before the invention of printing, monks used to copy books by hand. Some of the monks were not only calligraphists, but good artists as well. Many of those illuminated manuscripts are treasured works of art. Artistically ungifted scribes, however, did a very poor job of copying illustrations, especially scientific ones. The originals were done by excellent artists, on the basis of direct observation. But monks who were neither artists, nor sufficiently well versed in subjects which required illustrations of paramount importance, made copies of illustrations which had less and less relationship to facts, as one copyist tried to copy another copyist.

We may smile at these naive efforts, especially when we happen to have the fine originals, which we can compare with the bad copies. But we don't smile kindly when we meet an artist or art student, who paints carnations with the leaves of roses, or who makes a daffodil bigger than a prize-winning chrysanthemum.

Familiarize yourself with your subject. It will not only help you in the painting, but will save you embarrassment as well. I used to know a man who wanted to write short stories in foreign locations. He had never been abroad, but all his stories took place in China, Borneo, Russia, Afghanistan, and other faraway lands. He thought the strange places and foreign names would intrigue the readers. He wrote a story about a Russian girl who suffered from the delusion that she was the pendulum in her grandfather's clock. The author called the Russian girl Vanya. Unfortunately, Vanya isn't a feminine name in Russia, but the petname of Ivan. The author made a laughingstock of himself among his acquaintances, and none of his stories was ever published.

stems,
leaves, buds

Stems aren't merely thin, green tubes. Observe the shape, thickness, length, and color of every stem. In some species, the stem is interrupted by bracts, and such stems may not curve as gracefully as the ones without bracts.

Whatever the thickness and length of a stem may be, it is naturally able to support the flower which grows from it. Some flowers have rather stiff, almost branchlike stems, which stand vertically. Others have various patterns of inflorescence. Mostly,

the stem is bent down by the weight of the flower, but in no case can the flower be so heavy that it can break its own stem. Only clumsy, harsh handling can break stems. Flowers should be cut with scissors, not broken or torn by hand.

flowers and leaves must match

Florists usually add ferns to flowers, partly to make the bouquet appear to be larger, partly to protect the flowers, and partly for the interesting contrast between the lacy ferns and the more solid leaves of the flowers. If you paint such ferns, don't forget that they aren't integral parts of the blossoms. Don't paint a rose as if it were really growing out of a fern. This is just one of those little things that can make, or unmake, your floral picture. And don't kid yourself by thinking that nobody will ever notice such discrepancies. Many people won't, that's sure. But it's always the person who *does* notice things who counts.

what about imagination?

Recently, I saw a student paint entirely imaginary leaves with quite realistic flowers. When I suggested that he observe the actual leaves, he dismissed my advice with a blunt statement: "An artist has the right to make the changes he considers necessary to enhance the beauty of his painting. If he doesn't like the leaves nature had accidentally given those particular flowers, he should give them what he, the creative artist, considers more appropriate, more attractive!" Needless to say, his flower painting looked ludicrous. Suppose an artist painted an elephant with the legs of a gazelle! Nobody will deny that the legs of the gazelle are more graceful than those the poor elephant has to walk on, but wouldn't the elephant look odd with such legs?

buds are future flowers

Buds, too, are typical of their species. A rosebud is as different from the bud of a carnation as the fully developed rose is from the fully developed carnation. Each bud has its calyx. The leaflike formations of the calyx are visible on the bud, though often hidden in the full-grown flower, except when seen from the back or, sometimes, from the side.

Buds add to the interest and charm of almost any floral arrangement. They also guarantee, more or less, that the flowers will last for a while, as the buds will grow bigger, and eventually blossom, while other flowers wilt and die. Watch the growth of, and the delicate changes in the buds as well as the changes in the flowers. A rose, especially, goes through several phases, from the delightfully streamlined bud to the half-open, to the almost fully-open, and ultimately to the wide-open flower, whose center is completely visible. Carnations, daisies, asters, chrysanthemums, and many other flowers don't change very much in form, once they're in full bloom. They merely wither, turn rusty, and die. Even dying colors have beauty. Vincent van Gogh painted one of his most famous pictures, *Sunflowers*, showing the brownish hues of age.

roots

You are unlikely to see and paint the roots of flowers in an artistic flower picture. If your flowers have roots, they're usually in the earth, in a pot, or in the actual soil of your garden.

how to keep flowers

If you work from fresh flowers, you ought to make a layout quite fast, and first paint the flowers which are known to wilt, or discolor quickly. You can keep flowers for a while in a cool room. Add fresh water, every now and then. Aspirin is said to be good for flowers; dissolve a tablet or two in the water. A wilted flower can be replaced by a fresh flower anytime. Flowers of the same species are sufficiently similar to enable you to continue the painting.

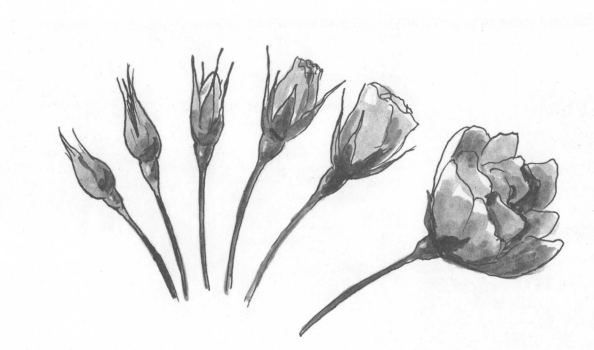

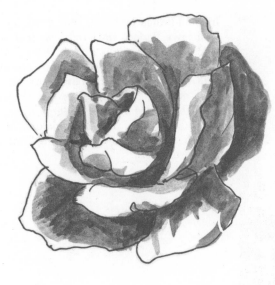

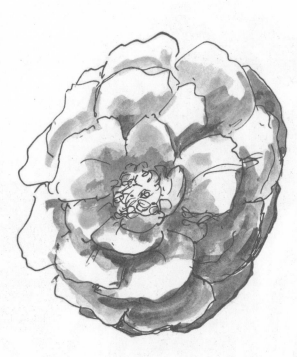

Study the flower from bud to maturity. The bud of a rose is small, but contains all parts of the rose. As it grows older, it opens wider and wider, until it barely resembles the young rose. The petals begin to fall off.

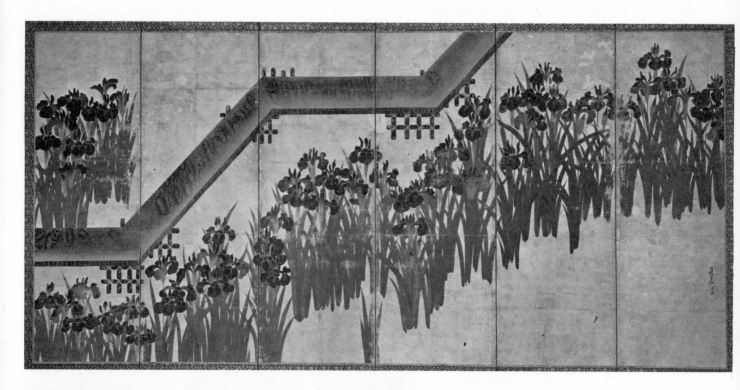

Iris and bridge by Korin, 1661-1716, Japanese, Tokugawa Period, 1603-1867; six-fold screen, painted on paper, 70½ x 146¼ inches. At least sixty flowers, hundreds of leaves, are painted with equal perfection in every detail. There is no concept of perspective: the flowers beyond the bridge are just as large as the ones on the near side. The Metropolitan Museum of Art, Mrs. Louise E. McBurney Gift Fund, 1953, New York.

Detail

Perspective is the visual appearance of things. With the exception of the sphere, everything looks different from every angle. Most people, however, including beginners in art, "see" things as they remember them, in their diagrammatic forms. This is the way artists in ancient Egypt and in other civilizations rendered everything: the way they *thought* objects looked, not the way the objects appeared to the eye. We know that an egg is egg-shaped, but we fail to realize that an egg looks spherical when viewed from one of its ends. It's oval only when seen from the side. If you place a dozen eggs on a plate, only two or three of them look truly egg-shaped; the others are seen from one end or another; from a three-quarter view, a two-thirds view, and so forth.

A lack of understanding for perspective is especially baffling in this age of photography. Almost everybody has a camera, and the photographs infallibly show perspective. Strangely, people accept perspective, even the considerable exaggerations typical of photographs, in camera-made pictures, but question the possibility of perspective in pictures drawn or painted by artists.

linear perspective

Linear perspective refers to changes in angles, shapes, sizes, the directions of lines as we observe them from various positions. A square looks like a square when we see it directly from the front-center. The moment you turn or tilt the square, or if you move ever so slightly to the right, the left, above or below the square, it ceases to look like a geometric square. As a matter of fact, none of its corners seems to be at a right angle, visually. A disk is round when seen directly from the center. From all other angles, it's an ellipse of varying widths, leaning in any number of directions. From the side, it may be nothing but a straight line or strip, visually.

Perspective is a general term. In humans, animals, and small objects, such as flowers, we speak of foreshortening. Perspective in flowers may be simple enough, but we have to cope with perspective in vases and other containers, in tables, in the various backgrounds as well as in the shapes of leaves and blossoms.

flowers as saucers

Even though some flowers, many petals, and leaves are fairly flat, when compared with animals, humans, and large, man-made articles, they're actually three dimensional, and are seen from a great variety of angles. Perhaps the majority of flowers would either cover a saucer, or fit into a cup. If you turn or tilt a cup or a saucer, it becomes different in appearance. So do the flowers. The best way of looking at any flower is to visualize it as a saucer or a cup, before drawing and painting any of its petals and other details.

flowers and cannonballs

Let's suppose you have a bunch of yellow asters, all about the same size. If you pile them up, in a bowl, or on a table, each blossom facing you, row upon row, the effect

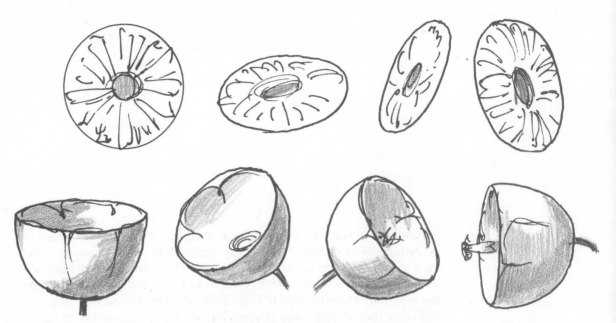

Study perspective in flowers. Most flowers fit into a saucer, or a cup, in general shape. Just as the visual appearance of a cup or saucer changes from every angle, so does the visual appearance of flowers change. A saucer is circular, when seen from above, but elliptical when viewed from an angle. Round flowers turn elliptical, visually, when seen from an angle.

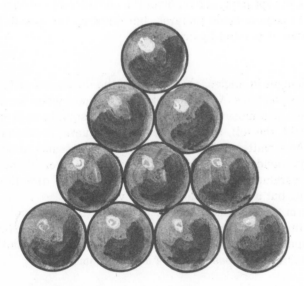

Flowers aren't cannonballs. Cannonballs, being spherical, look the same from every angle, and can be piled up into so-called pyramids. Flowers look different from every viewpoint; it would be ludicrous to pile them up, all looking straight at you. A heap of flowers would look like this — not attractive!

will resemble cannonballs piled into a pyramidal heap. Cannonballs are spherical, and thus look the same from every side. Flowers, on the other hand, are never completely ball-shaped. You can't render them like cannonballs. They're different from the front, the side, from a three-quarter view, from the back. And flowers are organic. They're alive. Set them up, draw and paint them as they are, varied in position, turning one way or another, not in a military order.

leaves fit into geometric forms

Whatever the diagrammatic shape of a leaf may be, it's never completely flat. Leaves are wavy, curled up; their tips are often twisted. And leaves, too, point in different directions; some are seen from the front, others are bent forward or backward. Leaves as well as flowers fit into geometric shapes. Disregard tiny details, sawtooth, or scalloped outlines; observe their main forms, first. Don't draw and paint either leaves or flowers from memory. Look at them carefully. Nothing takes the place of honest observation.

no spatial problem in bouquets

Foreshortening is important in flowers, but there's hardly a question of spatial relationship, because the distance between the flower nearest to you, and the one on the opposite side of even the largest bunch is usually not more than twelve or fifteen inches. Each item in a bouquet consisting of the same kind of blossoms is almost exactly alike in size. It would look funny, if not weird, if you painted one rose twice as big as the other eleven, in the same bouquet.

If, however, you have an arrangement in which the flowers are actually different in size, or in which there are different kinds of flowers, observe the natural variations in size as well as other features, and paint them as they are. Many students have an inexplicable tendency to paint flowers bigger and bigger, as they're adding details, more petals. At the end, a carnation resembles a huge zinnia, a rose is as big as a rhododendron, lilies of the valley are as big as gladioli. Only the vase remains small; the entire painting has an impossible appearance.

perspective in flower containers

Flowers thrown casually on a table, sofa, or floor might make an interesting painting. Normally, though, we display flowers in a vase, bottle, bowl, or pot, on a table, or on a stand. Many students fail to consider perspective in the container and in the table. Yet, no matter how pretty your flowers may be, perspective mistakes in the table and the container ruin the effect, unless you are a primitive painter. (In that case, your flowers ought to be primitive, too.)

The first, and most general, mistake of students is to render vase, bottle, or bowl with horizontal lines representing the bottom. In reality, a straight top and a straight bottom are possible only in a squarish container. However, in a round vase, bowl, or other article, both the top *and* the bottom are round, too. Observe the mouth and the base of the container you're painting. Compare the visual lines of the container with the horizontal edge of your support, or with the handle of your pencil—held horizontally over the visual line of the container's top or bottom. Making this comparison will enable you to evaluate the size of the curvature in the container.

perspective in tables and stands

In all my years of teaching, I've never seen a student who didn't indicate a table in a still life by drawing a horizontal line straight across the center of the support. When I asked the student what that line meant, the answer was: "Why, the table, of course. Aren't you supposed to establish the table on which the stuff is displayed before you do anything else?" I'd ask the student whether the table was horizontal from where he was looking at it. "Naturally. How could something stand on it if it weren't horizontal?" To be sure, a table must be horizontal. Otherwise, pencils, pens, and

Don't make this error when you render the container. Many beginners draw the bottoms of round objects straight.

In perspective, a round base looks even more rounded than the mouth of the container, because it's lower so you see more of it.

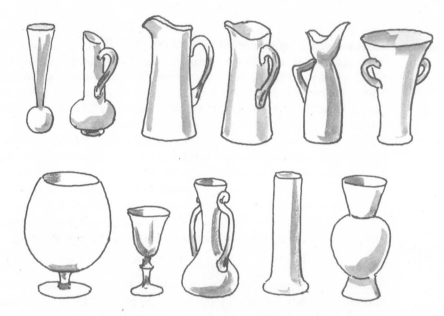

Flowers needn't be put in special flower vases. Numerous pitchers, stemmed drinking glasses, ceramic, metal, wood, and plastic containers are available in the average household. Containers with handles ought to be turned a little, one way or another, so that the handle or handles aren't seen diagrammatically, but from an angle.

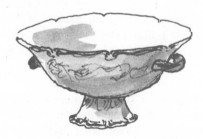

A fruit bowl, of any material, is a good container for short-stemmed flowers.

A basket, especially one with a handle, is an appropriate and rather charming container for fresh flowers.

all small articles would roll off, and larger objects would slide downward, or stand at a slant. But no table *looks* horizontal, unless you sit exactly in front of the center of the table. Normally, you look at it from an angle, so that the topline of the table seems to be going up, or down.

Dividing the support by a horizontal line across the center also creates the effect of a two-striped flag. It's more pleasing to the eye, if the table is at a slight angle, and considerably below the center of the support. Don't paint tables as if you were an ancient Egyptian artist.

A small rectangular, or round table, in perspective, may look more artistic than a table cutting clear across the lower section of your picture. You might break the monotony by adding a small tablecloth, a centerpiece of lace or linen, under the vase or other container. Use a rectangular tablecloth on a round table, a circular piece on a rectangular table. Study flower still lifes by experienced artists. You needn't, and shouldn't, copy them, but learn from them.

perspective is everywhere

There are other ways of showing flowers, besides having them on tables or stands. How about a windowsill? On a shelf, between books? Or on the floor, if it's a large plant? The flowers might be in an ornamental china or metal pot, perhaps placed on a low stand, in your living room. Or in a wooden bucket, placed on a brick or flagstone floor. In such cases, perspective is not to be disregarded. The floor must appear flat, not standing up, the way it does in Oriental, or Middle-Eastern miniatures. Receding lines, sizes diminishing with distance, visual changes in forms, must be observed and rendered, in order to avoid amateurish results.

Flowers on a windowsill, with a view of scenery, or buildings, also require a knowledge of perspective. In all cases, when flowers are painted in conjunction with other pictorial elements, not just a plain backdrop, every part of your painting has to be considered in reference to proportions and perspective.

color perspective

The term "color perspective" refers to changes in colors due to distance, light, and atmospheric conditions. It used to be called "aerial perspective" before flying became an everyday occurrence. Now, aerial perspective means the visual appearance of scenery, architecture, and all other objects from above the earth. What used to be known as a bird's-eye-view is now literally a man's-eye-view.

Color perspective plays only a small part in a vase of flowers, because all flowers are close together. A yellow flower fifteen inches farther from you than another yellow flower is exactly the same color and value. If, however, you paint flowers as part of a complex picture, with a large room, or scenery as a background, you have to observe color perspective as well as linear perspective.

It's also important to realize what colors can do to each other. A light blue blossom between yellow or red flowers may appear to be far behind the others. Or it may seem to be the sky, or some light object, seen through a hole between the flowers. All colors have to be compared with each other, not only in the actual hues, but in their values as well. That is, every color should be compared with white or black, to see how much lighter it is than black, or how much darker than white.

flowers on a windowsill

Let's say you place a container of flowers on a windowsill, overlooking a vast panorama of hills, houses, and sky. Although the flowers are your main theme, they take up only about one-fourth of the space on a horizontal support. No matter how bright the background may be, you have to show that it's much farther away than the floral arrangement. Paint the background in softer, hazier tones, with fewer details than you paint in the flowers. Otherwise, the background will resemble a curtain right behind the flowers, without any sense of space.

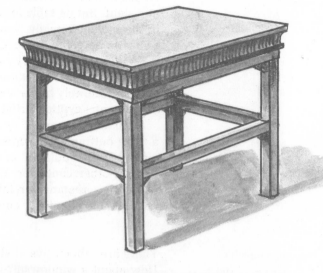

Egyptian artists rendered all articles diagrammatically, the way most people remember things (left). On the right, the same table is rendered in true perspective. Naturally, the table would look different from every angle, but it never looks like a diagrammatic drawing.

Egyptian paintings. Both table and urn are carefully, but diagrammatically drawn. The flowers in the urn are utterly naive. Stems, flowers, and buds could hardly stand up straight, looking in the same direction as depicted here. On the right, the same table, urn, and flowers, as we would really see them.

Colors in the flowers are often repeated in the background. You may happen to have blue flowers against a blue sky; red flowers against a red rooftop; yellow blossoms, and a yellow house, not to mention green foliage in the distance, and green leaves in your bouquet. Naturally, you must distinguish foreground from background. Make colors in the nearby flowers stronger than similar hues in the distance. Don't go by the name of a color; observe its visual appearance. There are countless shades of red, yellow, blue, and all other colors.

**flowers
in a room**

Painting a vase of flowers on a table, with the whole room as a backdrop, often suggests the simple trick of doing the room in very dark hues, so that the flowers are bound to stand out. However, it's more interesting and artistic to observe the actual color contrasts, and to render them without undue exaggerations. The colors in the background are likely to be softer, cooler (that is, more bluish), than in the flowers and the foreground. A picture on the wall, a door, a curtain in the back cannot be as bright, and as detailed, as the flowers and other items in the foreground. It's possible, of course, to have a brightly illuminated room, with flowers displayed in a dark section in the shadow. That's a different project. You still have to observe the values, and subdue the background.

**avoid confusion
in objects
and colors**

Every serious artist and art student loves challenges. A complicated background is such a challenge. But avoid impossible, or absurd tasks. For example, don't try to paint a floral arrangement as it appears in front of an open shelf containing books of the same hues as the flowers. Or avoid placing your flowers right in front of a curtain made of a bright, floral print. Such juxtapositions of subjects and backdrops would not only be immensely difficult to paint, but esthetically worthless, too. Unless you want to give your painting the title: *Find the Subject!*

natural distortions

Many artists distort shapes deliberately. There are perfectly natural distortions which have nothing to do with such artistic ideas. For example, a round glass distorts everything seen through it. Stems, leaves inside the vase are visually broken up by the roundness of the glass. The table, and any object behind the glass vase, are also broken up.

The breaking-up, and the distortions are even more prominent in a rippled, or fluted glass container. Colors are also changed. The clearest glass has a color, perhaps greenish, occasionally bluish, which affects every hue seen through it. A thick glass container makes all items seen through it grayish, slightly hazy. Water in the container adds to both the distortion in forms and the haziness of colors. Observe everything you paint, instead of taking for granted that you know exactly what's in that glass. What you see is very different from what you think you *ought* to see.

**distortions
in metal
and ceramics**

Distortions also appear in reflections on highly polished objects, such as silver, brass, chromium, and glazed ceramic containers. The distortions are caused by the rounded surfaces. The more varied the curvature of such a shiny, mirrorlike, article, the odder the reflections. Convex sections — such as the "belly" of a vase — elongate, or widen the shape of everything reflected in them. Concave sections — such as the neck of a container — reduce sizes. As there are innumerable kinds of rounded containers, and innumerable articles that may be reflected in them, all I can say is: observe what you see, and try to paint it correctly. Such reflections are interesting, often fascinating; and they are integral parts of perspective and artistry as well.

Round glass distorts whatever is seen in or through it, especially when the glass is fluted or rippled. Stems, leaves, table, seen through the glass, aren't the exact continuations of the objects seen outside the glass. They're broken up, widened, narrowed, twisted, according to the shape of the container. Water in the glass adds to the distortions. If you're planning to paint a recognizable, serious picture, observe what you see, instead of working from memory.

Nearby articles are reflected in all shiny surfaces, in distorted forms unless the surface is absolutely flat and vertical or horizontal. The degree of distortion depends upon the shape and glossiness of the surface. A highly-polished metal vase reflects like a mirror; reflections in a glazed ceramic vase aren't so clear. Convex forms elongate; concave forms reduce the reflected images, and cause other distortions as well.

A vase of flowers by Jacob Vosmaer, Dutch, 1584-1641, oil on wood, 33½ x 24⅜ inches. Holland is considered the birthplace of still life and flower painting in the Western world. It is quite typical of Dutch flower paintings that the flowers and the container practically cover the entire support. The Metropolitan Museum of Art, Purchase, 1871, New York. ▶

Still life: flowers by Pierre Auguste Renoir, French, 1841-1919, oil on canvas, 32 x 25½ inches. Renoir, derided as a slapdash, new-fangled artist for many years before he attained fame, is especially admired for his rich coloring, whether the subject is a young woman, a group of nude bathers, or a bouquet of flowers. There's a kind of prismatic glow in his paintings. Thannhauser Foundation, The Solomon R. Guggenheim Museum, New York.

5 Composition in Flower Painting

Flower arrangement is an art in itself. The Japanese are noted for their special dedication to this form of art, which is practically a religious ceremony, and part of the way of life in Japan. The Japanese flower arrangement, now extremely popular in the United States, is more akin to sculpture than to painting, but can be very picturesque as well.

Japanese flower arrangement

Several, but not many, flowers and accessories, such as a curiously shaped piece of stone, or driftwood, a graceful weed, or bamboo, are put together in an appropriate bowl. The arrangement serves as an esthetic and spiritual focus in the main room of the house. Only one floral piece may be had at a time, and, as a rule, it harmonizes with the scroll on the wall behind it. Both flowers and scroll are indicative of the season, or some important event in the family, or the country.

incongruous arrangements

The Japanese art of flower arrangement has inspired Western florists to combine odd items, such as a couple of weird, almost animal-like exotic flowers with common, local blossoms, or to "embellish" garden and hothouse flowers with sprigs of weeds. Since our florists are able to obtain flowers from any part of the world, and keep them fresh for quite a while in huge refrigerators, bizarre combinations are possible.

The Japanese would only employ flowers and objects found at the same time, in the same place. Purists everywhere prefer the Japanese principle, but our florists offer some charming arrangements of their own. For example, I've seen flowers put in ice cream soda glasses, with a small red blossom topping the arrangement, like a maraschino cherry, and a soda straw sticking out of the glass. Needless to point out that such cute items aren't worthy of painting, especially as the person viewing the painting would never know it represented flowers. The painting would look like a picture of an ice cream soda.

composing with artificial flowers

Incongruity is quite frequent when an artist paints from artificial flowers. These can be wonderfully made, usually in plastics, cast from actual petals, leaves, stems, and other parts of real plants, then assembled by hand. You have to take a close look to realize that they are artificial. This kind of artificial flower is a far cry from the thick, naive flowers made of wax, velvet, or crinkled paper, popular in the early years of this century.

The danger with artificial flowers lies in the fact that they're available all year round, not only in big department stores, but in five-and-ten-cent stores as well. You are, therefore, more likely to make odd combinations than if you bought fresh flowers. Do some window shopping, first. Scrutinize the displays in florists' shops before purchasing artificial flowers. You'll have a better idea of what flowers go with each other.

**pictorial
arranging
of flowers**

A regular bouquet or display of flowers ought to look good from *every* angle, as it's usually expected to serve as a centerpiece on a table. In painting, on the other hand, you have to make sure that the arrangement is good from where you paint it. Still, it's best to have a full arrangement, instead of setting the flowers up on one side only. Otherwise, your bouquet might look flat. Even though you don't see flowers and leaves on the back, they help in giving a three dimensional effect, and some of the colors of hidden flowers sparkle between the leaves.

**how to start
a flower
arrangement**

You may have an interesting container, and the sudden inspiration to fill it with flowers, and to paint the subject. Or you may receive a gift of flowers, or happen to buy one for a special occasion, and decide to perpetuate it in a painting. All you need is a satisfactory container which goes well with the flowers.

A glass vase isn't the only receptacle for flowers. Silver, brass, pewter, porcelain, ceramic vases are just as good. Bowls of an equal variety of materials and shapes exist, too. Nor is it necessary to put flowers in something specifically manufactured for that purpose. You'll find any number of containers, not planned to hold flowers, which might serve beautifully. Wine and liqueur bottles come in countless shapes, some plain, some ornate, exotic, in many colors, in glass, opaque glass, or ceramics.

The labels on the containers add color and design effects. You may wash off the label, if you wish; or turn it the other way. You're not planning to paint an advertisement for a certain alcoholic beverage. If you paint the label, or part of it, don't paint an exact, legible "picture" of the label. Merely suggest the shape and color of the trade mark, and the bigger lines or words, for the sake of artistic interest.

A sprinkling can, a pitcher of any material, an old coffee pot, a very tall drinking glass—with or without a stem—a champagne cooler, an old wooden bucket, are other possibilities. Baskets of diverse shapes and sizes are also quite picturesque. Certain flowers come in ordinary earthenware pots, and can be painted that way. Others might be put in ceramic or porcelain containers. For a truly rustic effect, remove the label from a tall fruit juice can, remove the top, batter the can with a hammer, and let it rust, if possible, to make it look quite shabby.

**match flowers
and containers**

The battered old can may be exactly right for a bunch of wild flowers you, or a friend of yours, had just picked in the country. But you wouldn't place a dozen "American Beauty" roses in such a receptacle. You would hardly place a small bunch of violets in a tall, heavy-set vase; a drinking glass, possibly with a short stem, would be more appropriate. Two long-stemmed chrysanthemums would look forlorn, and absurd, in a very wide-mouthed vase. There are thin, tall containers for such flowers.

Baskets are indicative of just-picked flowers, and add to the feeling of freshness. An elegant, ornamented silver vase or bowl is better for formal arrangements.

**composing with
cut flowers and
potted plants**

In city homes, probably most flowers are cut flowers, not expected to last more than a few days. However, many people like real, growing flowers in pots, filled with the right kind of earth. Such potted plants are best painted in the original, simple earthenware pots. It has become fashionable to wrap these pots in some colored foil. The carelessly applied, wrinkled foil, with its metallic sheen, is quite attractive, and doesn't detract from the rustic appearance of the earthenware pot.

There's no reason why certain flowers or plants should not be placed in more elegant pots, or in hanging brass, copper, or glass receptacles. Your motto should be: "To each its own." Every species of flowers ought to have the appropriate container, the right place, and the most suitable background, as practically the first step in a floral composition.

symmetry versus asymmetry

Although bouquets in vases are bound to be more or less symmetrical in general appearance, avoid perfect symmetry. On the other hand, you wouldn't want them to look as if they were about to topple over, by placing more and bigger flowers on one side than on the other. Try to preserve a certain naturalness. Just put the flowers together, place them in the container, and look at them from diverse angles. Pull one flower from one place, and put it where it goes better with its neighbors in form, size, or color. Leaves, ferns, and whatever else you add, should also be uneven, rather than symmetrical.

In bowls, especially in elongated containers, asymmetrical arrangements are recommended. An off-centered display of flowers in a low bowl doesn't give you the somewhat disturbing feeling that the whole thing might fall out of the container. In such a bowl, you may let a few blossoms or leaves hang over the rim; you might let others rise much higher than their neighbors in the same bowl. A cattail or two, or some other tall item, could be employed in the arrangement. At any rate, turn the floral display round and round, or walk around it, before deciding from which angle it looks most picturesque.

where to place flowers

The simplest, and most common place on which to set up the flowers is a round or rectangular table or stand. This may be natural wood, with dull or glossy finish. A glossy table reflects flowers and container to a certain extent. If it's very shiny, it acts like a dark mirror. If it has only a slight sheen, the reflections in it will be just suggestions of the colors in the flower display. In a large picture, a shiny-surfaced table offers a chance for introducing colors in a table that otherwise looks dull and empty, in contrast to the brilliance and variety of hues in the flowers above.

The nonreflective table, on the other hand, shows a cast shadow rather than a reflection. With this kind of table, you might also place a small tablecloth under the vase or bowl, to add a variety of colors and shapes, without repeating the hues of the flowers. Painting a reversed image of the flowers in the tabletop may be a real challenge, but it may also be confusing, if the reflection is too clear and precise. My advice is that you place your flowers on a somewhat shiny, but not mirrorlike surface.

As I mentioned in the chapter on perspective, flowers may be anywhere: on a shelf, on a windowsill, on the wooden or parquet floor of a living room, the brick floor of a terrace, the flagstone walk in the garden or patio. They can be in a receptacle hanging from a bracket, thrown pell-mell on a kitchen table or on your couch; they can be sticking out of a sheet of green paper, or in a long, white paperbox, which florists often use for wrapping flowers.

flowers in nature

Flowers can also be painted as they appear in a garden, growing from the soil, or running up a wall or fence. Painting flowers in their natural location is only possible if you are in the country, or if you happen to have a garden or a penthouse with growing flowers. In a garden, or in the country, you have to select a spot where a group of flowers is sufficiently separated from the rest of the view to serve as a pictorial subject. If you paint a large segment of the scenery, your painting will be a landscape with flowers. On the other hand, if you move in too close so that flowers and their leaves take up almost the entire support, the result will appear to be a piece of wallpaper or chintz, rather than an individual flower painting.

how about copying photographs?

Color photographs, or reproductions of good flower pictures are available, as a rule, and may be most helpful. But beware of mere copying. Copying normally leads to cold, meticulous, stiff painting. Flowers executed from photographs lack the freshness, the crispness found in paintings done from life. Use photographs or reproduc-

A shadowbox is an inexpensive necessity for still lifes. You can obtain veneerpanel or Masonite, cut to size, at any lumber yard. The following sizes are usually satisfactory: 16″ x 24″ for the floor; 16″ x 23″, for one wall; 16″ x 15″ for the other wall. You'll also need so-called one-by-one strips (actually three-quarter-by-three-quarter), one 24 inches, one 15 inches long.

tions only to assist you in composition and in proportions, but have fresh, or excellent artificial flowers in front of you for actual observation.

shadowbox for flower still lifes

Even if you have a regular studio, where you can work undisturbed and where you can set something up and keep it indefinitely, I suggest that you get a shadowbox for your still lifes. The shadowbox consists of an oblong floor, about 18 x 24 inches, made of quarter-inch veneer panel, or Masonite; upright walls attached to two of its sides, one long and one short side. The walls may be 18 inches high. Nailed together with the help of narrow strips of wood, such a box is most practical for any sort of still life.

If you cannot make or obtain one, pick up a big corrugated box at your supermarket; cut off its top, if it has any, and one long, and one short side. Strengthen the floor of the box by gluing another sheet of corrugated paper onto it, or by getting a sheet of Masonite, or veneer panel for it. Any lumber yard will cut it to size.

A shadowbox takes up very little space. It can be put on top of a shelf or cabinet, when not in use. Set up your still life in the box. Add the desired background, and you can work on your painting whenever, and as long as you want to.

composing backgrounds for flowers

Some artists paint flowers as a charming decoration on a door, the footboard or headboard of a bed, or on a wooden chest. A few gay colors enliven the room, and a decoration of this kind can be quite artistic in its own way. In the fine arts, though, it's customary to go beyond such decorative concepts. Flowers ought to be painted as a complete subject, in which the main theme, the background, the foreground and, very often, accessories, too, are involved. In a fine arts painting, every part of the work is ultimately of equal importance.

drapery backgrounds

In a small picture, the background should be as simple as possible. If, however, you have sufficient space around the flowers, try to have a richer background, without making it too complicated. A piece of drapery, hanging in soft folds, often makes an excellent backdrop. Avoid the use of heavy, ornate drapery, with huge folds. All you need is an indication that the background isn't a flat wall. The moment you make the folds big, they appear to be objects sticking out of the wall or standing on the table, competing in power with the flower subject.

scenic background

As I've already pointed out, a vase of flowers on a windowsill or on a balcony might have a scenic background, a view of the countryside or a cityscape. Such a background requires a large enough support to incorporate all the elements on a fair scale. In a floral subject, your best bet is to paint the flowers lifesize, the background in proportions. If the background is a scenic view, work on a horizontal support, giving more space on one side than on the other, so as not to have the flowers in the exact center.

Leave a lot of sky; keep the horizon low. This helps you to differentiate between background and flowers. Naturally, perspective is quite important in this kind of subject. If you include the windowsill in your composition, look at the sill from an angle, so that it runs slightly upward, not horizontally. A horizontal windowsill right above the bottom section of the frame would make that part of the frame appear to be wider than the rest of the frame; it would also be monotonous. It isn't necessary to paint the windowsill and the frame of the window. You can easily suggest the fact that the flowers are in a window by merely showing the top of the container, with a bunch of flowers, and the scenic view beyond. A curtain, or part of a curtain on one side or both sides may be attractive. Make sure, though, that if you paint curtains on both sides, the two sections aren't of the same width.

This kind of drapery, with heavy folds, strong shadows, and bright highlights, is inconsistent with the delicacy of forms and colors in a floral arrangement.

Place drapery at a slight angle and merely indicate that it isn't flat by doing a little shading and highlighting on it, without harsh contrasts.

When your drapery hangs down at an angle, don't paint it diagonally across the whole support, dividing your picture into two triangular halves. This arrangement, plus contrasty shadows and highlights, would surely "kill" your floral still life.

Let the drapery hang softly, unevenly, in an off-centered fashion, in order to serve as an unobtrusive background.

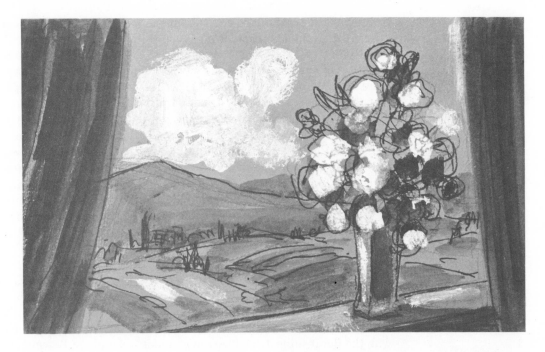

When you paint flowers on a windowsill, you needn't show the whole window, just part of the sill. Keep the view fairly low, in order to give more prominence to the flowers. A curtain on one side, or both sides, may be shown, but not in a perfectly symmetrical manner.

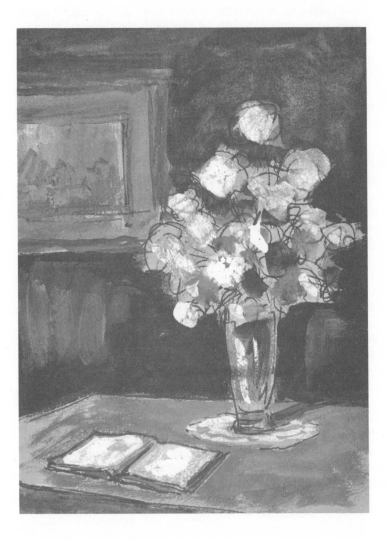

When you paint flowers on a table, the flowers should dominate the picture. The simpler the background the better. A book, or some other article on the table, adds interest, but shouldn't detract from the flowers.

composing flowers in an interior setting

If you want to paint the interior of a room, a composition that also includes a flower arrangement, decide, first, what is more important: the flowers, or the room? You might paint an interesting interior, with a vase of flowers as a small part of the picture. Or you may make the flowers your main theme, merely indicating that there's a room behind them. Since we're dedicated to flower painting, we assume that the room is secondary, and will serve only as a backdrop.

Select a sufficiently large support to enable you to do the flowers in lifesize, yet with enough space to show the room as well. Here, too, perspective plays a role. You have to indicate the table, perhaps an object or two on it, in addition to the flowers. A piece of furniture in the background, or a painting on the wall, perhaps a simple curtain on a window or door, will create an illusion of space, provided, of course, that everything in the background is subdued in color as well as in size. Don't allow colorful, big items in the back to cause confusion. Don't attempt to put too much into the picture—a common error of beginners.

props for flower subjects

A flower still life may contain other items besides the flowers and the container. Nor is there any rule or limitation on what may or may not be combined with flowers. A large seashell, a book or two, a piece of driftwood, a toy, a plate of fruit, a glass of wine or water; a statuette; scarf, gloves, a lace fan, a purse might go very nicely with the floral subject. You may even place a couple of flowers on the table, in order not to leave too much empty space at the bottom of the picture.

Props offer stimulating textural differences well worth painting. A piece of driftwood looks most interesting against a shiny tabletop, a glass vase, and bright flowers. Be sure to paint each accessory or prop as carefully as you paint the flowers. Always carry the entire picture to the same level of execution, whatever your style may be. And don't overcrowd your picture. Avoid placing all props on one straight line; have some in front, some behind the container. Don't place objects next to each other, as if they were displayed on a shelf in a store. There must be some cohesion between the various objects. They must look as if they had a reason for being in the same picture.

who decides the rules in composition?

"Why should I do it this way? Is this a law? Who decided all this? Isn't it true that great artists do things differently? Aren't there many ways of doing things in art?" These and similar questions have been fired at me by students countless times. The answers are simple enough. There's no law in art. Nobody can force you to do something against your will. But great artists learned from teachers, and added new ideas to what they had inherited. And it's by scrutinizing the works of great artists—artists whose works grow on us—that we try to figure out just what makes them great. What makes their works so satisfying to our eyes?

By analyzing great paintings, we have developed certain standards for what effects are pleasing. We understand that the lack of such effects is what often makes otherwise skillful paintings uninteresting or weak. You learn rules in singing, dancing, playing musical instruments, and in all forms of athletics. Why not consider certain rules in painting? Composition, more than any other feature of painting, is based on provable, psychological esthetic principles. These ideas are accepted by all experienced artists, regardless of style, technique, medium and "ism."

composition of the masters

Individual tastes are different, that's true, and tastes change in general. Yet, all through recorded history, there have been only two basic types of composition in the pictorial arts. In classic Greece and Rome, a symmetrical arrangement of the subject was the standard, due to the fact that Greco-Roman architecture was absolutely symmetrical. This symmetry continued through Early Christianity and

into the Renaissance. By the middle of the sixteenth century, though, composition became more and more asymmetrical, and has remained asymmetrical every since. It is interesting to note that Oriental artists, independently, also worked in off-centered composition for many centuries.

Manifestly, this is a universally liked approach to painting. You can compare the compositions of the greatest artists of West and East in paintings created during the past four hundred years, and you'll find a fundamental similarity that's nothing short of amazing. Consider the placement of the main figures and objects in paintings by Rubens, Rembrandt, Watteau, Turner, Manet, Cézanne, Whistler, Hokusai, Hiroshige, Picasso, Matisse, or any other well known artist, and you'll find that there's no real difference between them, even though the execution and the style are totally different. To put it into a brief statement, all major artists would accept the same layout, but each of them would develop it in his own particular style.

what not to do in composition

Here are some suggestions of things to *avoid* when composing flower painting.

• Don't make your floral arrangement perfectly symmetrical, lest it look monotonous, artificial.

• Don't place the flowers too far on one side because you'll leave a big, empty space.

• Don't make vase and flowers too big, because your painting will appear to be a piece of floral-printed chintz or wallpaper.

• Don't make vase and flowers too small as they will seem childish.

• Don't paint one flower leaning out of the vase towards the left, another flower leaning out towards the right. You wouldn't want to have that kind of flower arrangement on your table; why have it in a painting?

• Don't place two entirely different arrangements next to each other in order to fill the space on your support. There must be some relationship between the objects.

• Don't let all your flowers lean in one direction, like the Leaning Tower of Pisa.

• Don't cut a piece off your vase, bowl, or flowers, just because you placed them the wrong way, and there isn't enough room for them on your support. Make your drawing smaller, or move it up, down, left or right, in order to allow space for the entire still life.

• Don't paint the table or stand horizontally across the center of your support, so it will appear to be a flag with horizontal stripes.

• Don't paint the table on too much of a slant, either, because the vase and flowers will seem to be sliding downhill, or climbing uphill on a slope.

what you ought to do in composition

Here are some suggestions for things to try when composing flower paintings.

• Place the flower subject slightly off-center.

• Paint the flowers and vase approximately lifesize, in such a manner that no part of the vase and flowers should touch the edges of your support. And, certainly, no part should be cut off.

Too symmetrical. These flowers resemble a naive design, rather than a fine arts painting.

Object too far to one side. The flowers seem to be trying to take up the empty space by bending over in an impossible fashion.

Subject too big. This vase and flowers might have been cut out of a piece of wallpaper.

Flowers too insignificant in comparison to the big empty space around them. The table is in the center, and at so steep a slant that it looks like a ski-slope.

Composition too symmetrical and flowers too large. The two flowers cannot reasonably be put into such a vase. Moreover, the table is too horizontal, like the stripe of a flag.

Items unrelated. If you fill the support with two unrelated items next to each other, it looks as if they were displayed on a shelf in a store.

Flowers too large. The subject appears about ready to topple over, because the flowers are too large for the vase.

The flowers and the vase go well with each other. The table is at a slight angle, just the way we normally see it.

The flowers are a little off-center; only the top of the vase is visible. This arrangement allows you to paint the blossoms lifesize.

Although the bouquet is large, the pot-bellied container, with its wide base, is strong enough to hold it. The shape of the container adds variety to the theme.

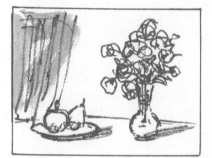

The plate of fruits and the curtain on the left make the horizontal format of the support desirable. The vase and the plate are sufficiently different in width, height, and shape to complement each other.

The basket, with its asymmetrical flower arrangement, its tall handle, and a couple of blossoms on the table, fills the support comfortably, without crowding it or without looking lost in it.

The round doily underneath the container and the big cast shadow on the right help make this rather tall painting look perfectly natural.

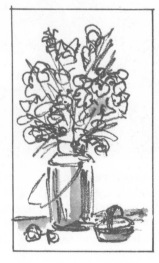

Living flowers in an earthenware pot fit nicely into the squarish format. The ordinary pot is neatly embellished by being wrapped in colored foil.

An old milk can, with freshly-picked flowers, looks right on the vertical format. The cap of the can and a couple of flowers on the table are natural accessories.

Dying plants (sterbende Pflanzen) *by Paul Klee, Swiss, 1879-1940, watercolor, 19⅛ x 12⅝ inches. Klee had a highly individual sense of design, and a classic Greek feeling for delicate lines. If you look closely, you'll discover that the dying plants have human faces and figures. The Philip L. Goodwin Collection, The Museum of Modern Art, New York.*

• If the flowers are quite big, show only the top of the vase, below the flowers, not the entire container. This is a deliberate cutting-off, not an accidental one.

• If you have space to fill, indicate the shape of the table, showing a corner of it; or place a small tablecloth or doily under the vase. Leave a couple of stalks of plant or flower on the table, in front of the container. Another practical, and artistically acceptable idea is to place a plate or saucer of fruit on the table, near the vase. A glass of wine or water, a small statue, a nifty little box, a pair of gloves, a silk scarf . . . there are countless articles in your house which could be placed on the table.

size of support

The size of the support on which you paint depends upon your subject, your technique, your medium, and your temperament. Flowers ought to be done in actual size, because they are not too big by nature. We don't mind seeing pictures of humans and animals on a smaller-than-life scale, and, of course, one can hardly expect lifesize pictures of mountains, lakes, sailboats, skyscrapers, and thousands of other things. Flowers can also be done *smaller* than they actually are, but most professional artists seem to prefer the exact size of each blossom and leaf.

I advise you not to paint them *larger* than life, though, as such pictures invariably look empty, odd, even repulsive. The lily of the valley is one of the most charming and ingenious creations of nature. Make it much larger, and it'll look like a mechanical gadget without any delicacy. Snapdragons, enlarged to several times their actual size, would probably look like some species of beast.

Floral paintings may be very large, of course, as for example in decorative panels made for a ballroom. As a rule, though, they needn't be bigger than what fits the average home. An 18 x 24-inch support is just about right for a vase of flowers. Larger sizes are required for paintings in which flowers are combined with other items, such as scenery, cityscape, the interior of a room, and the like. Most artists work on supports with a ratio of three to four. That is, the short side is three-quarters of the long side. But many other proportions exist. I usually work on 18 x 24, 22 x 28, and 19 x 32-inch supports. Every now and then, especially in aquarelle, I use a 15 x 20 or 15 x 22-inch paper or illustration board.

Have several different sizes on hand. Don't try to force a very tall floral display onto a comparatively low surface, or vice versa. A student of mine once insisted upon painting large flowers in a wide-mouthed and vide-based ceramic vase, with two books and a red apple in front of the vase, using a canvas ten inches wide and twenty-four inches high. The vase itself filled more than half the width of the support, while the flowers were compressed. From a distance, the picture appeared to show Santa Claus trying to get down a chimney. The books and the apple were hopelessly and unreasonably distorted, narrowed out of shape, out of perspective, in order to get them all on that narrow canvas. The result was certainly no work of art.

shape of support

Size is not all that matters. You have to consider the shape of the support, too. Whatever subject you set up, look at it for a minute or two, and decide whether it's wider than it is high, or higher than it is wide. Quite often, a floral subject appears to be tall, because the container is high and the flowers stick upwards. Considering the whole picture, though—including table and certain props—it's possible that the painting would look better on a horizontal support. Lay it out both ways: horizontally *and* vertically. Try it on various supports, until you find the best shape and size. I often make sketches in pencil. When in doubt, I prepare a full-scale layout on a sheet of tracing paper, before I make my final decision. You can push the tracing paper up or down, right or left.

Notice the group of sketches I've made, showing various possibilities in composition—good and bad ones.

Etruscan vase by Odilon Redon, French, 1840-1916, tempera on canvas, 32 x 23¼ inches. In Redon's world, reality and unreality were completely interwoven. His paintings have a decorative as well as spiritual, or perhaps spiritistic, aura. The Metropolitan Museum of Art, Purchase, Maria DeWitt Jesup Fund, 1951, from The Museum of Modern Art, Lizzie P. Bliss Collection, New York.

6 Color in Flower Subjects

Flowers, like everything else, can be rendered in black-and-white pictures—drawings, paintings, photographs, reproductions—but you'll miss one of their most wonderful features: their colors. It's an unquestionable fact that every shade of every hue known to the human eye, except perhaps black, exists in the realm of flowers. Flowers thus offer you a perfect opportunity to satisfy your love for colors, and to express this feeling in painting. Flower subjects offer great possibilities for using a wide range of colors. The blossoms themselves are varied in hue, and can be combined with colorful backgrounds and containers.

selecting colors in flowers

The enormous variety of hues in flowers may prompt you to put together bouquets in which every blossom is of a different color and shade. The result is likely to be a hodge-podge. We normally prefer to see flowers of the same, or similar, harmonious hues in a floral display. Wild flowers are a different proposition. We pick them as we find them, and a great many varieties may be included, together with some weed and grass.

In a more formal bouquet, a certain uniformity is desirable. Roses of various shades of pink, for example, or asters of diverse yellow tones are pleasing to the eye. In a seasonal arrangement, such as a group of autumn flowers, it's quite natural to group yellow, orange, ocher, purple, violet, maroon, and red flowers together. For a patriotic celebration, you might take bachelor's buttons, surround them with alternating rings of white and red carnations, but you'd hardly use such a set-up as a pictorial subject.

The more elegant a floral arrangement, the more uniform the sizes and hues of the flowers. One single dark red rose among eleven yellow roses, or two white carnations in the center of a bunch of two dozen red ones would look incongruous. You may deliberately set up a bunch of flowers in which every blossom is of a different color, if, for whatever reason, that's what you want. However, if you paint such an arrangement, most people are likely to exclaim: "What a colorful picture!" or "Gee-whiz . . . you sure have plenty of colors in that painting!" Such exclamations are not necessarily the equivalents of praise. They're polite indications of the fact that those people have a low opinion of your taste.

colors for containers

Don't place a multicolored bunch of flowers in a very ornate vase or bowl similarly rich in color, because one set of colors would compete, or clash with the other. You may have a Baroque or Renaissance Italian majolica pitcher, decorated with gay figures and flowers, a beautiful and perhaps valuable heirloom. It may be fine for a bouquet of white, or pink, or blue flowers, as these colors stand out against the yellow, orange, and green hues in the pitcher's decorations. A solid-colored container is usually a much safer bet, and more artistic as well, if its color harmonizes with the hues in the floral arrangement.

One single, very dark flower, in the midst of a bunch of light-colored ones, would look incongruous and forlorn. So would a very light-colored flower, in the center of a large bouquet of dark blossoms.

It's delightful to have a variety of shades in the same general color, such as diverse yellows, ocher, rust, or various shades of pink and orange. A couple of white flowers go with practically any group of light-hued blossoms.

practice color composition

Certain artists believe a beginner should work with a restricted set of five or six colors until he learns how to handle the brushes and paints. I don't agree with this idea. The beginner should use all the colors an experienced painter uses in order to learn how to handle, how to mix those colors. I do, however, think it's advisable to start with a comparatively simple set-up. Put flowers of the same species and of similar hues in an undecorated vase, on a plain table, with an undecorated wall or curtain as a background. As you become familiar with flowers or plants and the delicate handling of colors, add more complex flowers, and some accessories, such as a book or a piece of driftwood on the table, in front of the container.

Then you might combine two pots of flowers or plants, one pot a little larger than the other, with several objects on the table, arranged in a casual fashion. Never place articles of equal shape, size, and color next to each other. Consider the psychological factors in reference to placing objects too high, or too low, too far to the right, or too much to the left, discussed in the chapter on composition.

background colors

When you first paint flowers, your inclination almost surely will be to paint the background very dark, in order to "bring out" the vivid colors of the flowers. It's undeniable that gay flowers look strikingly bright against a dark backdrop; quite a few artists toward the end of the nineteenth century painted dark backgrounds for portraits as well as still lifes. The trouble with a dark background is that it causes the subject to appear bigger than it really is; and that it turns an otherwise free, artistic picture into a sort of powerful poster.

Your best bet is to acquire materials of diverse colors—in construction paper, glossy paper, or textile remnants—and try them out before you start to paint a subject. Place one color after another behind the floral display, until you find a color which looks truly good with your subject. You may have to move a blossom or two, in order to obtain the most satisfactory effect. For example, a light blue background may seem to be right, except that some flowers of about the same blue color happen to be sticking out of the bouquet in such a manner that they blend into the color of the background. All you have to do is to move those blossoms somewhere else, or pull them out, and put them on the table.

warm and cool backgrounds

As a general rule, select a cool color for the backdrop when the flowers are mostly warm in hue (yellow, red, orange shades); and paint a warm background for cool-colored flowers (white, blue, blue-violet tones). A bunch of yellow flowers against an orange-red backdrop resembles a conflagration, a house on fire. Bluish flowers look faded, anemic, when placed in front of a gray-blue backing. A green background, often favored by students, causes green stems and leaves to disappear, or compels the painter to exaggerate highlights and shadows on the stems and leaves to make them visible. A bright green backdrop also causes red, and orange-colored flowers to jump in your painting. You wouldn't want to paint bright red flowers against a bright red curtain.

paint the background with care

In a good painting, the background is just as important as the subject itself. It's a mistake to paint all the flowers and the container first, then paint a background around them with a flat color as if this were merely a matter of routine. True, you can always go over the background with another color in oils, casein, polymer, and even in pastel; you can make the background darker in aquarelle, too. But every time you go over the background, trying to leave the original shapes of the flowers and leaves, you make your picture more and more labored in appearance. The outlines of flowers, stems, and other items become harder and harder. At the end, the floral arrangement may very well appear to be a picture applied with a stencil.

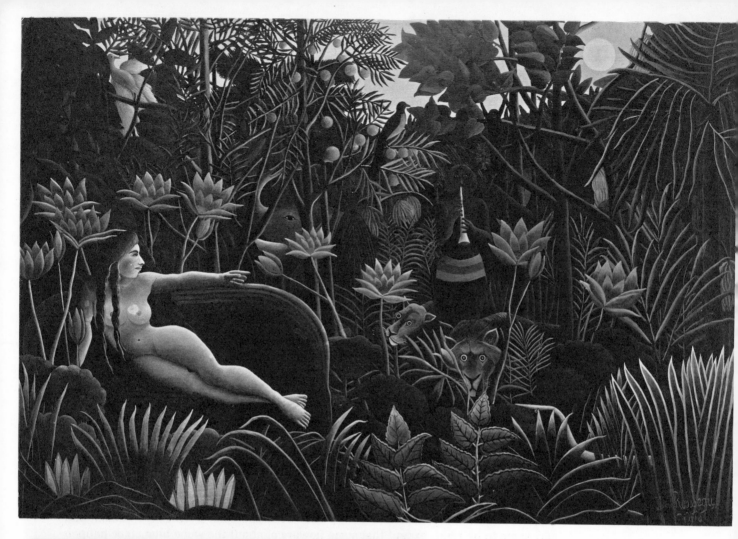

The dream by Henri (Le Douanier) Rousseau,
French, 1844-1910, oil on canvas, 80½ x 117½
inches, painted in the last year of his life.
Fantastic flowers and plants, executed like
jewelry, surround an inexpertly drawn nude,
various beasts, and birds. Collection, The
Museum of Modern Art, Gift of Helen A.
Rockefeller, New York.

Detail

7 Lighting Effects in Flower Painting

Illumination gives us the play of light and shadow which enables us to achieve the feeling of space in our paintings. In Western art, three dimensional effects — conveyed through light and shadow, superimposed upon linear perspective — developed to a high degree as early as the days of the ancient Roman Republic. Effects of space or spatial relationship are still important even in contemporary nonobjective painting which may still give the onlooker a feeling of great physical depth.

lighting has two meanings

Lighting — or illumination — means the light by which we work. It also means the light we render in our painting. Artists in past ages must have done their work by daylight, except when painting murals directly on walls. At least some sections of those murals must have been executed by the light of oil lamps or candles. The light and shadow effects which were rendered in their paintings were usually standardized: the light coming from the upper left- or right-hand corner, and the shadows constructed with geometric accuracy.

Realists, led by Michelangelo Amerighi Caravaggio (1569-1608), melodramatized the lighting effects by making shadows extremely dark. Individualists, especially El Greco (1541-1614?), Rembrandt (1606-1669), and Goya (1746-1828), introduced fantastic, mysterious, or spiritual effects with the help of lights and shadows.

The twentieth century has brought us remarkable sources of artificial light. We now can work anytime, day or night. And the variety of pictorial styles is so great that some of us render light and shadow with photographic realism, other artists handle light and shadow individually, capriciously, softly, boisterously, mysteriously, or poetically. Still others dismiss such effects completely, and rely on color schemes alone, even in otherwise realistic paintings.

try various light effects in flowers

Do a little experimenting with light and shadow. Set up a vase or basket of flowers, and place them in a sunlit spot. If all flowers are hit by the light, the effect is bright, but rather flat. If you keep all the blossoms in the shade, they look quite dull and pale. Place them in such a way that some of the flowers are illuminated, others are in the shade, and the total effect is richer, more three dimensional. The same diversity of effects may be achieved by any artificial source of light, but the illuminated flowers will appear to be even more brilliant, because shadows are usually darker by artificial light than by sunlight.

Illumination pertains to *everything* that goes into your painting, not merely the flowers. The container, the table or stand, the background, and whatever you may have in the foreground, must be included in the total lighting effect. A brightly lighted bouquet of flowers against an equally brilliant backdrop would be lost. A bouquet in the shade, on a windowsill, shown against a bright blue sky, would look like a grayish silhouette pasted on a bright sheet of paper.

Light comes from the upper left, giving the flowers and the basket a strong three dimensional appearance.

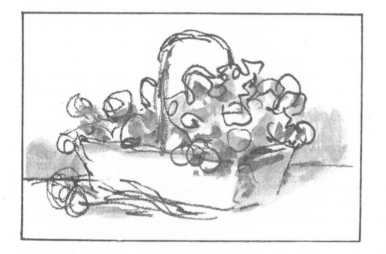

Here is the same subject in an over-all light, such as the lighting from fluorescent lamps or in a shady place where there's hardly any difference between light and shadow. The flowers appear to be flat.

contrasty lighting

The most practical and visually simplest lighting comes from slightly above and from slightly in front of the upper left- or right-hand corner. Right-handed artists usually have the light come from the upper left-hand corner; left-handed artists paint the light as if it came from the upper right-hand corner, as a rule. Such light illuminates about two-thirds of the flowers on the top and the side, leaving the bottom of each flower and about one-third of the entire set-up in the shade.

It's possible to illuminate flowers from below, as if they were seen in the light of a very short candle or flames in a fireplace. Such tricky illumination requires a great deal of acute observation for changes of colors. Candlelight throws a yellowish veil over everything it hits. The light of a fireplace depends upon what's burning in it. The flames may have a reddish, orange, or greenish glow. Lighting effects of this kind aren't easy to depict without showing the source of light, too. In other words, you ought to show the fireplace itself, or the candle, in order to explain the extraordinary color effects. An interesting and artistic project, worth trying sometime.

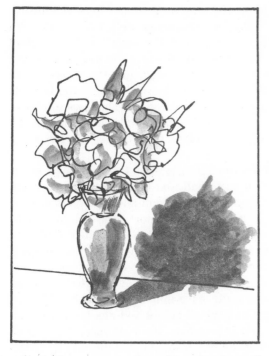

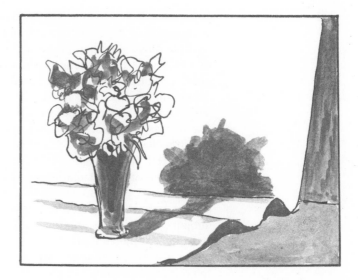

Cast on a wavy drapery, the shadow follows the waves, then goes up the flat part of the drapery which serves as background. Observe the shape, size, color, and value of each shadow the way you observe all other parts of your subject.

The shadow, cast on flat table, hits the wall in the background and climbs straight up on it.

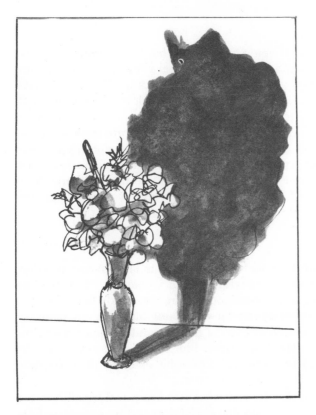

Here the cast shadow is much bigger than the bouquet, because it's illuminated from a low point.

This cast shadow resembles the silhouette of the devil. With a little ingenuity, you can create intriguing shadows with flowers.

cast shadows

Wherever there's light, there must be shadow. Not only what we call local shadows — on one side or the other of each object — but *cast shadows* as well. Every article hit by light throws a shadow on the surface in the path of the same light. An object standing on a table casts its shadow on the table. An object on a wall has its cast shadow on the wall, on the opposite side from which the light hits the object. A tall article on a table casts its shadow on the table and on the wall behind the table as well. One of the most fascinating sights outdoors is to watch the shadows of clouds run across valleys, hills, meadows, and mountains as the clouds move across the sky. It's also interesting to see the shadow of an airplane dash across the terrain as fast as the plane flies.

Both local and cast shadows have to be observed in reference to shape, size, color, and value. If you paint a shadow too big, or too small, too light, or too dark, it will be just as wrong as if you made similar mistakes in the illuminated sections of your subject. Too dark a shadow looks like a hole in the support. Too bright a light resembles a piece of white paper stuck onto the picture. It's a good idea to place a white item — a handkerchief or a piece of white paper — next to the subject, temporarily. You needn't paint it, but it serves as a standard of comparison.

Compare the true white with your flower set-up. The chances are that not even the white flowers — if you have any — look quite as bright as true white. They're likely to have a yellowish or pinkish tint. Compare all colors and shades with each other. Which blossom is lighter in value: the yellow rose, the pink rose, or the pink carnation? Which flower is darker in value: the red rose, the red carnation, or the purple dahlia? What is darker: the shadow on the pink rose, or the shadow on the yellow aster? The shadow on the blue vase, or the cast shadow on the brown table, or the shadow on the gray wall?

dramatic shadows

Cast shadows can be most dramatic, if you want them to be. For instance, the cast shadow on table and wall will be much bigger than normal if you place a light at a low point, and push the flower arrangement close to the backdrop. This can provide weird, almost frightening effects. You must have seen shadow plays done with human hands. Faces and animals can be reproduced in an uncanny fashion, silhouetted against a brightly-lit wall. Would you like to incorporate such an effect in your painting? All you have to do is to arrange your flowers accordingly. Move a blossom or leaf this way or that way, and you'll have the face of the devil, or a monster on the wall right behind your pretty flowers. If you do this deliberately, it may be interesting or amusing, but beware of having a rabbit or elephant in your cast shadow by sheer accident. People will consider it silly.

effective use of shadows

A painting is good if every ingredient seems to be just right in size, shape, position, color, and value. Lights and shadows are integral parts of a painting. They must be neither dominant, nor unimportant, nor superfluous. They must be where they are because, without them, the picture wouldn't be complete. My tempera painting, *Flowers in Italian Vase*, would be unimpressive if I hadn't painted the cast shadow across the table and up the wall. The few bright, illuminated blossoms, and the sparkle on the glazed decorations of the vase are counter-balanced by the soft-edged shadows. ·

In *Japanese Garden*, an oil painting, the cast shadows are transformed into big city buildings surrounding the delicate toy garden in the floral arrangement, with its bridge, the fishermen, the woman with a paper umbrella, and the tiny herons. The arrangement is in a big, round blue glass bowl on a table covered with red velour. The contrasty picture is perfectly natural, as it points out the tremendous difference between a poetic Japanese garden and a huge, forbidding city.

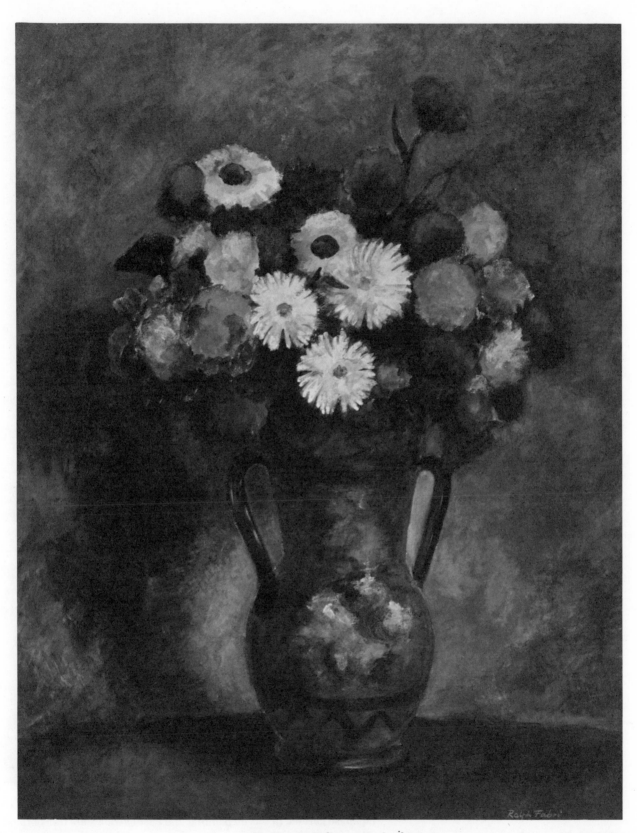

Flowers in Italian vase. In this tempera painting, the sparkle and the lightly colored design on the glazed vase add color to the lower part of the picture. The cast shadow, running across the table and up the wall behind the floral arrangement, lends dramatic power to an otherwise simple composition. Collection, Mrs. A. C. Zingher.

Japanese garden. *In this oil painting, the cast shadows are transformed into big city buildings. The dark monumentality of the background enhances the poetic charm of the tiny garden, with its creek, footbridge, fisherman, lady with an umbrella, and herons. The little garden is in a wide, simple, blue glass bowl, placed on a red velours tablecloth.*

Art isn't pure pleasure. It's hard work much of the time. The hardest part is observation. Don't take anything for granted. Don't think you know it all. Look for and at everything. You needn't be academic, traditional, photographic, but, as long as you want people to recognize your flowers, you must be earnest in observing your subject, flowers, container, background, foreground, colors, values, lights and shadows. Observe them by comparing one thing with another. Once in a while, place your painting near, or next to your subject. This is especially easy when you have a shadowbox for your floral set-up. Compare the subject with your painting from a distance. If they aren't sufficiently similar in effect, something must be wrong with your painting, not with the subject.

Looking at the subject and your painting together in a small mirror, held in your hand, is extremely helpful. As a matter of fact, there's no better way of comparing your work with its model than in a mirror. Both images are reversed, of course, and, strange as this may sound, mistakes are easier to notice in a reversed picture than in the original one.

Amaryllis and anemone by Emil Nolde, German, 1867-1956, water-color, 13¾ x 18⅜ inches. One of the most sensitive of the Expression-ists, Nolde usually worked in somber tones, with a mystical feeling. Members of the Expressionist school imbued even the simplest objects with a sense of sadness and anxiety. Gift of Philip L. Goodwin, Collection, The Museum of Modern Art, New York.

8 Flower Painting in Watercolor: Technique

Flowers were painted in oils long before watercolor was introduced as a fine arts medium in the West. Yet, the general public has a tendency to associate floral subjects with watercolor. When the American Society of Painters in Water Colors, now known as the American Watercolor Society, was founded in 1866, very few serious male artists in the United States worked in this medium. Hand-drawn or engraved topographical views, military maps, pictures of elegant private mansions and gardens were colored in aquarelle. This was the only real extent of its use.

Introduced as a regular medium for fine arts painting by Paul Sandby (1725-1797), in England, aquarelles were first shown at the Royal Academy's exhibition in 1780. A group of thirty watercolors, by a handful of American artists, was shown in New York's First World's Fair, at the Crystal Palace, in 1853-1854. It took many years for the artists, critics, and public to realize that watercolors can be as diverse as oil paintings.

At present, there are several media applied with water. This chapter deals only with what we often call *transparent* watercolor, or aquarelle. Opaque watermedia will be discussed in other chapters.

cakes, pans, or tubes?

Transparent watercolor comes in cakes, pans, and tubes. Dry cakes and pans are more practical for outdoor painting, as they can be kept and carried in a small box. Tubes are favored by most artists working indoors, because the already moist paint is easier to handle, faster to apply, especially over large surfaces. The consistency of the tube colors appears to be similar to that of oil paints, but beware of using such watercolors as they come from the tubes, without adding plenty of water to them.

I used to know an artist who had never worked in watercolor, until she received a set as a gift and decided to try the medium. She applied watercolor (in tubes) with a painting knife on gesso panel. Her work looked exactly like an impasto in oils. I warned her that her painting will literally fall to pieces if she should ever happen to drop it or hit it against the table. In fact, I warned her that the paint would probably crack off by itself within a few weeks. My friend didn't believe me.

To prove how ridiculously wrong I was, she deliberately dropped the painting. The thick paint cracked into hundreds of pieces. All my friend could do was to fetch a dustpan and brush, and sweep up the chips, grinning sheepishly.

potentials and limitations

Every medium has potentialities, limitations, problems, and special effects. If you attempt to achieve effects not in keeping with the medium, you'll only have the kind of hodge-podge so characteristic of the Victorian period, when the idea prevailed that steel should be made to look like wood, stone ought to look like velvet, wood must look like plaster, plaster should be painted like marble, iron cast to resemble filigree brass.

The intrinsic beauty of aquarelle is that it's aquarelle: a painting applied in thin, translucent washes. Even the so-called dry-brush technique has to be done with a slightly wet brush, on a very rough surface, without permitting the paint to flood the crevices of the paper. Watercolors generally have a crispness, a sparkle, a feeling of spontaneity often lacking in oil paintings. Powerful, dramatic effects are quite feasible in this medium, but a true watercolor should never be mistaken for an oil painting.

control the watercolor

Don't let the water run away with your brush and with your painting. Apply the first washes as wet as you wish, but use less water in subsequent applications of washes, because one layer of watercolor picks up the previous one, mixing the colors. If one of your colors runs into the wrong place, it can cause you considerable damage and extra work. No matter how hard you try, a blue wash over a yellow wash turns green; a red wash over a blue wash becomes violet or maroon. As a rule, you cannot paint light hues over dark ones. However, certain colors are opaque enough to cover certain other colors, if applied with very little water over small sections of your painting.

changes and corrections

Experience will teach you that impetuosity is costly in this medium: mistakes in aquarelle are difficult, though not impossible, to correct. Wash a section, or the entire painting, with a slightly wet sponge. Do this by pressing the sponge on the paper, time after time, picking up paint section by section. Don't rub the paper in this operation or you'll destroy its surface. Small highlights or details may be scraped out with a razorblade or an artist's knife. These small areas can also be removed with a hard rubber eraser, such as a round typewriter eraser. Wait until the painting is finished, perfectly dry, before you erase or scratch out any part of it. You cannot go over such scraped or erased sections with paint again without causing ugly and irreparable spots.

A tricky way of making changes or corrections — but aquarelle is full of tricks — is to cover the mistake with opaque casein or polymer titanium white. Let it dry, then work over the white as if it were the plain paper. The white paint must not flood and obliterate the teeth of the paper.

how to lighten watercolors

For lighter tones, add more water to the paint or buy lighter shades of the same color. Aquarelle doesn't weigh much; a few extra cakes, pans, or small tubes make little difference. For darker shades, use less water, but never apply the paint in thick layers. Build your painting up gradually. You can always add more paint, in thin washes, but it's difficult to remove surplus paint without damaging the paper and ruining the fresh appearance of your aquarelle.

supports for watercolor

Aquarelle is traditionally done on paper, except miniatures, which are executed on ivory, porcelain, or plastic. There are many kinds of paper, ranging from the tissue-thin, but remarkably strong Japanese so-called ricepaper to the expensive, hand-made, pure ragpaper, and the cheap, machine-produced papers of different thicknesses and textures. Try a number of papers, in order to find out which one serves your purpose, technique, subject, and temperament best.

pads, blocks, sheets

Watercolor sketch pads are satisfactory for outdoor sketching, but the paper is likely to curl up, which may make it unsuitable for framing. Blocks, in various sizes, are pasted down all round the edges, except a short section in the center of one long side.

When you set out to work, don't remove a sheet from this block; work directly on the block. The edges of the paper are glued down, and the paper flattens out as it dries. When your painting on the block is finished, and absolutely dry, insert a flat knife or letter opener in the short section that's open, and cut off the sheet carefully by sliding the knife all round. The next sheet is ready for painting.

Most artists prefer individual sheets. The lightest of these is what we call about 40 lbs, the heaviest is a 300-pound sheet. (Don't get frightened. No single sheet of paper weighs 300 or 40 pounds, or anything near that weight. Weight is reckoned by the weight of a whole ream in each particular kind of paper. If a 500-sheet ream weighs 72-pounds, we call each of the five hundred sheets a 72-pound paper.) In watercolor, it's unwise to work on a sheet of paper that's lighter than 72 lbs.

Paper can be hot pressed (H.P.), which means it has a smooth surface; cold pressed (C.P.), with a rough surface; and very rough (R). Ragpaper is more expensive than paper made of woodpulp; hand-made paper costs more, naturally, than machine-made paper. Actually, a good-quality machine-made sheet is quite satisfactory for all but the most fastidious artists. You needn't go into great expenses while studying and practicing.

stretching paper

The heaviest kinds of paper are so strong that they won't curl up when you've finished painting. Lighter sheets, however, have to be stretched, glued down to a board on all sides. Wet the paper on both sides, lay it on the board, and paste it down with one-inch gummed paper tape, half of it on the sheet, the other half on the board. Scotch tape, or Scotch masking tape won't do.

Another method of stretching paper is to fold up half an inch of the sheet all round; spread a fast-drying glue on the folded-up section. Wet the rest of the sheet, press down the edges with the glue, pulling the paper outward at the same time, in order to make it as taut as possible.

Still another system, generally practiced by European aquarellists, is to paste the paper onto a frame made of the same kind of stretchers we use for canvas in oil painting. This method keeps the bottom of the sheet open, and thus assures faster drying. The method requires more careful handling, though. If you happen to drop a heavy or sharp object on paper glued to a set of stretchers, the sheet is likely to be torn beyond the possibility of repair.

size of watercolor paper

You can obtain watercolor paper in any quality, in many sizes, from 9 x 12 inches to about 30 x 40 inches. There are illustration boards and multimedia boards ranging up to about 40 x 60 inches. Larger sizes in paper can only be bought in rolls, and those are really for drawing, rather than watercolor. They're used mostly for commercial purposes, such as window decorations in stores. Prices of paper are from a few pennies to several dollars a sheet or board.

list of watercolors

Most aquarellists work with twenty to twenty-five colors. Here's a recommended list of colors you might try:

Alizarin crimson	Burnt sienna
Geranium lake	Cobalt blue
Rose madder	Ultramarine blue
Cadmium red medium	Phthalo blue
Cadmium red deep	Phthalo green
Venetian (Indian) red	Viridian green
Cadmium orange	Chromium oxide green
Cadmium yellow light	Hooker's green

Cadmium yellow medium	Cobalt violet
Gamboge (Indian) yellow	Payne's gray
Yellow ocher	Ivory black
Raw sienna	

All major manufacturers produce student watercolors, for those who are studying, and fine watercolors, for those who wish to have the best, strongest pigments. At any rate, buy only colors produced by well-known manufacturers, and buy them in artists' supply stores, not in stationery or five-and-ten-cent stores. Cheap, nameless colors have more fillers; that is, they contain too much of a substance without any coloring power. They're for children, not for serious artists or art students.

**palette
for aquarelle**

You need a large enough white-enameled metal box for the paints, with a palette of the same material, which is usually combined with the box. There are separate palettes — with sections for mixing — made of metal or plastics. Since watercolor requires the use of water, an ordinary flat wooden or paper palette won't do. Many artists use the so-called butcher tray, a white-enameled iron tray with high sidewalls, easy to clean, and quite practical, but it must rest on a table. It's too heavy and clumsy for you to hold in your hand. The butcher tray could never be employed outdoors, where many artists like to hold the palette in one hand, while painting with the other hand.

brushes

A large, round, pointed brush, No. 12, is a must; a couple of small, round, pointed brushes for fine details and lines are good to have. Most watercolorists also like a one-inch-wide flat sable brush for applying skies, and other large washes. Test every pointed brush at your art supply store by dipping it in a jar of water (every store has one at the brush counter), and shaking out the brush. If the hairs of the brush don't come to a sharp point after the dipping and shaking, the brush is useless. Try another one.

Never use the same brushes for both oil painting and watercolor. For some reason or other, brushes lose their hairs quickly if you disregard this good old warning. All watercolor brushes have short handles. There are diverse qualities and diverse prices, of course. Avoid buying the cheapest, even if you cannot afford the costliest brushes.

accessories

A medium-soft pencil is fine for laying out watercolors on the paper. Don't use charcoal or crayon, because charcoal particles get into the paint, and watercolor doesn't cover crayon. A soft rubber eraser is needed for eliminating pencil lines. A hard rubber eraser helps in correcting mistakes.

A sponge, preferably a natural one, or an artificial sponge with very small pores, is necessary for washing out mistakes and for wiping your brushes. Pull your wet brush over a sponge to eliminate excess water, without damaging the brush. Keep at least two large cans of water on the table, and change the water frequently. For outdoors, acquire a watercan-cup combination made for this purpose. Have rags for wiping hands and brushes. Also, plain white blotting paper for catching runaway colors.

**maskoid
or frisket**

Maskoid and frisket are waterproof substances similar to rubber cement. They are employed by many aquarellists for a perfectly sound and recommended technical trick. Let's say you're trying to paint a few very delicate flowers with lace-like ferns and leaves. It's literally impossible to paint these in subtle hues, then go round them

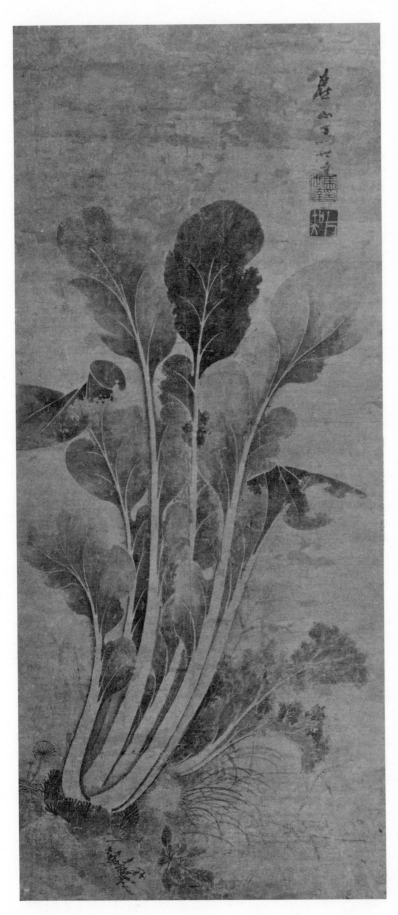

A cabbage plant, attributed to Ma-Shih-ta, Chinese, probably Ming Dynasty, 1368-1644. This 43⅜ x 18⅜ inch painting is a striking proof of how an artist can turn even the lowly cabbage into a work of art. Executed with loving care, the plant seems to be as tall, as monumental as a cluster of big trees. The Metropolitan Museum of Art, A. W. Bahr Collection, Fletcher Fund, 1947, New York.

with the colors of the background. Make a good pencil drawing of the floral subject; cover it carefully with maskoid or frisket; paint the entire background, whatever it may be, across these protected parts of the paper. When all the rest is done, rub the substance off with your fingertips, and finish the delicate flowers and leaves.

Chinese white

Purists object strenuously to the use of white paint in aquarelle, saying that the white of the paper is the only white needed. But not everyone is a purist. Many, if not most, artists believe that the ultimate result is all that matters. The goal sanctifies the method in art. Several of our best-known aquarellists have admitted to me that they use white paint for final touches. They only work with the finest Chinese white, sure to stay white forever. Other whites may turn pink, gray, or yellow within a very short time.

Test watercolor white on a piece of paper; cover half of it with another piece of paper, and expose the paper to sunlight for a week or so. You can easily determine whether a white is permanent or not by comparing the exposed part of the paint with the covered-up section.

pencil or no pencil?

I hope you've never jumped into a swimming pool that contained no water. I'm sure you can imagine the consequences. Well, don't dive into a watercolor without a layout. Mistakes are too difficult to correct in this medium. I'd be the last person to tell you to be afraid of watercolor, but I suggest that you begin with reasonable care. Make a simple layout with a pencil. Apply light washes over the pencil lines until you have the desired over-all effect, in very soft tones. When this is dry, go over it with a soft rubber eraser and eliminate the pencil lines. You'll be surprised to find that the eraser doesn't eliminate the colors at the same time.

Certain artists like to leave the pencil lines in the finished watercolor, but I don't agree with them. I prefer to eliminate the lines, and have a watercolor executed entirely in color. Many artists still follow the original British example, and prepare a pencil drawing in every detail, then just paint between the lines. They called this kind of work watercolor drawing. It's too stiff, too meticulous, for my taste.

how much water in watercolor?

Some artists think a true watercolor ought to be mostly water, with a drop of pigment in it, here and there. They flood the paper before starting to paint, drop watercolor on the soaking wet surface, and allow it to run whichever way it wants to. Other artists work on dry paper, with plenty of water in each brush stroke. Still others use just enough water to make the paint cover the paper. You can work wet-in-wet, wet-in-dry, dry-in-wet, dry-in-dry. It all depends upon you, and upon the effect you wish to achieve. Use common sense. Apply the watercolor according to the subject, rather than according to a preconceived notion.

Flowers are well defined by nature. Their petals, stems, leaves are blurred only in a downpour, which is unlikely to happen in your room or studio. Flowers ought to be painted as they are: soft, delicate, but nonetheless solid in shape. For white flowers, utilize the white of the paper, just adding shadows. Build up your aquarelle in well-controlled washes, using as much, or as little paint as a particular section of your painting requires. The ultimate aim of a watercolorist is to create a good and artistic painting. The notion that a real watercolor must invariably look wet is as absurd as if an oil painter would flood his canvas with linseed oil.

is there impasto in watercolor?

As I pointed out earlier, watercolor cannot be applied in thick strokes because gum arabic, the binder which holds the pigment in aquarelle, adheres only in thin layers. The binder differs from linseed oil and various polymers, which cause pigments to

stick together, and to adhere to a support in very thick batches or lumps. Yet, it's possible to create impasto effects in watercolor with the help of certain new materials. You can apply an underpainting with gel, or an extender, also called modeling paste. You can then paint over this surface in watercolor in the regular fashion.

Gel is now specifically made for watercolor; you may actually *mix* aquarelle with this substance, which resembles vaseline. The extender, or modeling paste, is a polymer (plastic) product, which dries very fast, and allows you to achieve bas-relief effects.

Whether you employ impasto is up to you. There are no strict rules in this field. We judge all works of art by their appearance, rather than by the methods employed in obtaining the ultimate results. Still, I am inclined to declare that a watercolor ought to look like a watercolor, and an oil painting ought to look like an oil painting. You'll see, in the chapter on polymer, that we have a new medium, which permits us to work in any technique, any style.

can we varnish watercolors?

There are varnishes for aquarelle, and polymer varnishes may be used on watercolors, too. Many artists varnish their aquarelles, instead of showing them under glass. Glass, especially on darker paintings, acts like a mirror. Much of the time, you see yourself, instead of seeing the picture. But watercolor societies accept only watercolors executed on paper, unvarnished, matted, and under glass. These are rather arbitrary restrictions. Eventually, the restrictions will disappear. In the meantime, aquarellists have to adhere to the rules if they want to participate in exhibitions. Some artists exhibit watercolors unvarnished, then take them out of the frames and varnish them.

mounting and framing watercolors

Regular watercolors do look better in mats. Make sure the mat covers the painting at least half-an-inch all round. Hinge this mat to a backing of cardboard by pasting it at the top of the cardboard with gummed paper. Attach the painting to the backing, rather than to the mat itself, with a small piece of gummed paper in the two upper corners; let the rest of the paper hang free. If the picture is quite large, paste the paper to the backing in the center, too. Don't use Scotch tape for this work, because it discolors the paper and will eventually dry out. Gummed paper is harmless.

The mat itself shouldn't be less than three inches wide. It's customary, but not necessary, to make the bottom section a little wider than the other three sides. An off-white, or cream mat is usually required, but a light gray mat is often better. Avoid loud-hued mats. Most exhibitions forbid them, anyway.

As for framing, select a simple frame, two or three inches wide, finished in a neutral grayish-brown tone. This usually serves the purpose. Ornate moldings aren't recommended for exhibitions. Make sure that your framemaker gives you a clear glass, not the kind which lends your painting a greenish or bluish hue. Nonreflecting glass is available, but it's quite expensive and, even more important, it gives the illusion of flattening your painting. This is a disagreeable effect, which makes your painting look more like a full-color reproduction than a real painting.

The frame is an important part of your picture. A bad, shabby, crooked, warped frame — in the wrong color — can do your painting more harm than you realize, while the correct frame can be of immense help in enhancing the attractiveness of your work. Get your frames from a framemaker experienced in the field of fine arts framing, rather than from a souvenir shop, or from the bargain basement of a department store.

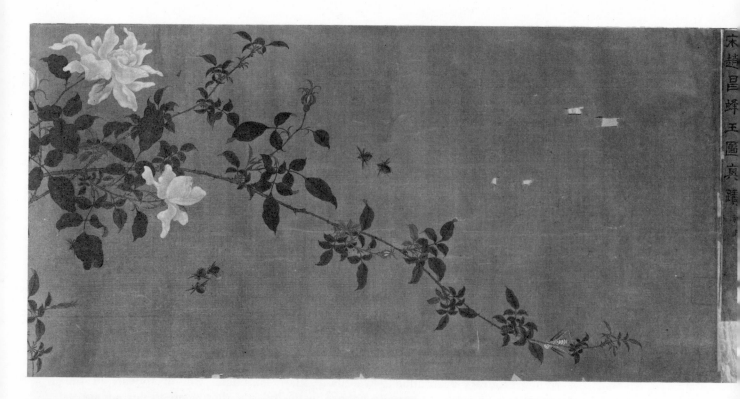

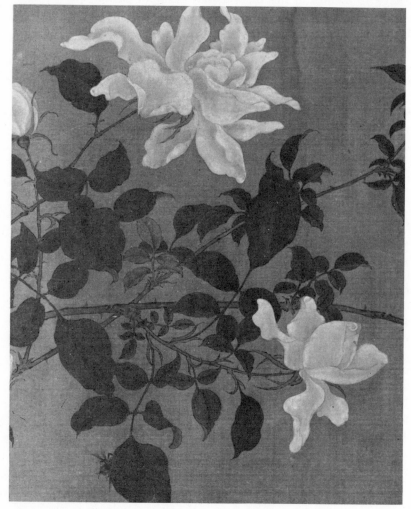

The queen bee, attributed to Chao Ch'ang, Chinese, Sung Dynasty, 960-1279, size: 10 x .79⅝ inches. The amazing perfection of details in Japanese and Chinese floral paintings, which are often combined with insects and birds, may well be due to an intense and humble love for nature. Observation, skill, devotion and artistry are inseparable in this painting. The Metropolitan Museum of Art, A. W. Bahr Collection, Fletcher Fund, 1947, New York.

Detail

9 Flower Painting in Watercolor: Demonstration

There are several major techniques in watercolor. Certain artists always work in one of these techniques only, but many aquarellists vary the technique according to the particular subject. The main techniques are:

A. Wet-in-wet technique, in which the paint is applied with loads of water, and the colors are often allowed to run into each other.

B. Dry-in-wet technique, in which the main hues and forms are done in very wet strokes, but colors and forms with just a little water are added for more definition.

C. Completely controlled watercolor, in which every form and color is executed with sufficient care, using as much or as little water as permits the artist to create a full-fledged painting in watercolor.

I am going to demonstrate these three major techniques. Turn to the color section in this book for illustrations of these demonstrations.

wet-in-wet technique

My subject for this demonstration consists of a slender, so-called colorless glass vase; yellow, pink, and white roses, a couple of white carnations, with their stems and leaves. I took a sheet of the finest rough watercolor paper, mounted on board. I cut the 22 x 30-inch piece into two halves, and worked on a 22 x 15-inch support. (By the way, it's an international agreement that when you list the size of works of art you list the height first, then the width.) The vertical shape of the support suited my tall vase and flowers.

I added water to my watercolor pans, so that I could dip my brush into any color and use it without delay. Then I flooded the support by squeezing plenty of water on it from a natural sponge. Working entirely with a No. 12 pointed, round sable brush, I dropped small amounts of cadmium yellow light and alizarin crimson—for the yellow and pink roses—into the water on the paper. I added viridian green for the leaves; a drop of cadmium yellow medium in the center of each of the yellow blossoms; a mixture of ultramarine blue and viridian green into some of the leaves where I needed more strength. To make parts of the red flowers darker, I dropped more alizarin crimson here and there.

I dipped my brush in cobalt blue, and quickly applied a wash around the flowers and the vase, adding a tiny bit of Payne's gray to the blue, and a little alizarin crimson in some spots. I didn't care if colors ran into each other, but kept the yellow and pink roses sufficiently clean, and left the paper white for the white flowers.

As a final touch, I dropped a little alizarin crimson in the table; a little Payne's gray to suggest the darker parts of the glass vase, and the same color for the shadow on the background. I made the pink roses stronger by dropping a little more pigment of the same alizarin crimson into each. All this was done so fast that the paper was still completely wet by the time I considered my painting a good example of wet-in-wet watercolor, done without any layout, and without any hesitation. The result may be seen in the color section.

Is this a great work of art? I certainly don't think so. It seems to me this is a

valuable exercise in handling watercolors, in keeping the colors clean where brilliance is necessary. It's also good for studying general color combinations. It's a sketch — perhaps a clever one — but it cannot be considered a full-fledged work of art. It's a beginning, not an end. Remember, though, that even in such a sketch, colors and shapes must be under the control of the artist. This is not the type of automatic art in which the artist is supposed to express himself by throwing, squeezing, or squirting paint on a support.

It would be quite easy for me to go on from this sketch; I could add more distinct shapes and details to it, working with more pigment, less water, until I'd have a real watercolor painting. Actually, a few strokes, with strong enough colors, would establish the vase, each flower, every leaf, and the table, and still leave me with a far-from-photographic rendering.

I recommend this kind of sketching very highly. This work can be done on a cheaper grade of paper than I've used here. Place a soaking wet sheet of such paper on a batch of equally wet newspaper, in order to keep the watercolor flat while you're working on it. As it dries, it will curl up, of course, but that won't matter in quick, experimental sketches. If you do this kind of sketching, though, don't use exactly the same flower arrangement for each. Change the flowers and change your technique, too. Use a little less water, use more paint, here and there. The purpose of sketching is to acquaint yourself with the tools, materials, and techniques of this medium.

<div style="float:left; width:25%">dry-in-wet
technique</div>

Using the same flowers and vase, with a slight rearrangement, I worked on a rough sheet of watercolor paper, 20 x 16 inches in size, pasted down all round with gummed paper on a drawing board.

Step One: With light pencil lines, I barely indicated the positions and sizes of the flowers, leaves, and the vase.

Step Two: I went over the pencil lines with a small, pointed brush, using the respective colors of each item, yellow for yellow roses, alizarin crimson for pink roses, and so forth. The colors were very light, and I didn't wet the paper before starting. As soon as the outlines dried, I rubbed out the pencil marks with a soft eraser.

Step Three: I went over the paper with a wet sponge, without flooding the sheet, and began to apply washes. This time, however, I observed the shapes of the bigger petals, leaves, and the vase. I also used more pigment in the brush, but at no time did I work without keeping my brush quite wet. I worked around the white flowers with the colors of other flowers and leaves, leaving the paper white for the white blossoms. I quickly applied a wash to the background. First, I dropped plenty of water with my brush into the deepest section of my palette; then I added cobalt blue, Payne's gray, alizarin crimson, yellow ocher, while brushing the background as fast as possible.

When you do a wash on the background, start close to the subject and brush away toward the edges of the support. Most students begin to paint the background in the upper left- or right-hand corner of the paper, and go towards the flowers. This method makes it impossible to work fast enough: the watercolor dries before you go round the flowers, leaving ugly rings, lines, and spots all over the background. If you start *next* to the flowers, you can guide your brush fast around the corners, add more paint and water, and brush the colors away towards the empty corners.

The first wash is the hardest. Make it very light. Be sure to keep the edges of every brush stroke wet. If you don't, another brush stroke — overlapping the dry one — will leave a big, unremovable spot. Add the darker shadows on the back-

ground to the wet paint by using more pigment. The table is suggested in the same fashion as the background.

Step Four: I added details to flowers, leaves, and vase by using a drier brush, with more pigment. It's better to achieve darker tones by using several washes than by using too much paint at once. I left the paper unpainted for the white flowers, and the highlights in the glass vase. Don't go into too many details in a painting of this sort. You aren't planning to do a botanical illustration, but a crisp rendering of attractive flowers. I went over the background and the table with another wash, but allowed both to remain sketchy.

Cadmium yellow, chromium oxide green, and several other colors are opaque enough to cover a mistake or two. Alizarin crimson and Payne's gray are very transparent, and have to be used with care. The shadows in the white flowers were obtained with Payne's gray and cobalt blue; in the red roses, I added a little ultramarine blue to the alizarin; the shadows in the yellow roses were done with a drop of yellow ocher and burnt sienna. I mixed viridian and chromium oxide green strokes with ultramarine blue and burnt sienna, to obtain darker shades of green. Where the green was darker than I thought it should be, I went over it with a cadmium yellow, or yellow ocher wash.

It's all right to permit a few spots of white paper to show between brush strokes and around some flowers and leaves. This gives watercolors their sparkle and crispness. Many aquarellists love this effect and never go beyond a sketchy approach. Frankly, I prefer to achieve more than a snappy sketch, even in watercolor. After all, one can do sketching in oils, too; and watercolor lends itself to fully finished paintings as well.

painting the finished watercolor

To create what I'd call a finished watercolor — as opposed to a sketch in watercolor — I set up the same glass vase, with approximately the same flowers, but I placed a yellow rose and a pink rose on the table, next to the vase. I worked on the same kind of excellent watercolor paper, mounted on board, that I used for my wet-in-wet sketch, 22 inches high by 15 inches wide.

Step One: I made a light pencil layout of major forms, so that I could apply colors without any hesitation. I went over the pencil with faint lines of the respective colors, and erased the pencil as soon as the colors were dry.

Step Two: I used light washes, the faintest tones of alizarin crimson, yellow, viridian green, leaving the paper white for the white blossoms and for the highlights in the vase. Then I applied a light, gray-green-blue wash over the background, with a flat brush — leaving a spotty effect — in order to avoid the appearance of a printed poster.

After the first wash in the background, I painted the table with a mixture of alizarin crimson, cobalt blue, and Payne's gray, indicating the same color visible in the bottom of the vase. Round glass distorts everything seen through it. Observe the distortion of color as well as shape. The stems of flowers are also distorted by the glass and by the water in the glass. If you fail to observe such facts, the stems will look like something on the outside, rather than inside, of the glass vase.

Step Three: From now on, it's merely a matter of going over each part with washes, without more water than absolutely necessary. I retained full control of every hue, every shape, every value. If your color is too thin, squeeze out your brush and pick up the excess water. When any brush stroke runs away, so to speak, catch it with a dry brush, or with a corner of a blotting paper, or with a corner of your sponge. Try not to rub the paper, though, or you may damage its texture.

If a green leaf looks too harsh, or too bright, I go over it with an ocher or burnt sienna wash, to tone it down. No shadow is black in this picture. The darkest spot

is the shadow on a few green leaves. The pink in the roses is yellowish, here and there. Some of the darker parts of the yellow roses are painted with cadmium orange and yellow ocher. The shadows in the white flowers are a combination of Payne's gray and yellow ocher.

I went over the entire background with a slightly darker wash, mixed from ultramarine blue, chromium oxide green, yellow ocher, with Payne's gray and alizarin crimson added in the cast shadow on the backdrop. Again, I began by applying the wash around the flowers and vase and then I worked toward the edges of the paper. I made the background more solid looking, but left enough vibration of colors in it, in order to avoid a mechanical appearance.

Step Four: More details in petals, glass vase, table. Also, in the two roses on the table, and their shadows. Note that I made the vase look quite sharp against the backdrop. Glass is a hard material, and shouldn't be left fuzzy, as if it were hair, or a flower with very soft, thin petals. A little last-minute scrubbing was necessary on the left-hand side of the vase, near the bottom.

Somehow or other, my brush slipped, and the glass seemed to bulge out at that point. It annoyed my eyes, as the bulge was obviously a mistake. A bigger bulge might have been an actual form on the vase, but the bulge would have to be balanced on the right-hand side as well. Errors in the flowers and foliage couldn't be noticed, but a manufactured article, such as the glass vase, has to be correctly drawn. That little bulge would have been an eyesore to me, and probably to almost everyone else. I also had to do a little scraping with a single-edged razorblade on the highlights in the glass.

I signed the painting, let it dry, then turned it over and painted the back with a very wet watercolor, in order to keep it from warping. This is a simple method, and usually advisable when you work on a mounted sheet of paper.

10 Flower Painting in Oils: Technique

Oil colors were known in very ancient times, but were forgotten during the Dark Ages. We attribute their reintroduction to two great Flemish Artists — the brothers Hubert (Huybrecht) and Jan Van Eyck — early in the fifteenth century. By the sixteenth century, the medium was popular all over Europe. Many murals were executed in oils, on canvas, and attached to the walls, rather than painted directly on fresh plaster in watercolor, as theretofore.

merits of oil colors

One of the most valuable qualities of oil colors is that they adhere to practically any clean surface, especially if the surface is coated, primed, with a layer of gesso. The idea of gesso came from the plastered walls upon which frescoes used to be done, and this proved so practical that we still paint most of our oils on gessoed supports. Oil paints are waterproof and acid proof. They are easy to blend. Varnish gives them a final protection against dirt and dust. Oil paints can be cleaned, restored, revarnished many times. When oil colors are dry, you can cover them with any other oil color, without picking up the previous layer. Oil paint may be applied in any thickness, from transparent glazes to heavy impasto.

limitations of oil colors

Oil colors have their problems and limitations as well. Paint prepared from inferior materials deteriorates, cracks, peels, fades, or changes considerably. Even the finest oil colors acquire a brownish tone with age, due to the darkening of oils, turpentine, and other mediums with which the colors are prepared and/or applied. Some people are allergic to turpentine; many are irritated by even the finest oils. Although oil painting seems to be very simple, it requires a great deal of technical knowledge and skill to do it right. Still, it's the most popular of all painting media, and everybody ought to try it.

supports for oil painting

We can paint in oils on wood, Masonite, veneer panels, canvas, and other textiles, canvas board, special paper, glass, metal, concrete, bricks, velvet, and so forth. Mostly, we work on canvas or panels primed with gesso. Painting in oils on metal used to be fashionable about a century ago. Glass painting existed until recent times but, as a rule, painting on glass and metal was mostly a kind of commercial work.

canvas

Canvas comes in many qualities and textures, many widths and lengths. Normally, it's tacked onto strips of wood called stretchers. Cotton canvas is less expensive than linen canvas, and pleasant to work on, as its weave is usually more even than that of linen canvas. When you feel you're ready to paint professionally, spend a little more and work on the best linen canvas. Until then cotton is good enough. Canvas boards are most practical, but come only in small sizes — up to 25 by 30 inches. You can buy raw linen canvas, stretch it and prime it yourself, and save money

panels

Masonite is a highly-favored support. It's smooth on the front, griddled on the back. Coat both sides with gesso, to keep the board from warping. You may paint on either side. Veneer panels can also be covered with gesso, but watch out for the slivers on its edges. Ordinary paper wallboard is not recommended because it's sure to warp out of shape. It will also deteriorate. All boards ought to be nailed to strips. Otherwise, you may lose a corner or two as you bang them into floor or wall.

paper for oil painting

Paper imitating the surface of canvas is available, in sheets and in sketchbook form, but this material is not very stimulating, to say the least. If you wish to work on paper, use watercolor. For oils, use canvas or gessoed panels. I once knew an art teacher who wanted his students to save money, and so he allowed them to paint in oils on rolls of household wax paper. It was a miserable experience, literally a waste of time. If you wish to save money, don't paint at all. Put all your money in savings banks.

colors in oil painting

Manufacturers' color charts list approximately sixty oils, but all you need is about fourteen. Other colors may come in handy for special projects, when you might require a great deal of some special color, and it's easier to buy such a color ready-made than to keep mixing it from other hues. The following is a list of permanent, completely intermixible, colors, used by probably most professional artists, and certainly sufficient for flower painting.

Alizarin crimson	Ultramarine blue
Cadmium red medium	Pthalo (phthalocyanine) blue
Cadmium yellow light	Pthalo (phthalocyanine) green
Cadmium yellow medium	Chromium oxide green
Cadmium orange	Burnt sienna
Yellow ocher	Ivory black
Cobalt blue	Titanium white (large tube)

Flake white and zinc white used to be the favorite whites before the discovery of titanium white. Flake white turns pinkish, grayish, or yellowish within a short time; zinc white is very transparent, without any covering power. Titanium is strong and entirely permanent. Some artists like Venetian (Indian) red, Indian yellow, burnt and raw umber, raw sienna, green earth (terre verte), Prussian blue. These colors are either unreliable or unnecessary, or both. The same hues can be obtained by mixing within the list of fourteen colors above.

brushes

Most oil painters work with bristle brushes, but some like red sables, at least for finishing touches. There are three major types of oil painting brushes: *brights, flats,* and *rounds.* The brights are squarish in appearance; the flats—silly as this may sound—are less flat than the brights, but have comparatively longer hairs; the rounds, naturally, are round; they come to a blunt, not to a sharp, point. I prefer the brights in bristles, but you're likely to need a couple of round, pointed sables for fine details and for your signature.

Oil brushes have long handles, and you ought to hold them as far from the tip as possible, except while doing fine details, when you have to lean on a finger, on your wrist, or on a *mahlstick*—painting stick—in order to hold the brush steady. The more brushes you have the better, but you need at least one each of quarter-inch, half-inch, three-quarter-inch bristle brushes. And buy a fairly good quality, if not the very finest. Nothing is more detrimental to inspiration than a brush which falls apart as you use it, or loses its hairs, three or four at a time, or goes in the opposite direction from where you'd like it to go.

Don't use the same brushes for watercolors and oils, no matter how well you wash them after every use in soap and water.

painting knife

Impasto, a heavy application of paint, is quite popular. You need a long-bladed palette knife for cleaning your palette and for scraping off mistakes in your painting. Short-bladed, triangular, trowel-shaped knives are better for pictorial work. The size and shape of the knife depend upon your style and temperament. Try various types before deciding which one suits you best. The steel blade must be flexible, but not so soft that it stays bent after a couple of strokes. Beware of the cheap painting knife in which a piece of thin, shiny metal is merely soldered to a metal rod sticking out of a handle. It will only give you annoyance.

oil painting mediums

Ideally, oil colors should be used as they are squeezed from the tubes. However, the addition of a small amount of certain liquids is often a great help, in order to make the artist's work easier. In the first layout of an oil painting, artists like to establish the main lights and shadows as fast as possible, all over the support. A few drops of rectified, artists' quality turpentine — not ordinary household turps — should be added to the colors. Later on, though, use the paint in the consistency in which it comes from the tube.

If you continue a painting over a period of several days, add linseed oil, rather than turpentine to your paints. Remember the old motto: you can paint fat over lean, but not lean over fat. Too much oil causes your colors to crawl; that is, they don't stick to the support, but seem to roll off or curdle. Never use any dryer in a fine arts painting because it's bound to darken your colors and it causes them to crack, within days. If you'd prefer slower-drying colors, add poppyseed oil to them, instead of linseed oil. Turpentine makes them dry a little faster than linseed oil.

quick-drying whites

Most major manufacturers have quick-drying whites. Such a special white may be added directly to any color, including regular white, and will make those colors dry faster. You can regulate the speed of drying, after a little experience, by adding more or less of this white. The big problem is what to do with dark hues you cannot mix with white. Another problem is how to avoid the disagreeable effect of chalkiness in the lighter colors if you mix all of them with this white. You can overcome the chalkiness by adding some other light color, along with quick-drying white, such as ocher, orange, or yellow. You can also add a small amount of this white to dark hues, but, when the painting is finished, you'll have to go over the truly dark sections with plain dark colors.

retouch varnish

Oil painting has a tendency to *sink in* — that is, to turn matte. Nobody has succeeded in finding a solution for this. The sunk-in spots are in marked contrast to the shiny ones. Apply retouch varnish to such spots, or to the entire picture, as soon as the paint is dry to the touch. The retouch varnish brings all hues to their original brilliance, and you can continue to work over this varnish as soon as it's dry, in about fifteen minutes. Apply retouch varnish with a mouth atomizer, if possible. Spray cans are not easy to control, and some spots may be flooded. Keep the support in a horizontal position when applying retouch varnish, so that the liquid shouldn't cause the paint to run.

varnish as a medium

To avoid these sunk-in spots, some artists add damar varnish to their colors as a medium. This is a widespread, but bad idea. It does give your paintings a glossy surface, but it also causes the paints to dry too fast, making the blending of colors

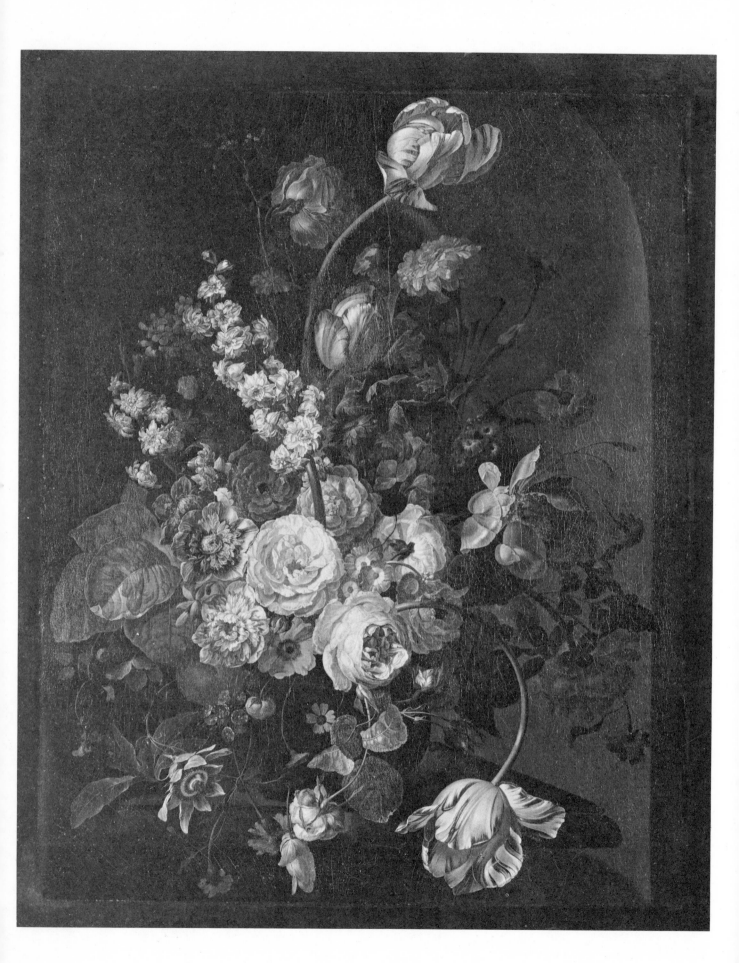

84

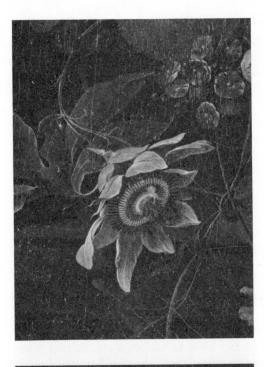

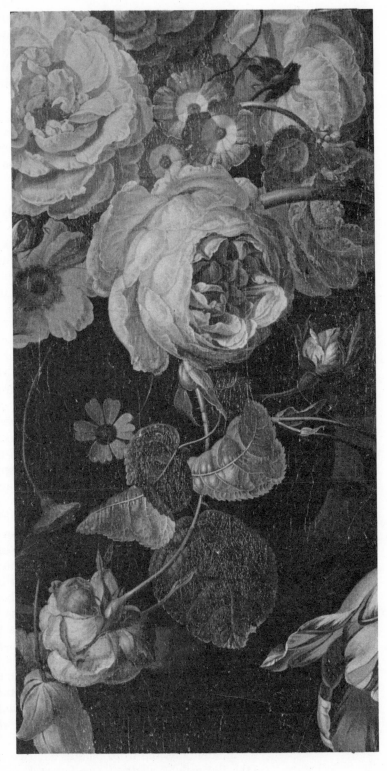

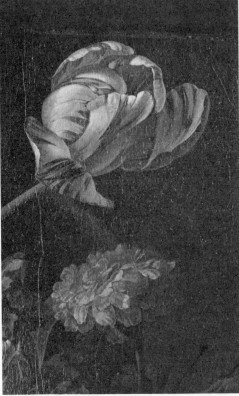

Flowers (left) by Rachel Ruysch, Dutch, 1664-1750, oil on canvas, 35⅝ x 29¾ inches. We know the names and works of very few women artists from before the mid-1800s. There were several of them in Holland, though, in the seventeenth and eighteenth centuries. Study the details of this painting, reproduced above. The Metropolitan Museum of Art, Purchase, 1871, New York.

difficult. A shiny painting may lull the artist, and perhaps the buyer of the painting, into the false belief that the work is varnished, and thus safe. But it isn't. The solvent made for the final varnish doesn't affect regular oil colors, so that the varnish may be removed anytime. If, however, the colors contain varnish, the solvent will remove them, too, when someone cleans the painting at a future date.

final varnish

For a truly protective coating, oil paintings should be varnished, but not sooner than at least a year after the work has been completed. There are various varnishes. Study their properties on the labels, or in booklets published by manufacturers. Use the varnish as directed on the label.

All oil painting varnishes posed a problem until recent times: they darken with age. Synthetic varnishes have recently been introduced, and these are crystal-clear. When I varnish a painting, I write both the name of the varnish and the date on a label. I glue the label on the stretcher, so that anyone wishing to remove the varnish should know what solvent to employ. You can never tell which one of your paintings will turn out to be a masterpiece, worth preserving for posterity. I believe in modesty, but I also believe that a painting worth doing is worth keeping.

paintbox and palette

I've known students who kept their oil colors in a shoe box, or in a plastic bag. They had to look for every item, and their brushes soon lost their shapes. You can buy an unpainted box for a very low price, and varnish it, stain it, or just cover it with self-polishing wax. Aluminum boxes are lighter than wooden ones. All regular paintboxes have wooden palettes. If the palette is raw wood, apply linseed oil to both sides before using it. Otherwise, it will absorb the oil from the colors like blotting paper.

Or get a metal tool box which opens upward, and contains trays on X-shaped brackets that rise and close as you open or close the box. This is a sturdy box, with ample room for your materials, but no space for a palette. Buy a paper palette that contains fifty sheets of oilproof paper and a thumbhole. Discard the sheet after a day's work.

Acquire the habit of squeezing colors on your palette in a certain order, along the top and one side of the palette, about an inch from the edge. Leave the bigger part of the palette free for mixing colors. White is usually in the center. The warm colors: yellows, ocher, orange, reds, burnt sienna, on one side; the cool colors: blues, greens, on the other side. Violet and black may be wherever you wish. Establish a system for your palette, and stick to it. It's an absurd handicap to squeeze colors at random. You have to look for the right color every time.

Be sure to have the palette that suits you. Right-handedness refers to the artist who works with his right hand. This means that the right-handed palette is held in the left hand. The left-handed palette is held in the right hand of the left-handed painter. Does this sound queer? The thumbhole is designed so that your thumb can stick through it and the bigger part of the palette rests on your arm. Actually, it's very tiresome to hold a palette in this fashion, as the pressure on the base of your thumb cuts your blood circulation. Most artists keep the palette on a taboret, a high stool, or stand.

Incidentally, the word *palette* has two meanings to the painter. Palette refers to the flat article, made of wood, metal, paper, plastic, or glass, used by artists for arranging their paints. It also signifies the kind of colors an artist likes to use. For example, we speak of a light palette, or a dark palette, a cool palette, or a warm palette of an artist. We don't mean the actual weight or the actual color of a palette, but the generally light, dark, cool, or warm tones he employs in his paintings. You may hear the expression that a certain artist had changed his palette considerably since his last one-man show. This refers to the fact that his color combinations are quite different from what they used to be.

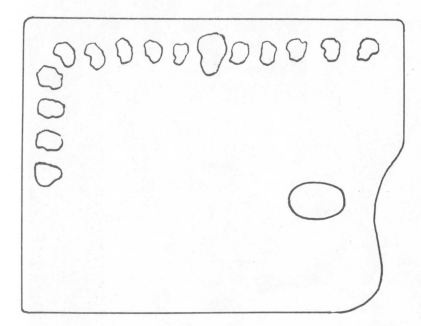

Correct position and layout of colors on a right-handed palette.

A haphazard, confusing layout of paints. You have to look for the right color every time you want to dip your brush into the paint.

An old-fashioned palette, still preferred by many professional easel painters.

Guitar and flowers by Juan Gris, Spanish, 1887-1927, oil on canvas, 44⅛ x 27⅝ inches. A cubist presentation of table, musical instrument and flowers, emphasizes three dimensional space with strongly delineated geometric shapes, vivid lights and very dark shadows. The Museum of Modern Art, Bequest of Anna Erickson Levene in memory of her husband, Dr. Phoebus Levene, New York.

11 Flower Painting in Oils: Demonstration

For an informal arrangement of white, yellow, dark pink, orange, and blue flowers, I found an old, battered one-gallon milk can which still had a metallic sheen, especially on the inside of its cap. In front of a greenish-blue background, I placed the bouquet on a work table covered with green leatherette. (Turn to the color section for the illustrations of this demonstration.) Although both the table and the background are in the green family, the difference is sufficiently marked, and much more subtle than a very contrasty color scheme would be. Since there are so many bright colors in the flowers, I didn't want to add any more hues in the table and in the backdrop than I had to. The strong cast shadow on the right-hand side not only helped to create a three dimensional effect; it also brought out the brilliance of the flowers.

step one

Working on an absorbent canvas tacked onto a set of stretchers 24 inches high and 18 inches wide, I laid out a simple charcoal drawing of the milk can, the stems of the flowers coming out of it — bending in various directions — and the main shapes of the blossoms. I also drew the cap of the can, with the slanting line of the table clear across the layout. It's important to draw the entire line, not only the visible sections, in order to make sure it will be a continuous line.

Many students draw and paint the table horizontally and, most of the time, the visible parts of the table do not match. A student of mine had made such a discrepancy between the two halves of a table that I felt really puzzled. After a few questions, it turned out that she had painted the left side in a standing position. By the time she reached the right-hand side, she felt tired and sat down. She saw much more of the table while she was standing than when she was sitting. This was a case of extreme naivete, to be sure, but I explain now to all students that the entire painting has to be done from one-and-the-same viewpoint.

I went over the charcoal lines with a thin yellow ocher in casein — not in oil — and wiped off the charcoal, in order to eliminate the charcoal dust which gets into the paint.

step two

Instead of doing the painting in oils, I made an underpainting in casein: casein dries fast and you can quickly establish the bright flowers and the colors of background and table, without worrying about getting your colors muddy or all mixed into each other. In this, as in my watercolor, I started painting the background from the flowers and milk can outwards, toward the edges of the canvas. This is the only way you can compare the values of colors. A certain blue-green might look fine in the corner of the canvas, away from the flowers. The same color turns out to be too strong, or too weak, when placed next to the blossoms. Always go from the center outward, rather than from the outside toward the center.

I didn't worry about stems and small leaves; I just wanted to apply the brightest and darkest colors, to indicate lights, shadows, and reflections.

step three

Continuing in casein, which dries waterproof and permits instant changes and corrections, I gradually covered the whole canvas, including the reflection of the old milk can in the leatherette cover of the table. I developed the forms of the flowers, with lights and shadows, and painted the main leaves. Note that I paid no attention to the stems. I knew, from my original layout, that the flowers were in the correct positions, and that the stems will match the blossoms. The wire handle of the milk can is also just barely suggested.

step four

I sprayed the painting with a casein varnish. This is necessary because the absorbent canvas and the equally absorbent casein would swallow up the oil from the oil paint so fast that I could hardly move my brush across the canvas. By the time I squeezed the oil colors on the palette, the varnish was dry. I could go over the underpainting with oil colors very directly, without any hesitation, because I knew where each color, each light, each shadow was. This eliminates the muddying of oil colors, a constant source of worry and annoyance in oil painting. Your best bet, in an oil painting, is to stop working after an hour and a half or so, and wait a couple of days until the paint is fairly dry, before continuing. There's no such problem in casein.

While working, I realized that the blue flowers on the right — immediately above the mouth of the can — stuck out too far. I changed this error by painting the shadow over a couple of these blossoms. When all the flowers and leaves, the can, background, and table were done, I painted the visible stems, a few additional leaves, and the wire handle of the old milk can.

I applied the paint in regular, thin strokes at first. Later, I used thicker strokes, especially on some of the petals, the highlights on the can, and in the cap of the can.

colors I used

Both in the casein underpainting and the oil overpainting, I worked with all the colors on my palette. The yellow flowers required cadmium yellow light mixed with white in the light sections; in the shadows, cadmium yellow light mixed with yellow ocher, a tiny little burnt sienna, and a touch of chromium oxide green. The orange-colored flowers were mixed with cadmium red medium in some sections, with cadmium yellow medium in other sections. The red flowers have a lot of cobalt violet in the mixture with alizarin crimson. The light parts of these flowers were mixed with white, to reproduce their cool appearance, in contrast to the very hot colors in the orange flowers. The white daisies, all in different directions, have a little cobalt blue and ocher in the shadows, and just barely a touch of yellow in the illuminated petals. The blue flowers were mixed with a little alizarin crimson in the shadows.

The background consists of patches of ultramarine blue, mixed with white and ocher; patches of phthalo green, also mixed with white and ocher. The cast shadow on the right needed more ultramarine blue and alizarin crimson on the wall; a little black on the table. The table itself is mostly chromium oxide green with burnt sienna and alizarin crimson. The can is basically ivory black and yellow ocher in the dark sections; white, cadmium yellow light, and ocher are added to the light parts.

Interesting little reflections of orange, white, and blue flowers can be detected in the round shoulder of the milk can. You cannot see the flowers in the reflection, just their hues. The brightest highlight is on the inside of the cap, a somewhat bluish white, reflecting my big studio windows. At the same time, however, the inside of the cap also reflects some of the red curtain in the corner of my big studio window. This small spot of red, with the bright highlight next to it, puts life into the otherwise dark lower segment of the painting.

As you see, this painting isn't a painstaking illustration for a botanical treatise. It's a painting by an artist who merely wanted to create a bright, pleasing picture, and who enjoyed every minute he spent doing it.

is casein
underpainting
necessary?

No, it isn't, but it proved to be helpful for two reasons. It enabled me to lay out the brilliant colors faster than would have been possible in oils, without being compelled to wait for the paint to dry. And the casein varnish over the underpainting kept the oil colors from sinking in—an inevitable problem in oils. No retouch varnish was needed in this painting. I'll be able to give it a final varnish in a year or so. If you use a casein underpainting, be sure not to apply it thickly, because heavy casein cracks and peels off the support within a very short time.

I'd like to mention that most artists of the past did underpaintings for their important works in tempera, which is very similar to casein except that casein dries faster. You needn't work in the style of the Old Masters, but it helps to learn their techniques.

Flowers and flowers, polymer painting. A friend presented me with a big bunch of flowers. The only container I could find at the moment was a Chianti bottle. The neck of this bottle isn't big enough to take more than half-a-dozen stems. Even though most of these had two or three blossoms, several flowers were left over. I placed them on the table, in the crumpled green paper in which they came. In quick-drying polymer, I was able to complete the entire painting in one long sitting.

12 Flower Painting in Polymer: Technique

Polymer is the now generally accepted term for the newest painting medium, in which pigments are mixed with a plastic—or synthetic—binder, or a combination of such binders. The new medium burst upon the art world like a bombshell in the 1960s, but it was actually born a few decades earlier. Some of the Mexican muralists are believed to have been the first to look for paint that would be waterproof for outdoor use. United States artists also tried to find similar paints, and experimented with Duco enamels on Masonite during depression times. Since ours is an age of synthetics in every field, it was only a matter of time to realize the potentialities of synthetic colors.

Acrylic and vinyl proved to be the most practical binders, when combined with each other. A combination of two synthetics is called a polymer; combinations of two or more polymers are copolymers. In the big rush to cash in on the novelty, every manufacturer marketed his plastic colors under a different brand name, creating much confusion. Since all makes contain a combination of plastics, the word "polymer" is mentioned on all labels. An oil painting is an oil painting, no matter what brand of colors you use. A polymer painting ought to be a polymer painting, regardless of any brand name.

two main kinds of polymer

Certain polymer colors are compatible with turpentine or other mediums used in oil painting; we call these "oil polymers." However, the vast majority of polymers are applied with water, and thus belong to the watermedia or aquamedia family. This is the kind of polymer I describe in this chapter. The oil-compatible polymer differs from regular oil colors largely insofar as it dries faster. The water polymer differs from both watercolor and oils. It dries in seconds, and becomes waterproof immediately, so that you can paint any color over any other color, without picking up one layer with the other. This means that you can work all day long, without muddying your paints the way you do in oils. You wash brushes and hands in water and soap. You need no odoriferous, occasionally allergy-causing, ingredients.

use as aquarelle or oil colors

Add as much water to polymer as you like, using it exactly like watercolor. But, naturally, you paint without the problems of aquarelle, because you can paint one hue over another—light over dark, yellow over blue, and so forth. No maskoid or frisket is necessary; no scraping, erasing, scrubbing. One really wonders why aquarellists still persist in working with watercolors, when the identical effects can be achieved in polymer, without any technical difficulty.

Apply polymer as it comes from jar or tube, and you can obtain the effect of oil painting. Impasto is easy in this medium. The paint remains flexible indefinitely. Colors don't change in any way; they neither fade, nor darken. They're waterproof. When coated with a plastic varnish, they become scuffproof. They need no glass, whether or not they're varnished.

Polymer is an invitation to boldness, because you can correct any mistake you might make. This doesn't mean that you should make mistakes, but it's no catastrophe, no tremendous extra work, if you do. Glazing, the application of thin, transparent washes, is a "natural" in polymer.

supports for polymer painting

Polymer adheres to any surface, except an oily or greasy one. Never use polymer on an oily canvas, or over any surface previously painted in any kind of oil paint. Work on paper, illustration board, multimedia board, absorbent or raw canvas, or any other textile, Masonite, veneer panel, plaster, concrete, stone, bricks, plastics of all sorts. Since polymer remains flexible, you can roll up paintings, such as theatrical backdrops, curtains, scrolls, and so forth, without fear of cracking.

polymer gesso

A coat of polymer gesso, thinned with water, makes any surface — except oily ones — ready for painting, but you can work without gesso, too. This is a matter of habit or preference. Most artists like the gesso priming on the support because they're accustomed to it. Gesso adds weight and resistance to textiles, so that they look, and feel more like regular artists' canvas. Polymer gesso dries fast; you can paint over it within ten minutes. You can work on a polymer gesso surface in any medium — oil, watercolor, casein — but you cannot apply polymer over an oil gesso.

list of polymer colors

Polymer colors come in a little over thirty hues, and most of these have the same names as oil, casein, and watercolors. Certain synthetic pigments are added, such as "Mars" colors. These are more permanent, and more uniform, than similar natural hues. Here's a list of the colors which you should certainly have:

Alizarin crimson	Phthalo (phthalocyanine) blue
Cadmium red medium	Phthalo (phthalocyanine) green
Cadmium orange	Hooker's green
Cadmium yellow light	Chromium oxide green
Cadmium yellow medium	Phthalo violet
Yellow ocher	Burnt sienna
Ultramarine blue	Mars black
Cobalt blue	Titanium white (large tube or jar)

Polymer colors come in jars and tubes. The colors in jars are often thinner than the ones in tubes, but they soon gain the consistency of tube color when placed on the palette, or if you leave the jar open. Since all polymer colors dry very fast, don't place more on your palette than you expect to use up in a short while. You can keep the paint wet by frequently adding a drop of water. There's also a medium which retards the drying time.

Warning: Not all makes of polymers are intermixible. Use only *one* brand in the same painting. Or try to mix different makes together and watch whether they mix smoothly or not. If they do, they're all right for painting. If they crawl, or seem to curdle up, don't use them together.

brushes

Use the same kinds of brushes you would use in oil painting: flat bristle brushes for large strokes; a couple of pointed, round sables for finer details; flat sable brushes for glazing. Normally, you need quarter-inch, half-inch, three-quarter-inch-wide brushes, at least one of each. Polymer is rather tough on bristle brushes. Recently, nylon brushes have been marketed, and these promise to last much longer when you paint with polymer or casein. They come in the same sizes as bristle brushes. Wash all brushes promptly in soap and lukewarm water. If you neglect to do this, the polymer

paint dries hard in them. Soaking such hardened brushes in denatured alcohol for a while might soften them, but only before the brushes are completely hardened.

mediums and varnishes

There are two mediums in polymer: matte and glossy. Both also serve as final varnishes. A drop of medium in each color will suffice to give even the thinnest wash enough adhesive power, and to make your painting uniformly matte, or uniformly glossy, depending upon which medium you employ. I seldom add medium to my paints, but I do like to varnish my painting as soon as it's finished. Normally, I use the matte varnish. I use glossy varnish only on work exposed to mishandling, or on paintings which will be hung outdoors.

Both mediums resemble buttermilk, and it's rather frightening the first time you use either of them as a varnish. No need to fret. The thick, white substance dries crystal-clear, within a few minutes. Add water to the medium constantly while using it as a varnish. Apply it with a wide, clean, good brush, first in one direction, then crosswise. When the entire picture is covered, rinse the brush, wipe it dry, and pull it all along the edges of the support, in order to remove excess varnish that usually accumulates there.

On a very rough surface, the varnish may coagulate in the teeth of the texture, and dry to look like snowflakes. Should this happen, immediately go over the varnished surface with a clean, wet, stiff bristle brush, and push the white spots out of the crevices, spreading the varnish evenly over the picture, rinsing the brush time after time. The snowflakes will disappear. I must repeat that this can only happen on a very rough surface. Watch the varnish dry; if snowflakes don't appear within a half hour, they won't appear at all.

modeling paste or extender

This marvelous material comes in cans. Made of white marble dust, it permits you to build up any form to any thickness in order to create an effect of bas-relief. Mix the paste with paint, or apply the paste as it is; let it dry, then paint it. The extender can be applied with brush, spoon, palette knife, toothbrush, or whatever tool you happen to have. It dries fast, and becomes so hard that you cannot remove it. Work on a strong support if you use heavy impasto. Plain canvas or thin paper won't hold it. The modeling paste has a remarkable adhesive power, so that it's especially good for collage, in which you want to stick diverse materials onto the support.

gel for polymers

A substance previously used in oils only, gel is now available for polymer and water-color as well. It transparentizes any color, without reducing its brightness. Polymer gel becomes hard in a short while, and cannot be removed. Use it only where you're sure you want it. If applied upon a section of your picture you had already painted, gel absorbs the color beneath it. For example, I painted a couple of orange and red flowers in polymer, then applied thick strokes of gel to indicate petals. Gel looks like vaseline, a greenish-gray hue. The next day, I found that the gel petals had the same orange and red colors in which I had painted the flowers. Needless to say, you can also paint over gel in any color you like.

Both gel and modeling paste are ideal for floral subjects. You can give flowers and all accessories their natural textures. Petals can be made to stick out, if you wish, so that you needn't bother with shadows. They'll cast their own shadows, and catch their own highlights!

washes and glazes in polymer

All polymer colors can be thinned down with water to transparent washes or to form glazes. I usually paint my pictures realistically, but using more or less basic colors only. Later, I go over the paintings with many transparent washes. You can achieve

a truly brilliant violet by painting a spot in cobalt blue, then going over this passage with an alizarin crimson wash. Such a violet appears to have more depth than if you simply mix cobalt blue with alizarin crimson. The same is true for other hues.

Polymer dries so fast that you can alternate solid applications of paint with washes any number of times. There's no danger of cracking. The only thing to watch is not to apply polymer paint in huge heaps. It takes time for the inside of a big heap to dry. It's always safer to do an impasto gradually, giving each layer a chance to dry for a few minutes before adding another batch of paint.

blending colors in polymer

Polymer dries so quickly that you cannot blend colors unless you do the blending immediately. Experiment for a while. Don't assume that you can dive into a new medium, understand all its potentialities, and handle all its problems by sheer intuition. You have to learn everything. Polymer is no exception.

palette for polymer

Special palettes are available for polymer. These have cubicles for colors, and covers as well, so that you might keep the paint wet even overnight by adding a few drops of water to each color. I prefer to work on a 12 x 16-inch paper palette made of a very glossy paper which doesn't absorb moisture, and keeps polymer colors usable longer than ordinary paper palettes do. Any paper with an oil-based surface coating can serve as a palette. A glass palette is fine, but you need a solid table to support it. Don't use polymer on a wooden palette, because it's literally impossible to scrape the dry polymer paint off such a palette without ruining the wood. A strong plastic tray, however, may be quite all right.

Flowers in glass vase: wet-in-wet. *Working on a 22 by 15-inch finest watercolor paper which was mounted on board, I literally flooded the support with water squeezed from a natural sponge. Previously, I added water to all my watercolor pans, in order to have them ready for fast action. I applied very wet paint, cadmium yellow light, alizarin crimson, viridian green, right into the water, without any kind of layout. While these spots of color were running in all directions, I dropped cadmium yellow medium into the yellow flowers, a darker alizarin crimson spot into each of the red flowers, a little ultramarine blue into the green leaves, a little Payne's gray into the vase.*

Then, I dropped a quick, very wet wash of blue and Payne's gray in the background, alizarin crimson in the table, and into the bottom of the vase, where the color of the table was visible. I kept dipping my no. 12 pointed brush into water and into the paint; yet, at no time did I lose control over my colors. I let them run just so far, leaving the paper white between flowers and leaves. The entire work was accomplished in a few minutes. This is a good exercise in fast control of mind over matter. Such an exercise forces you to look hard and fast, react quickly, and learn how much paint and how much water will go how far.

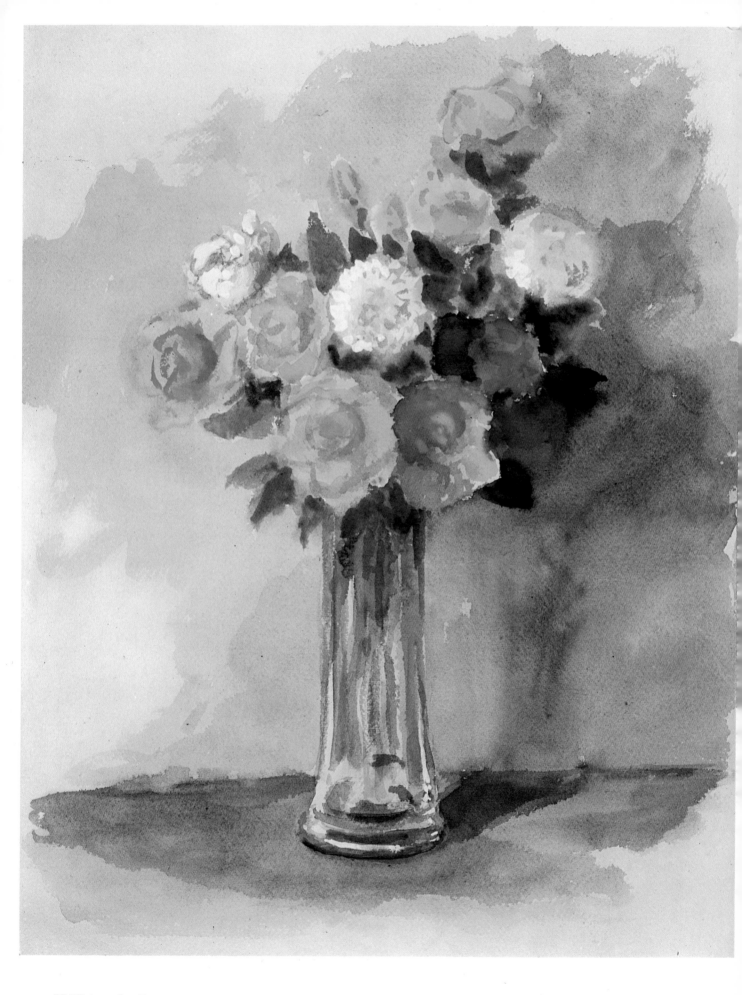

98 Watercolor Demonstration

Flowers in glass vase: dry-in-wet. *Without flooding the sheet, I wet the paper and I laid in the colors over a light pencil layout, not allowing the colors to run into each other. After applying the washes, I added details to flowers, shadows, and petals, using a dryer brush, and more pigment. I went over the background with another wash and added the cast shadow while the background was still wet. My aim in this sketch was to execute it as fast and as crisp as I could.*

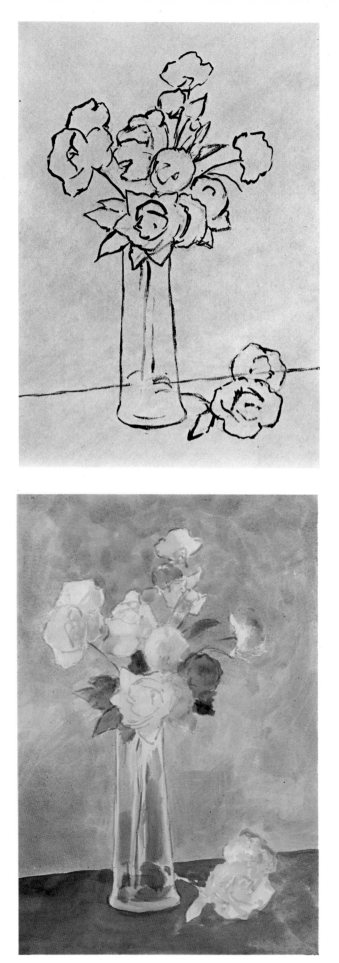

Step one. *My support was a fine watercolor paper, mounted on board, 22 inches high by 15 inches wide. I made a light pencil drawing, went over it with faint colors which matched the colors of the objects. As soon as these were dry, I rubbed the pencil out with a soft eraser. Such an eraser removes pencil lines without damaging the watercolors.* ▶

Step two. *I went over each flower, leaf, the glass vase, the table, and the background, with light washes, using the right amount of water: more in larger parts, less in smaller sections. I left the paper white for white flowers, and left a little white space between various items. Wherever necessary, I added more pigment, but avoided employing so much paint that the form should look opaque. It's better to add more thin washes.* ▶

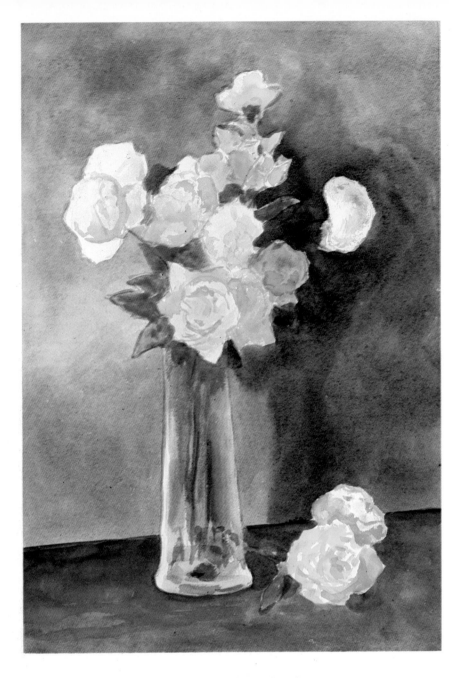

Step three. Certain colors can be made darker by picking up more paint with the brush In others, however, I used darker colors, such as ultramarine blue in the alizarin crimson, yellow ocher or burnt sienna in the yellow, alizarin crimson in the green, Payne's gray and a touch of ocher in the white flowers and the vase.

Step four. Final stage, White, Yellow, and Pink Roses, I went over the background with a darker wash and enough water with my one-inch flat brush; I added more paint, less water, in the cast shadow on the wall. At the end, I was sorry to find that the glass vase had a small bulge near the bottom, on the left-hand side. I eliminated it by scrubbing it with an old bristle brush. I also had to scrape out, with a razorblade, some of the highlights in the glass vase to make them stronger.

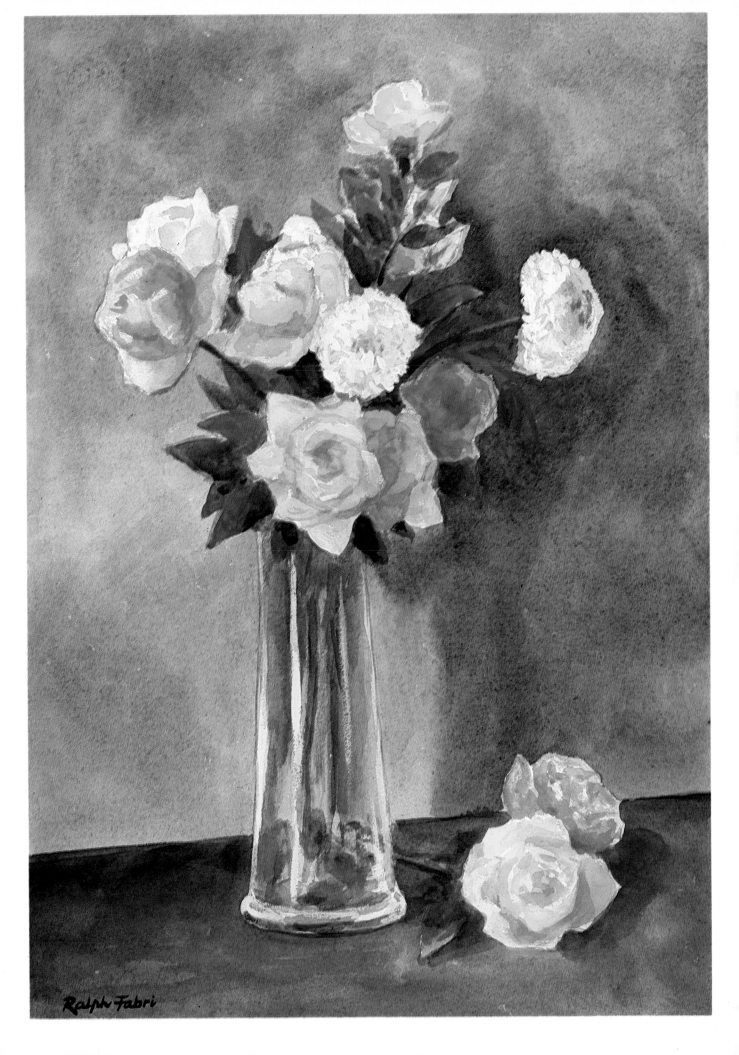

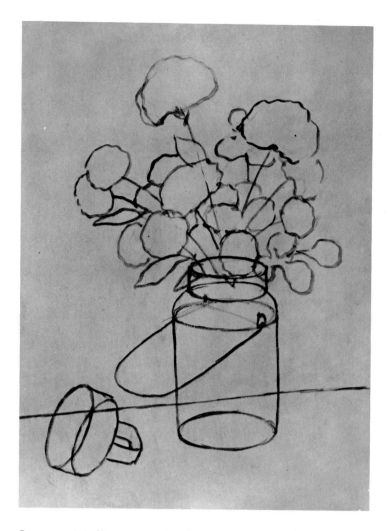

Step one. *Working on an absorbent canvas, 24 inches high by 18 inches wide, I prepared a simple layout of the whole subject, in charcoal, indicating the main flowers and their stems, the can, the cap of the can, but I didn't draw in any details. I went over the charcoal in light yellow ocher, in casein, and wiped the charcoal off immediately.*

Step two. *I decided to do an underpainting in casein. This medium dries fast; changes can be made without the danger of muddying your colors, as in oils. I did the major spots of colors and shades in the flowers and in the can, then painted the background, starting right next to the objects, going toward the edges of the canvas. Once the correct positions of the flowers were established, I went over the stems with the background colors (phthalo blue, chromium oxide green, yellow ocher, a touch of ivory black, titanium white, in a variety of mixtures). It would be foolish to paint the background all round the stems and small leaves. Such details can be easily painted over the background later. The cast shadow on table and wall is a mixture of ultramarine blue and alizarin crimson. The can is done with ivory black, yellow ocher, plus white.*

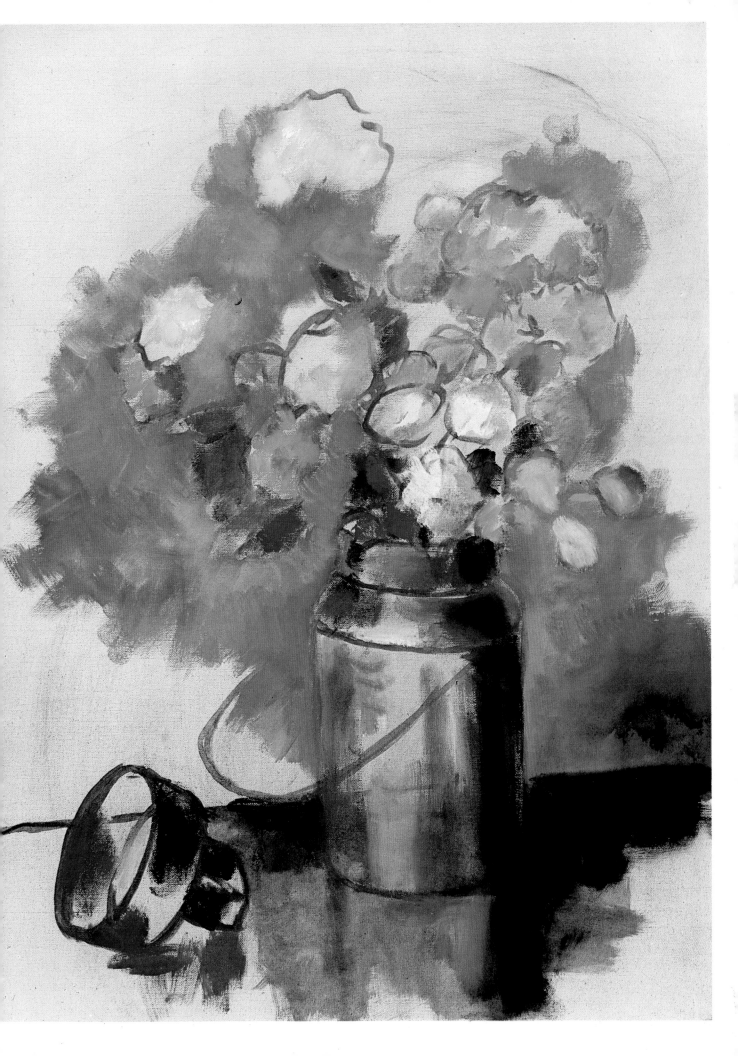

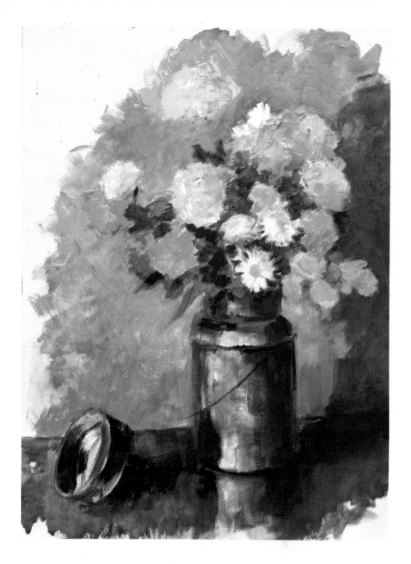

Step three. *Jumping from one spot to another, I added a shade here, a shade there, until the entire picture was on the same level of execution, neatly painted, but without final details. I sprayed the work with a casein varnish, which dries quickly. Without this varnish, the absorbent casein on an absorbent canvas would literally swallow all the oil from the oil paints, so that you could hardly work with them.*

Step four. *Final stage, Flowers in an Old Milk Can. The underpainting, in full color, made it possible for me to apply oil colors without hesitation, without any waste of time and paint. I knew exactly what shade of what color to apply, and where. As usual, I discovered a mistake. The blue flowers on the right-hand side, immediately above the milk can, stuck out too far. I cut off a few of the blossoms by painting the cast shadow in the background over them. It was just a minor operation. The finishing touches comprised the brilliant highlights on the shoulder and in the cap of the milk can. The inside of the cap also reflects the deep red curtain framing my big windows. Note that the highlights aren't pure white. Had I painted them white, they'd look like pieces of plain paper stuck onto the picture. The brightness and naturalness of the highlights are due to the careful rendering of the warm, ocher-gray hues around them. The very dark shadows were mixed from ultramarine blue, alizarin crimson, chromium oxide green, with barely a drop of ivory black.*

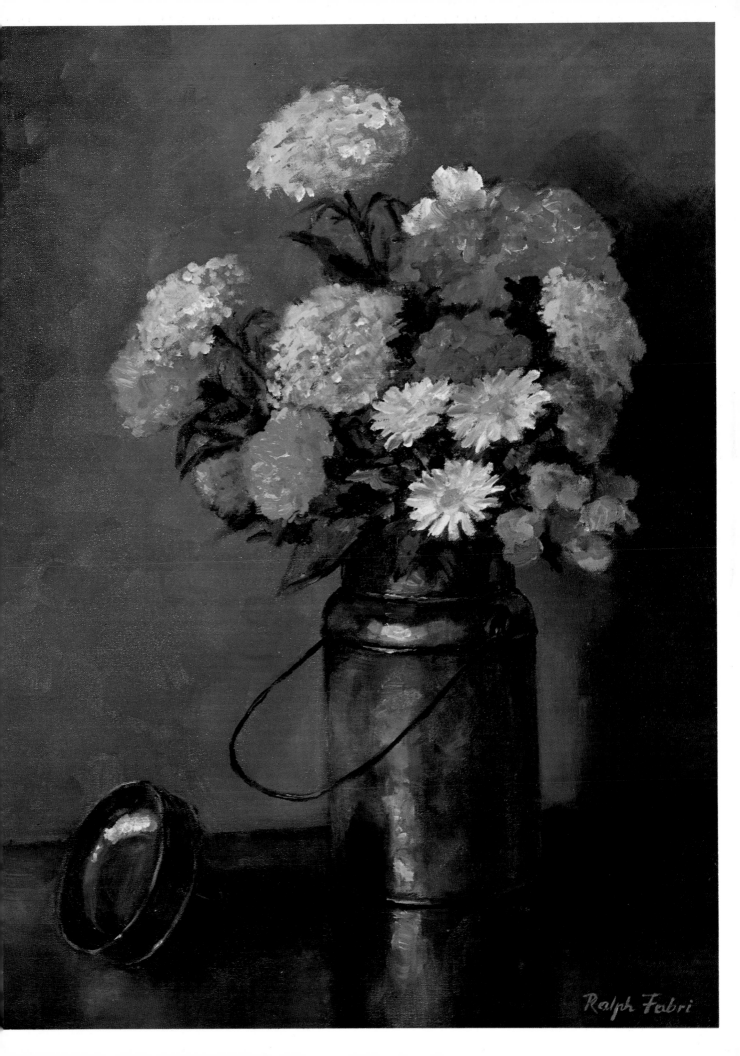

Step one. *For my polymer demonstration, I selected sketches I made on a recent trip to Sicily, especially views of Taormina, one of the loveliest towns in the world. I laid out a street scene, showing the upper floors of houses, in charcoal, on a rough multimedia board, 19 inches high by 32 inches wide. This is a comparatively long, horizontal support, well-suited to my particular subject. I went over the charcoal with very wet yellow ocher, in polymer, and promptly wiped the charcoal off the board.*

Step two. *In scenery, paint the sky first, going down into the hills, to avoid sharp outlines. The sky is mostly white, with a small amount of phthalo blue and plenty of water. The lower part of the sky is almost white. The hill on the left is only a couple of shades darker than the sky: white, cobalt blue, yellow ocher, alizarin crimson. The hill on the right, being closer, is more detailed, but still very light: a blue-green, with slightly darker spots suggesting shrubs and trees. The lighter the background, the greater the feeling of distance. I painted the hills into the houses, again to avoid sharp outlines which would look as if they had been stenciled. The houses are basically ocher, but with many shades of pink, blue, green, violet, gray, sienna, and yellow. Practically every section of each house is of a different hue.*

Step three. *Final Stage, Flowers in Sicily. I set up a large bouquet of flowers in a tall vase, and sketched it directly on the painting, using white chalk which doesn't scratch the board and doesn't dirty the paints. In order to have lifesize flowers, I showed only the top of the container, and no part of the windowsill. I arranged the flowers in such a manner that the sky, the hills, and the houses peek through here and there. Starting with thin strokes, I added more paint to some of the flowers, to give them extra brightness. The flowers stand out against the scenic background nicely, without any exaggeration.*

Step one. *I chose a very absorbent canvas, good for any medium, 24 inches high by 18 inches wide. Instead of making a charcoal layout on the canvas, I sketched it on a sheet of paper. The still life contains a blue pitcher with a handle, flowers, a low Chinese bowl with fruits, and an ocher-colored drapery for background and on the table. I traced the whole picture, except the flowers, on the support, with the help of a carbon paper made with graphite.*

Step two. *I went over the traced lines in yellow ocher (casein) and began to paint in the usual manner, mixing the right shades on the palette, and applying them directly. The blue pitcher isn't the same blue all over; the apple isn't just one red color, and so forth. I painted lights and darks, a variety of shades, all over the support, in order to achieve a general effect. As casein dries almost as fast and as waterproof as polymer, I could now proceed with the flowers.*

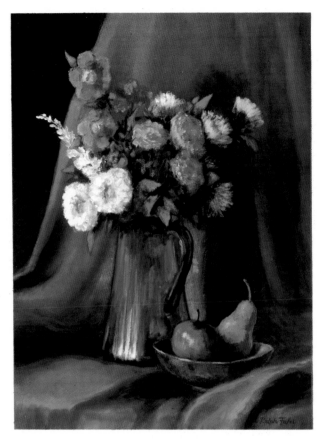

Step three. *I coated the back of the original layout with white chalk, and traced the flowers on the otherwise well-advanced painting. Chalk is easily absorbed by any painting medium, not like charcoal. The advantage of having finished the backdrop lies in the fact that it isn't necessary to go round every leaf and petal with the light and dark sections of the drapery, a difficult and tedious task.*

Step four. *Final stage, Blue Pitcher and Chinese Bowl. As always, I painted the flowers briskly, and directly. I finished the pitcher, giving it the bright highlights at the bottom. I completed the bowl, the red apple, the orange-ocher pear, and the folds in front of the objects. Almost instantly, I discovered an error of judgment. The shadow cast by the pitcher and flowers on the background blended into the pitcher itself. In casein, it's easy enough to make changes. I moved the pitcher forward, so that light would hit the drapery between the pitcher and its shadow. The change was accomplished in a few minutes. It's my habit to keep a new painting on my easel for a while, and to scrutinize it every so often. A couple of days later, I realized that the pear was of practically the same color as the lighted sections of the ocher drapery. From a short distance, the pear seemed to be an odd part of the drapery. I replaced it with a green pear of similar shape and size. The green made a big difference. Not only is it visible, but it also enlivens the lower portion of the picture, and enhances the brilliance of the red apple.*

Casein Demonstration 109

Step one. *As a change, I decided to select a warm background. I bought two sheets of maroon pastel paper, 19½ by 25½ inches in size; placed one sheet behind the flower basket, in the shadowbox, and tacked the other sheet on my drawing board. In pastel, the similarity of the color of the paper to the color of any major portion of the subject is most helpful. As in any other painting medium, I made a simple layout, directly on the support, indicating the colors of flowers, leaves, and basket in sketchy lines. Note that the table is drawn right across the basket, as if the basket were transparent.*

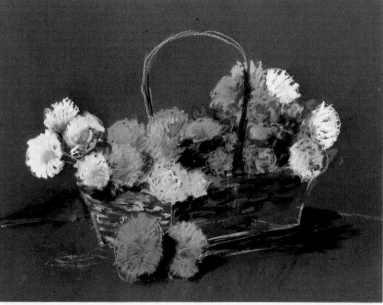

Step two. *I worked here and there, dashing off lights and shadows, applying pastel strokes according to the shapes of various items: long strokes radiating from a center, or small, round spots, which I rubbed in with a fingertip, and so on. In pastel, as in oils, it's easier to lighten a dark color than it is to make a light shade deeper. Remember that you cannot add layer upon layer indefinitely. Pick the right colors among the pastel sticks for almost every stroke: a light pink, if that's what you need, rather than a red, into which you'd rub white to make it pink. That can be done, too, if necessary, but ought to be avoided, wherever possible.*

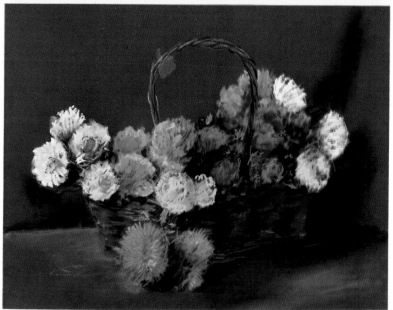

Step three. *More details, showing round, pointed, and lacy petals, shadows on table and wall. I rubbed burnt sienna into the table, and added more detail to the basket and its handle, rendering the woven pattern with the proper strokes. All in all, I used some seventy or eighty different soft pastels in this picture. No hard, or semi-hard pastel was needed.*

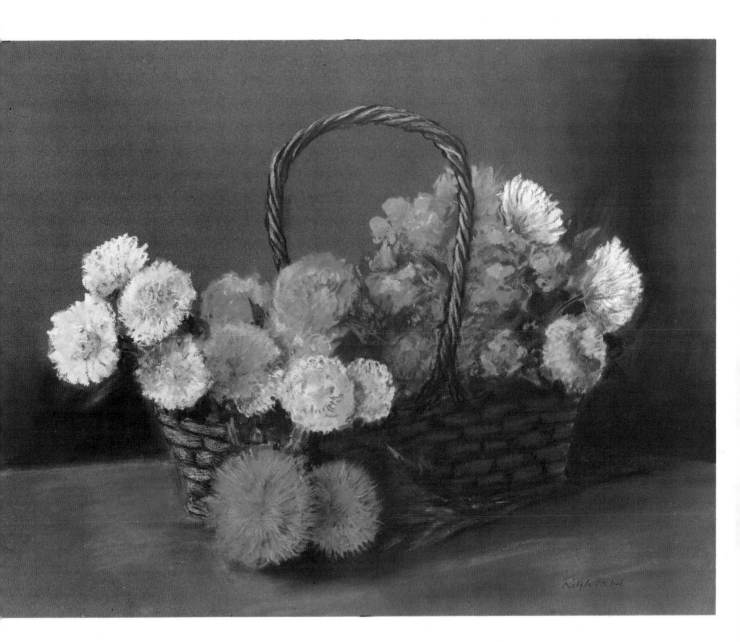

Step four. *Final stage, A Basket of Flowers. At first, I didn't like the silver-gray color of the basket, so I painted it in brown tones. Later on, I felt the gray would be more interesting, as a contrast to the flowers, the maroon background, and the burnt sienna table. I sprayed the pastel with a "reworkable" fixative, and continued to work over it. A bigger change was necessary in the two flowers on the table. They were quite alike in size. I made the one on the right smaller, and pushed it slightly behind the other flower. I also made the table lighter, the cast shadows deeper, and added some final highlights.*

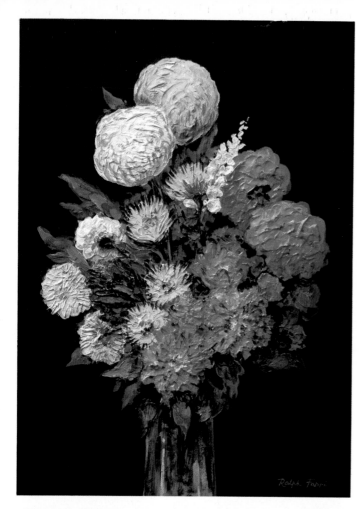

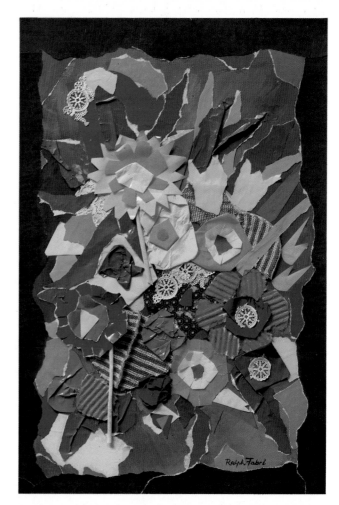

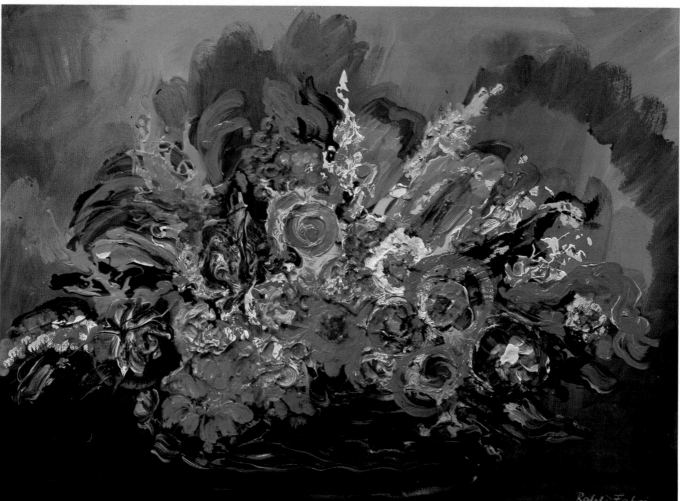

Realistic impasto. *(Top Left) One must work on a support strong enough to carry the weight of the impasto. I painted the background a dark tone, mixed from various colors, then applied modeling paste. (extender) with a small, trowel-shaped painting knife. Each stroke simulated the natural forms of petals and leaves. When the paste was dry, I painted each section in realistic colors, in polymer paint, using thick strokes applied with brush or painting knife, according to what was more practical. I didn't worry about shadows and lights, because the thick impasto cast its own shadows and caught its own lights with its edges and protuberances.*

Collage. *(Top Right) First, I covered my paperboard with a neutral brown coat of polymer. I cut or tore many pieces of colored, glossy paper, corrugated board, and textile remnants in diverse shapes and sizes. I folded some of these back all round; others, I bent upward. I pasted them on the support, with a few drops of fast-drying white glue in the center, so that I could raise the rim of some of the flowers. I pasted a smaller piece of a different color in the center of one flower, then a still smaller piece in the center of the second piece. Thus, I achieved a truly three dimensional effect. Pieces of soda straws serve as stems.*

Abstraction. *(Bottom Left) I coated my support with blue-gray shades of polymer. Then I poured bright colors from jars, squeezed paint from tubes, applied colors with tongue depressors, always bearing in mind that this was to be a floral abstraction. Twisting and twirling jars, tubes, depressors, and using my fingertips as well as the handle of a brush and a palette knife, I created imaginary flowers. Although I worked spontaneously—without a layout—colors and forms were under my control. If I didn't like an effect, I changed it by pouring or splashing some other color on top of it. It's a true abstraction; the subject is still recognizable.*

13 Flower Painting in Polymer: Demonstration

For my polymer demonstration, I decided to do a flower painting in which the background is a view of a Sicilian town. In these Italian cities and villages, you can hardly find a window or a balcony without flowers. In Sicily, especially, even the donkeys wear "corsages." I worked on the basis of sketches I made on a recent trip to Catania and Taormina, where practically every house is different in shape and size; where windows seem to peep through walls in any place, any corner; and where each house has many colors, some newly applied, some old ones showing where later coats of paint have peeled off, or have been washed off by rain. It's shabby, but picturesque. (Turn to the color section for the illustrations of this demonstration.)

Since polymer dries instantly and waterproof, I decided to completely paint the cityscape first, bearing in mind, of course, that one section of the view will be covered later with the flower arrangement. The advantage of doing the entire view first was that I could do it boldly, not worried about going round petals, leaves, stems with the colors of houses, windows, balconies, sky, and mountains.

step one

Charcoal layout of a street, showing about the upper two-thirds of the houses; underneath a light blue sky and blue-green mountains. I worked on a very rough multimedia board, 19 inches high by 32 inches wide. This board is made of a heavy sheet of pure rag paper, coated with white gesso, mounted on triple-thick board. As usual, I went over the charcoal with thin yellow ocher outlines, indicating only the main shapes of houses, the bigger windows, the outlines of the hills, without any visible suggestion of the flowers. I wiped off the charcoal, and spread the paint on a large paper palette, made of very glossy paper which doesn't absorb any moisture. It has a substance to which polymer doesn't adhere, so that the paint keeps wet on it longer than on any other paper.

step two

First of all, I painted the entire sky, going a half inch or so into the mountains, to avoid a very sharp silhouette of the hills. I used titanium white, mixed with a drop of phthalo blue; at the bottom, the sky is almost pure white. Then came the hill on the left, farthest away. I painted it in very light cobalt blue, with a little yellow ocher and alizarin crimson, here and there, to suggest the uneven trees, and shrubs. The lower half of this hill is slightly darker, but still mostly cobalt blue. The other hill — taking up about two-thirds of the width of my picture — is closer, and thus has to show more detail of the terrain: drab, ocher sections of soil; greenish parts suggesting grass, rows of trees; clusters of shrubs, but all this painted in very faint tones of blue, blue-green, blue-with-ocher.

I went into the houses with the colors of the hills, for the same reason that I went into the mountains with the sky. If you paint exactly to an edge, around an edge, there will be a sharp outline, like a piece of stenciled work. In reality, such outlines are not cut out of paper.

Now, I began to apply the various colors of the houses, some walls hit by a late-afternoon sun — not too bright — some walls in shadow. Most of the houses have an ocherish color, with many different sections: green, blue, pink, brown, rust, violet, in many shades. Some windows are open, and thus quite dark, but not black or even close to black. Compare the values of all colors with the extremes of white and black, in order to establish the true value of each. A very dark window would look like a hole, a very light spot would jump out of the picture. The shadows on walls, under balconies and eaves, are just a little darker than the respective walls.

I kept all colors quite light, because the houses are across the street from where my flowers are to be displayed. There must be a considerable difference between nearby and farther-away objects. This is what we call *color perspective*. Although I indicated windowpanes, and shutters, I avoided fine details. I painted flowers on various balconies, just a few specks of colors, before adding the balconies themselves: a few thin lines of dark gray uprights and a horizontal line across the top. Laundry is hung on some of the balconies, one of the trademarks of Southern European nations. I painted those in very light tones. In order to achieve the effect of the peeling, faded, or fresh colors on the walls, I applied many washes — some over a few square inches, some across an entire house.

When this part of the painting was finished, it looked like a typical Italian cityscape, colorful, varied, picturesque. I could have left it as it was, but I wanted to add the flowers.

step three

The painting was dry, of course, in a minute. I set up a large bouquet in a tall blue glass container, and sketched it carefully over my finished background in white chalk. Chalk is much better in a case like this than charcoal, not because it's white, but because chalk doesn't scratch the colors and it's completely absorbed into the paint, without the necessity of wiping it off. Instead of showing the full vase, I painted only its top, and thus had enough space to make the flowers fully lifesize. The vase is standing on a windowsill which happens to be below the eye level. White, yellow, and various shades of red and red-orange flowers fill the vase in an informal fashion, as one might pluck flowers from a garden.

The flowers on top are brighter than the rest, because they are exposed to more light. However, even the flowers in shadow are more brilliant than the houses across the street. The shadows in the white flowers are painted in cobalt blue and Mars black, both mixed into the white. On the red flowers, the dark sections are in a blue-violet tone, while the shadows on the yellow blossoms are in a greenish ocher. Thus, all the shadows are in the cool category, in pleasing contrast to the vivid, warm hues of the flowers in the light. Even the white flowers have a slight yellowish tint where the sun hits them.

The blue vase and the green leaves in the shadow form a strong, dark shape at the bottom of the flowers. This helps in separating the floral arrangement from the cityscape background. I applied the paint in thicker strokes in the flowers than in the backdrop, but not in real impasto. The brush strokes merely indicate the petals in a realistic manner. The floral arrangement is truly in front of the houses, because I first painted the cityscape, and then the flowers over it. Had I done the flowers first, painting the houses to the right and left afterwards, it would have been rather difficult to make the houses appear to be a continuous row. My method thus was quite helpful.

Naturally, the same method might have been employed in oils, but I would have had to wait a few days for the cityscape to dry before painting the flowers over the houses. In polymer, I was able to do it without any delay.

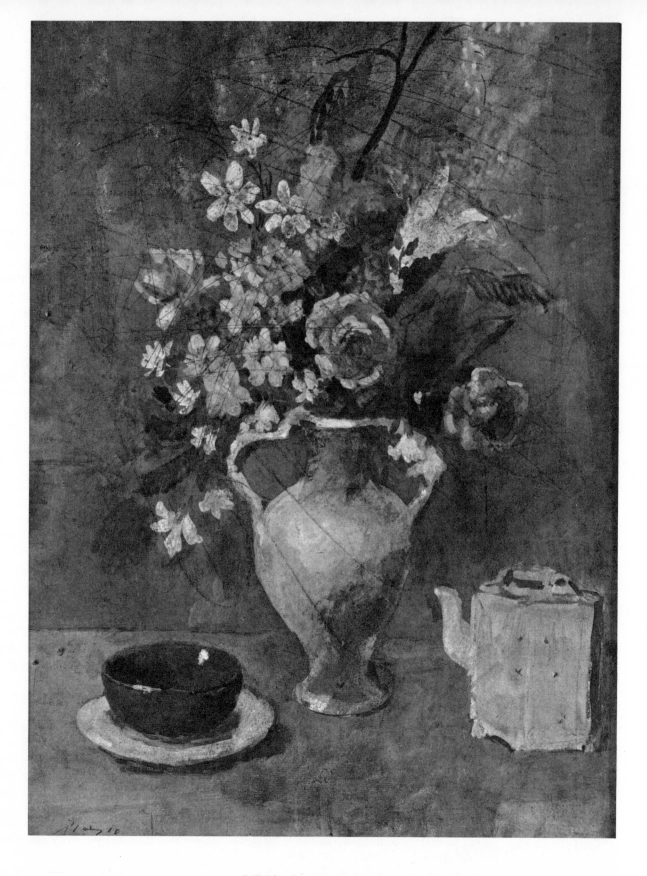

Still life: flowers in vase by Pablo Picasso, Spanish 1881 — , gouache on board, 27¾ x 21¼ inches. When Picasso painted this sketchy, but realistic still life, in 1905-1906, he was already beginning to be known as an experimenter. But even in later years, he often rendered flowers and plants in a delicate, realistic manner. Thannhauser Foundation, The Solomon R. Guggenheim Museum, New York.

14 Flower Painting in Casein: Technique

Casein is the name of a paint in which the binder for the pigments is casein, a protein found in curdled milk. Casein also forms the base of cheese. It had been known for some eight centuries, as a waterproof glue for cabinetmakers, before someone thought of adding it to paints. At first, it came in a very thick, white paste form, and had so foul an odor that one had to change clothes and take a bath, after using it. This odor was soon eliminated, and casein began to attract fine artists in the 1930s because it was a quick-drying watercolor, available in the same colors, under the same names, in tubes of the same sizes, as oil colors. Although it is a watercolor — that is, mixed with water — it is waterproof once it dries, unlike the watercolor I described earlier.

support for casein

Casein can be used on paper, illustration board, multimedia board, absorbent or raw canvas and textiles, plaster, and, indeed, any absorbent surface. It wouldn't adhere to shellac or to very glossy materials.

list of recommended colors

Basically, the colors recommended for oil painting are identical with those I recommend for casein. You may find that you'll want to add to or subtract from the list as you become proficient in the medium.

Alizarin crimson	Phthalo (phthalocyanine) blue
Cadmium red medium	Phthalo (phthalocyanine) green
Cadmium orange	Chromium oxide green
Cadmium yellow light	Viridian green
Cadmium yellow medium	Cobalt violet
Yellow ocher	Burnt sienna
Ultramarine blue	Ivory black
Cobalt blue	Titanium white (large tube)

brushes

Brushes are the same as you would use in oils and polymer, except that nylon brushes are recommended, because casein seems to corrode brushes faster than oil colors do. In every medium, the types of brushes depend on your subject, technique, and temperament. If you like to work in bold strokes, have bigger brushes. If you love fine details, and smaller pictures, you need smaller, fine-edged, and fine-pointed brushes.

medium

Actually, there's only one medium in casein: liquid casein, a substance that adds adhesive power to thinned down paints. I seldom use it. It's advisable to add a drop to each color, or to add a few drops to the water in which you rinse your brushes, when you dilute your colors to very thin washes.

varnishes	There are many sprays, matte and glossy, which can be applied to casein paintings, either at the end or in-between, depending upon whether or not they are "re-workable." Certain fixative sprays may be used on the same picture any number of times. You can work over them again and again. Others are for final application only. The label tells you which is which. There's a casein varnish that has to be applied with a brush. Polymer varnish, matte or glossy, may be used over casein paintings as well. Picture varnish for oils, however, doesn't work on casein because casein is very absorbent; the oil varnish·disappears. Whatever spray or varnish you use, read the label on the can or jar with care.
attractive features of casein	Casein was the first new medium since the introduction of watercolor, and it was the first waterproof watercolor. It sounded like a miracle that a paint can be applied with water, yet becomes waterproof, so that you can make changes and corrections without any difficulty. You could thin down casein and use it as if it were aquarelle. You could also work with it as it comes from the tube, or with very little water, and achieve effects similar to those in oil paintings. It's generally believed that casein was introduced and then propagated by artists allergic to turpentine. Casein had only a faint cheese odor, to which nobody could object. It was more pleasant to use for artists who had no regular studios, but had to paint in one of the rooms of their apartments.
limitations of casein	At first, casein would dry or separate in the tube. You either couldn't squeeze it out at all or, if you could, pigmets rolled out in small lumps, while a dirty liquid squirted in your eyes, on your clothes, or on the floor. These flaws were gradually eliminated, but even now, some casein colors dry in the tubes after a while, whether you use them or not. Don't buy more casein than you need. Some of the colors will not remain usable indefinitely as oil paints do. Casein dries a little lighter than it looks when you apply it. This has two drawbacks. One is that the general effect is lighter, less contrasty than you had planned. The other is that if you try to patch up something, such as a dirty spot in your painting, it's hard to match the shade because the color you apply will dry lighter. You may have to repaint an entire section, in order to get rid of one small mistake. Casein is waterproof, but not scratchproof, and one shouldn't leave it unprotected. Dust and fly specks would gradually damage the picture. You have to spray it, varnish it, or keep it under glass. Although casein may be employed as it comes from the tube, it must not be applied in thick, impasto strokes. Casein adheres to the support, but not to another full layer of casein. It's like true aquarelle, in this respect. Many artists are tempted to use casein as if it were oil, because of the similarity in consistency, only to find that double-thick casein cracks and peels off the support within a very short time. If this happens, don't try to patch the crack up by adding more fresh paint. Perform a little operation: scrape off the entire thick section, and apply new paint in thin strokes. Impasto effects are feasible only by using an underpainting polymer white, or modeling paste, or polymer gesso.
correcting pale appearance	The fact that casein colors dry lighter is not at all difficult to overcome. All you have to do is to paint all colors darker than you want them to appear. For the very darkest, use ivory black, mixed with alizarin crimson and perhaps ultramarine blue. An even simpler method is to spray the painting, not only for protection, but for bringing out the darks. Every spray — especially the varnish — darkens the darks, while having little effect on the light, bright hues.

exhibiting casein and polymer paintings

Both casein and polymer are watermedia, also called aquamedia, but both may be used in tube consistency, and polymer may be employed in heavy impasto, too. When varnished, both casein and polymer resemble oils to such an extent that only thorough scrutiny reveals the difference. Both may be diluted to the effect of true aquarelle. Here, too, only an expert can figure out the difference.

Exhibitions in which both watercolors and oils are acceptable require that a casein or polymer painting which looks, and is framed like a watercolor (that is, matted, under glass), is considered a watercolor, to be shown in the watercolor section. A casein or polymer painting which looks, and is framed like an oil painting (that is, varnished, shown in a frame without mat and glass), is to be handled like an oil painting. In other words, it isn't the actual medium, but the appearance that counts.

Certain artists exhibit a casein or a polymer — painted and framed like an aquarelle — in a watercolor show. Later, they varnish it, put it in a frame without glass, and call it an oil painting. These are among the confusing facts or issues of life. In the last analysis, only the artist himself knows for sure what medium he had employed. The time is sure to come when watercolorists, including the die-hard purists, will realize that any painting executed in a water medium is a watercolor, regardless of its appearance, the support on which it's done, or the type of frame in which it's displayed.

casein versus polymer

There are several similarities between these two waterproof, recently developed, media. The main difference is in the textural potentialities. Casein has a lovely, dry, pastel-like effect that makes it especially good for certain subjects, in which a dry, bright appearance is important. Flowers go very well with casein, because they're bright, crisp, pastel-like in nature.

15 Flower Painting in Casein: Demonstration

For this demonstration, I borrowed a beautiful, blue glass pitcher from a friend. I filled it with white, yellow, lavender, and pink flowers. I had a lovely, low, Chinese bowl, bright green inside, decorated in light hues and scratched-in designs on the hardly visible underside; I put a red apple and a bosc pear in it, and placed it in front, a little to the right, of the blue pitcher. For a background, I found an old, faded, yellow ocher textile, which I hung from the top of my shadowbox, and allowed the same textile to fall on the floor of the box. (Turn to the color section for the illustrations of this demonstration.)

I decided to work on an absorbent canvas, good for any painting medium, attached to stretchers 24 inches high by 18 inches wide. The reason I preferred stretched canvas to paper or paperboard was that I wanted to work wet-on-dry, without worrying about the warping, or bending, unavoidable in paper.

step one

I made a charcoal drawing of the whole subject on tracing paper of the same size as the canvas, rather than laying the picture out directly on the support. I also decided to take advantage of the fact that casein dries almost as fast and as waterproof as polymer. Instead of doing the entire still life, I traced only the main forms of the drapery, the blue pitcher, the bowl and the fruits on the canvas, omitting the flowers.

In order to transfer the drawing to the canvas, I first took a sheet of tracing paper, of the same size as the support, and rubbed it thoroughly with a stick of soft graphite, thus producing a carbon paper. Instead of graphite sticks, one can use the last, short pieces of pencils, removing the wood casing, and working with the lead. This is somewhat more difficult to hold than a square piece of graphite. Regular carbon paper is unsuitable because it's made with a dye which would turn the colors an ugly blue-red. Carbon made with graphite has no such effect, and it may be used many times, especially if you go over it with graphite after every second, or third use.

I placed this carbon paper, face down, on the canvas, beneath the outline drawing, which I then traced with a blunt, red crayon. The bluntness eliminated possible damage to both paper and canvas. The red color enabled me to see what I was doing. If you go over a black line with another black line, you cannot tell which part is done, which part isn't. Furthermore, I could wipe off the charcoal, when I was finished with the tracing, as the full drawing was visible in red, on the original sheet of paper.

step two

In order to see the graphite lines better, I went over them on the canvas with thin yellow ocher, and immediately began to apply colors. I painted every part as directly as possible: lighter, darker blues in the pitcher; yellow ocher, with a touch of orange, and a little white in the light parts of the drapery; ocher, mixed with ultramarine blue, alizarin crimson, and viridian green in the shadows. A few spots of cadmium red medium, alizarin, and orange in the apple; ultramarine, alizarin in the shadows of the apple; ocher, orange, burnt sienna in the pear; phthalo green and white in the

little visible inside part of the bowl; white with cobalt blue in the highlights on the pitcher; alizarin crimson, cobalt blue, a little ivory black in the tall, triangular background next to the drapery, on the left-hand side, until I had a complete background. The flowers were missing, and neither the bowl and fruits, nor the foreground and the pitcher itself were finished.

step three

I covered the back of the original layout with white chalk where the flowers were. I laid this white "carbon paper" on the canvas, and traced the flowers, nothing else, on the canvas. Now, I worked with a blue crayon, over the red outlines, so that I could see what I had already traced. Needless to say, the color of the crayon is unimportant. It could have been green and brown, orange and purple, as long as the colors were visible. The result was a somewhat strange thing: a half-finished painting, with white ghosts for flowers.

step four

I went ahead with the flowers, boldly, directly, with light and dark hues, and diverse shades, as the flowers and leaves really were. I finished the fruits, the bowl; the bright highlights of the blue pitcher, and the drapery on the floor, with its big wave in the lower right-hand corner. I discovered a foolish error. The pitcher was standing so close to the background that its cast shadow practically blended into the blue of the glass. From a distance, you couldn't distinguish the shape of the pitcher.

What's a little mistake in casein? I moved the pitcher away from the backdrop. Now the light hit the drapery between the pitcher and its cast shadow, creating a nice golden spot there, which brought out the complete form of the vase, and gave the picture a much better spatial appearance. It took only a few minutes to go over the shadow with the ocher mixed with a touch of orange. Highlights on apple and pear, the stems, and the bright highlights on the rim of the small bowl, and the very bright highlights at the bottom of the vase, were the finishing touches. The triple highlight on the pitcher was due to thé fact that my studio has a big triple window.

The painting turned out to be bright, yet subdued, because of the lovely dark blue glass pitcher, and the golden tones in the backdrop. The chalk lines of the flowers were quickly absorbed by the paint. Each flower is turned at a different angle. The arrangement isn't in the least formal.

As usual, I kept the painting on my easel, and looked at it a number of times, early in the morning, or just before going to bed. A few days later, I realized that the color of the bosc pear was hardly distinguishable from the light parts of the ocher-colored drapery. It looked as if it were the drapery itself. After a little hesitation, I replaced it with a green pear of about the same shape and size.

One is always reluctant to make such changes, but this change was worth the effort. The pear became noticeable from a distance, and enlivened the lower part of the picture. It also made the apple look brighter, redder. The artist isn't a camera. He can, and should, use his eyes and his judgment, and make changes he deems necessary, or advisable. The word *art* implies something deliberate, rather than something accidental. It's one thing to "work your painting to death" — as the saying goes — and another matter to create as good a painting as you can.

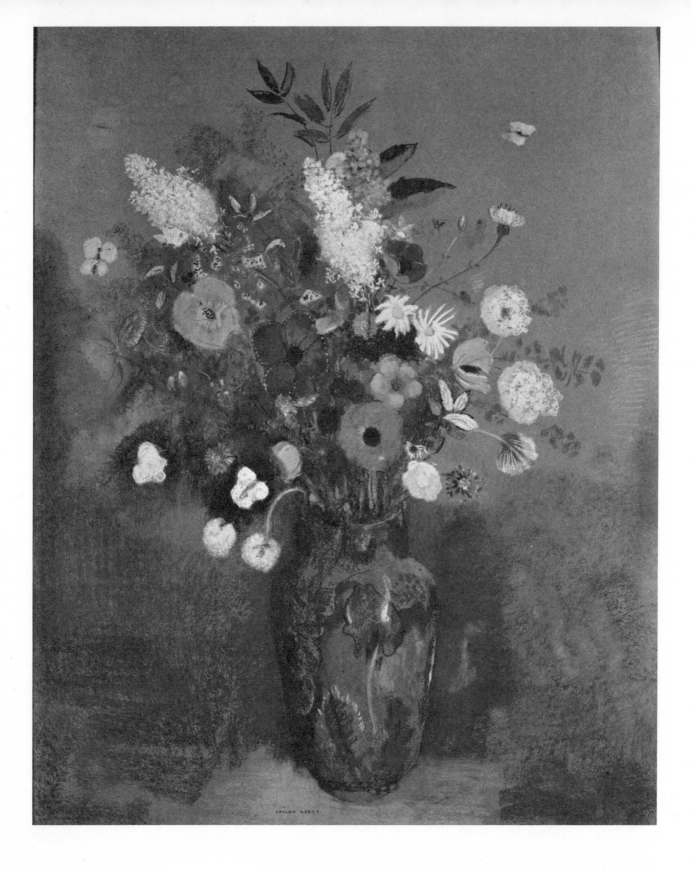

Bouquet of flowers by Odilon Redon, French, 1840-1916, pastel on paper, 31⅝ x 25¼ inches. Redon uses the dry, crumbly nature of the pastel medium to suggest the softness and delicacy of many of the flowers. He then exploits a different quality of pastel—its crisp, linear character—to render leaves, stems, and sharp accents. The Metropolitan Museum of Art, Gift of Mrs. George B. Post, New York.

16 Flower Painting in Pastel: Technique

Pastel is pure pigment pressed into short, cylindrical sticks. In South Africa, near some of the most beautiful paintings created by prehistoric artists, we have found large pencil-like sticks cut out of ocher, the natural mixture of oxide of iron and various other substances, popularly called "earth," of a yellow-brown color. The sticks were used for outlining those often stunning pictures of animals, and the less correctly done, but nonetheless fascinating human figures. Such ocher sticks may well be considered the first pastels.

invention of present-day pastel

The invention of our pastels is attributed to Johann Alexander Thiele (1685-1752), a German landscape painter. It should come as no surprise that this attribution, like so many others, lacks any historical substantiation. We have at least one pastel portrait by Guido Reni, the famous Italian master of light-and-shadow, who died forty-three years before Thiele was born. Thiele perfected the medium by working with it over a long period, but he was surpassed by a contemporary Venetian artist, Rosalba Carrera, one of the first women to become famous in the art world. The first artist to exhibit pastels in London was the Swiss Jean-Etienne Liotard, in 1775.

prejudice against pastel

Pastel painting has encountered more prejudice even than aquarelle. The first prejudice was that pastels are perishable; they can be blown or shaken off the paper like so much dust, and that there's no way of protecting them. The second prejudice was that pastels are for girls only. They're too sweet for men. The third prejudice was that pastels are good only for flower subjects, sketchy pictures of cute children and lovely, superficial, young women. These subjects — it is thought — lend themselves to a medium in which it's impossible to create strong, dramatic effects. In the popular mind, pastel is confused with pastel shades — very pale, feminine colors.

These prejudices are unjustified. First, there's no binder, or anything else in pastels that would cause them to change or deteriorate. Made of pure pigments, they're actually the most permanent of all painting media. Gargantua wouldn't have the lung power to blow pastel off a sheet of paper. Only excess amounts roll off; the picture itself remains undamaged, if executed on the proper support. It's true that pastel needs protection, but so do all other pictorial media.

Moreover, pastels are good for any subject. You can create contrasts as strong as in oils. Style, subject, artistry, and color effects depend upon the individual artist, not upon the medium. One can paint delicate flowers, lovely children in oils, and one can achieve powerful effects in pastel. Pastel shades are possible in any painting medium, not only in pastel.

support for pastel painting

Pastel adheres to almost any paper with a fairly even texture, such as charcoal paper and watercolor paper, but doesn't stick to very smooth sheets. There are papers specifically manufactured for pastel. A sort of sand-textured paper or board is satis-

factory. Some cheap wrapping papers are good in texture, but not recommended because they're bound to deteriorate. Velour paper or board has a velvety surface which adds to the effectiveness of the picture. A special board with a pulverized wood fiber surface and a board coated with white marble dust are both admirable supports for pastels.

The sizes of paper and boards range from about 18 by 24 to 30 by 40 inches, and cost from a quarter to several dollars a sheet. At five or six dollars a very fine sheet, it's still less costly than a fine canvas of the same size. However, don't start with the most expensive paper. Experiment on cheaper grades.

colored paper

Most pastel painters prefer colored paper: tan, brown, wine, fawn, gray, gray-blue, olive green, gray-green, rust are some of the trade names of the colors. Work on a soft, mixed shade, not on a very bright red, yellow, blue, green or orange, except when a brilliant hue is required for some special purpose. The soft tone of the paper is utilized as an intermediate color or shadow in the painting. Let the color of the paper harmonize with your subject. If you're planning to paint white flowers on a blue background, blue paper saves you much time. A rust-colored paper is appropriate for an autumn scene featuring yellow, orange, purple, red, green, and brown.

Remember, though, that any pastel works well on paper of any color. You can apply the brightest blue on a rust-colored sheet, for instance. The hue of the paper merely helps you establish a general tone, without compelling you to cover the entire sheet with pastel.

pastel on watercolor paper

A fairly rough watercolor paper is quite good for pastel, but I suggest that you give it a watercolor wash, first, instead of working directly on the pure white paper. As a matter of fact, you can lay your work out, and decide what color wash would be helpful in which part of the picture. You might give the sky a blue wash, red wash for red flowers, with a green wash in sections which will contain foliage. None of the washes need be exact or even-toned. Any little color in the background helps you when you're working in pastel.

soft pastels

Most artists work with *soft* pastels. Each of these pastel sticks has a paper collar which covers all but half an inch at both ends. The paper not only holds the pastel together; it also contains the name and number of the color. This is of greater significance than you may realize. Pastels can, and must, be mixed, like other media. Blue and yellow give you green; red and yellow mix into orange, and so on. But you cannot add pastel indefinitely. The powder must adhere to the support, so if you accumulate too much powder by mixing, the pastel won't stick to the support. You cannot rely on the possibility of endless changing, correcting, scraping, dusting.

In other painting media, we work with a dozen or fourteen colors. In pastels, we need scores of them. Even for a starter, get an assortment of about fifty soft pastels, at least. You'll soon find it necessary to add another fifty, or a hundred. Pastels are sold in wooden or cardboard boxes, in assortments of up to three hundred and sixty colors. The more shades you have the better. Buy a pastel-holder, so that you're able to use the last little bit of the pastel stick. Save the collars of the sticks, in order to know which shade of which color you have to replace.

semi-hard pastels

Also called half-hard pastels, these are longer and thinner than soft pastels, and their shape is square. That is, the crosscut is square, not round. The small amount of wax contained in these pastels makes them easier to handle than soft pastels. They're smooth on the outside, and do not soil your fingers. They can be sharpened

to a point, and are good for fine details. They're also well-suited for layouts and sketching. You can find semi-hard pastels in about a hundred colors and shades. You ought to work with them if getting pastel under your fingernails annoys you. At any rate, a dozen of the semi-hard pastels is recommended for finishing touches even if you *do* prefer soft pastels. Get a square pastel-holder for short pieces.

shades of gray

A set of different shades of gray is important for certain commercial projects, where the artist has to indicate the value of the gray tones for reproduction purposes. Such grays are almost meaningless in the fine arts, but it's a good idea to have a medium gray stick for applying shadows on white, or lights on black sections of your painting.

pastel pencils

Pastels also come in pencil form, encased in wood. These can be sharpened in a pencil sharpener, and are ideal for painting eyelashes, and similar small details. Don't drop pastel pencils; they break in the casing and you cannot sharpen them. Every time you get a point, a small piece of the pastel falls out. In a few minutes, your whole pastel pencil is gone.

stumps, brushes

Pastels ought to be rubbed into the paper, either with a fingertip or with a stump. The stump is soft, gray paper, rolled into the shape of a cigar with two pointed ends. You can do the finest details with the point of a stump. Rub the stump in a circular motion, turning it round and round, so as not to lose its shape. You might also try Q-tips in pastel painting, or wrap a finger in a paper handkerchief. Small bristle brushes are useful, too. You may have to apply a tiny bit of color in a tricky little corner. Rub the desired pastel on a piece of paper, pick it up with a small brush, and apply the color in the correct spot.

sprays

For a long time, there was no way of fixing pastels. Charcoal and pencil fixatives absorbed pastel completely. For a number of years, though, we have been able to fix pastels as well as charcoal work, by using crystal-clear synthetic fixatives. These sprays come in pressure cans. Read the label to make sure the spray is for pastel, and follow the directions. I am a great believer in reading directions, and I've never had reason for regretting this belief. Directions are composed by experts who know what they're talking about.

 After using a spray on your pastel picture, you can — and usually must — continue working, adding a highlight or two, a shadow here and there. Spray the painting again. Never try to use shellac or regular picture varnish on pastels, unless you want to act like a magician who makes something disappear. Your pastel would surely disappear, but you'd never be able to make it reappear again. If you wish to experiment, do so on a worthless piece of work.

changes, corrections

You must realize that soft pastels break if you press on them too hard. You'll find out soon enough that a little pastel goes a long way. Apply pastel of the color closest to what you want to obtain, and rub it slightly into the paper. You can add some other color on top of this, rubbing the two together, but never so hard as to damage the texture of the support. You need this texture so that you can add a new application of pastel. Pastel won't adhere to a smooth surface.

 In case of a mistake, wipe the wrong color off with the stump or with a rolled-up paper handkerchief. If the change or correction refers to a larger part of the picture, tap the back of the support at the spot where you want to make changes, to shake off all surplus powder. Take a stiff bristle brush and rub the rest of the powder off,

as if you were using a broom. The bristle brush doesn't smooth the paper the way a stump or your fingertip would. It scratches the surface a little and thus enables the support to hold pastel again after you've removed a spot. Don't overdo this scrubbing with a brush, though.

Another method of making changes is to spray the part with pastel fixative. You'll find it easy to work over the spray. Naturally, it's impossible not to spray a small area surrounding the spot you want to change. Blend the pastel into this area with your fingertip, or with a stump.

protection for pastel paintings

On paper or board of any sort, fixative is a satisfactory protection. You can also cover your pastels with a fairly heavy sheet of colorless, transparent plastic. Cut it to the size of your pastel and attach it, on top only, with plastic tape — one at the left, one at the right corner, and one in the center. Let the rest of the plastic hang free. Such a sheet is a good protection as long as you don't shift the sheet over the picture.

For permanent display, though, frame and glass are necessary. Make sure to have a double-thick, or triple-thick mat between the pastel and the glass, so that the glass will never touch the pastel. The moment it does, some of the powder will adhere to the glass and cause a cloudy, unpleasant effect. Should this happen, remove the glass and clean it thoroughly before replacing it. One such touch doesn't damage the painting.

pastels in exhibitions

Pastels in most exhibitions are included in the same category as watercolors. This is so because pastels are normally executed on paper and are left unvarnished. (The pastel fixative isn't a shiny, visible varnish.) Both pastels and watercolors are customarily matted, and shown under glass. Although aquarelles can be shown without mats, pastels must have a thick mat between the picture and the glass, to prevent the pastel from adhering to the glass, obscuring the painting.

The necessity of showing pastels in mats and under glass also affects the sizes of the support, as is the case with regular watercolors. The sizes of paperboard mats is limited by the maximum size of available matboard. Even if you might patch a mat together from several pieces, the strong backing and the large piece of glass needed for front and back protection would make the painting very heavy and fragile.

17 Flower Painting in Pastel: Demonstration

My "model" for a pastel demonstration was a gray basket with a tall handle; white, yellow, pink, and red flowers with their respective leaves, all set up in my shadowbox with a maroon background. I decided upon a bold approach, in order to show that it is feasible to make changes in pastels. (Turn to the color section for the illustrations on this demonstration.)

step one

Instead of preparing a careful pencil drawing, and tracing it on a 19½ by 25½-inch sheet of pastel paper, I made the layout directly on the maroon paper, indicating the most prominent white, yellow, and pink blossoms with a few sketchy lines, using approximately the color of the flower in each case: pink for the red flower, yellow for the yellow flower, and so on. I drew the shape of the table (actually, the floor of my shadowbox), across the basket, as if the basket were transparent.

step two

I went ahead, dashing off more and more forms and hues, handling the pastels in the directions of petals, and jotting down a few parts of the basket. The original outlines remained visible in most cases. I did the deepest shadows in purple, then toned this down with a dash of dark green. I left most of the table the maroon color of the paper—which was the same maroon as the background—with only a little burnt sienna rubbed into it, here and there, to separate table from background.

step three

More shadows in each flower, more indications of petals, some roundish, some pointed, some lace-like; details in the basket weave; shadows on table and wall. Shadows in the white flowers were done in very light gray and very light ocher. In the red flowers, I used various shades of orange, red, pink, whatever I found among my hundred and thirty or so soft pastel sticks to be closest to the shades I needed. In other words, I didn't make the red lighter by adding white, but by using a lighter red or pink. In some sections, however, it was necessary to do some mixing. I added a few strokes to the handle of the basket, the strokes following the actual direction, as if I were weaving such a handle.

step four

I added more leaves and blossoms where they were needed and made the forms more subtle. I also changed the color of the basket. At first, I thought a brown basket might be better than the gray basket I actually had begun to paint. Later on, I found that the gray was more interesting against the maroon backdrop and brown table. It took only minutes to carry out these changes, especially since I first sprayed the picture with a reworkable spray; that is, a spray over which one can continue to work. This spray separated the first colors from later applications.

The biggest change of mind, and change of picture occurred in the red flowers on the table, in front of the basket. I realized they appeared to be quite alike in size, seemingly next to each other. I made the one on the right smaller, with the help of shadows, and pushed it slightly *behind* the other flower. I made the table a little lighter, the cast shadows stronger and bigger. After completing the handle of the basket, I gave my painting another coat of spray, and added a few very bright strokes in the blossoms, with a few soft shadows in each, to make them look more three dimensional. My signature, a final spray of fixative, and the pastel was finished.

I did not plan to turn out a popular floral picture, and omitted many little details. What I wanted was a crisp, vivid basket of flowers, just the way they happened to be. The result has to speak for itself.

Textural effects have been enjoyed since prehistoric times, when artists utilized bulges in the natural walls of their caves in rendering the bodies of huge animals. Relief work in stucco was combined with pictorial images in ancient Crete, Assyria, and Babylonia. In recent times, impasto—a thick application of paint—has become very popular. Now, with polymer gesso, modeling paste, gel, and diverse underpainting whites, impasto can be done in practically all painting media. The artist can create pictures which literally are three dimensional.

impasto in flowers

In floral subjects, impasto is a "natural," because it helps the artist in differentiating between petals, without his having to paint them one-by-one, without his having to separate them with careful shading. You can practically construct flowers and leaves, in one of the several white substances available for textural effects, to such a degree of perfection that all you have to add is the local color; that is, the color given the flowers or leaves by nature. Shadows and lights will be created by whatever light hits the painting. The three dimensional edges and ridges will catch the light, and they will also cast their own natural shadows.

consider esthetic principles

The idea behind impasto and other textural effects must always be esthetic. If you merely want to prove that you can spread, or heap up, the paint as thickly, and in as bizarre a manner as the next artist, you're wasting your time and materials. Employ textural techniques only when, and where, they go hand-in-hand with the subject. The texture must be an integral part of the picture.

natural versus artificial impasto

As I mentioned before, a thick application of pure paint is possible in oils and polymer only. These media possess enough adhesive power, in any mass, to adhere to a support. Transparent watercolor, tempera, casein, gouache adhere to the support only in thin layers, but not in big heaps. Neither gum arabic, nor egg, nor casein— the binders employed in these media—permits the piling-up of paint. All of them can be applied over gesso, modeling paste, or extender, or the proper underpainting whites, to create the appearance of true impasto.

why not use impasto in aquarelle?

Although watercolor can be applied over polymer gesso or modeling paste—and there's a special gel manufactured for watercolor—I question the validity of impasto in this medium. Watercolor mixed with gel, or executed over a textural underpainting, would need to be protected by glass, or by varnishing, because watercolor cannot be cleaned like oil or polymer. Glass would make the impasto almost unnoticeable; varnish would rob the painting of much of the charm we associate with the medium.

Furthermore, a heavy application of paint would require a sufficiently strong support. Regular watercolor paper would bulge out from the mat, under the extra weight. Moreover, impasto loses much of its dramatic appearance when covered with glass. You can only see textural effects when they're hit by light from one side or another. Glass, with its natural reflections, obliterates such effects and the thick paint doesn't even catch the light as it would if it weren't covered by glass.

I suggest you do textural work in oils and polymer only, the two media inherently compatible with such techniques. Don't force a method natural in one field upon another field, which has its own natural methods. Let every material, each medium, work to its own best advantage. Don't paint an aquarelle in oils, or an oil which appears to be a watercolor, even if it's humanly possible to do so. We accept bricks printed on paper as a Christmas decoration, signifying the chimney through which Santa Claus is expected to appear. But you'd hardly want to live in a house made of paper bricks, no matter how pretty, and lifelike, those sheets of paper may look.

methods of applying textural effects

One method of obtaining textural effects is to paint the entire subject with a trowel-shaped painting knife, applying the right colors and shades directly. Wield the knife in such a manner that the strokes should resemble the natural, or desired, textures and forms. This way, you can do petals, leaves, and stems that are pointed, curved, twisted, bent; you can render the roughness, smoothness, grain, or thickness of any flower, any plant, any accessory in your painting.

Another method is to paint the whole picture first with brushes — without painting in small details — as a kind of underpainting. Go over certain parts with heavier paint, applied with the knife, or an old toothbrush, if that's the texture which serves your purpose. This method emphasizes the most prominent segments of your picture, leaving other parts subdued, flat.

A third method is to do an underpainting in gesso, extender (modeling paste), a textural or underpainting white, without any color. Allow the substance to dry, then paint over it the colors and shades you like. Polymer gesso and extender dry very fast; underpainting whites take longer if applied very thickly. In all materials, do the heavy parts in layers, rather than in huge batches, and wait a little while before adding another layer.

A fourth technique is to mix the modeling paste, gel, or quick-drying white with the desired color and shade, and to apply the mixture with brush, knife, spoon, or whatever you wish, until you find the result satisfactory. Needless to say that different thicknesses, different textural effects are necessary to achieve artistic results. If petals, leaves, stems, accessories, background, foreground are all done in equally thick strokes, the picture will be what may best be described as a mess. The purpose of impasto, in any technique and any medium, is to differentiate thicknesses.

polymer gel absorbs color

In polymer, you can use still another method for obtaining textural effects. Paint everything as you wish, thin or thick. Polymer dries very fast. Apply gel in strokes, blobs, or any other form, where you think they will do the most, and best, for the final effect. Let the gel dry for a few hours. You'll find that gel becomes as hard as stone, and that it absorbs the colors upon which it is applied. On a pink rose, gel becomes pink; on a red carnation, it is red; on a green leaf, it becomes green. It works like magic. Naturally, if you don't like this result, you can paint over the gel in whatever color you like.

work in the proper strokes

Experiment with various strokes; hold and manipulate your painting knife — and any other tools you use for textural effects — in different directions. See which tool

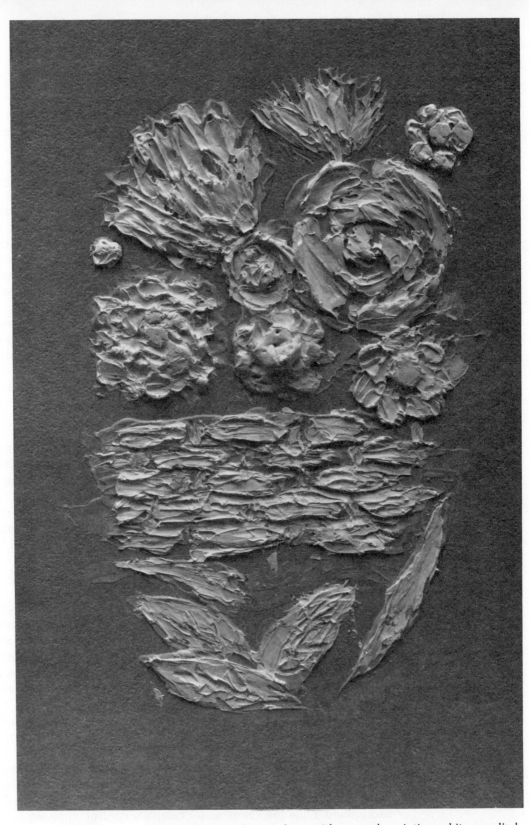

This impasto work was done with an underpainting white, applied with a small, trowel-shaped painting knife. The strokes follow the natural textures and forms: long, pointed strokes, radiating from a center, for certain flowers; rounded strokes for roundish petals, and so forth. Basket weave is indicated in the lower half (I scratched the lines with a pointed pencil). The thickness of the white paint ranges up to half an inch. Other substances, such as gel, modeling paste (extender), gesso, and just plain oil or polymer paint — in any hue — are handled in the same fashion.

gives you rounded forms, which is good for pointed shapes, curves, and so forth. There are instances when the simplest technique is to squeeze the paint directly from the tube, twisting or spiraling it. At other times, paint, or any of the ingredients, should be dropped or spread with a tongue depressor, or with your fingertip.

use the
proper support

Heavy impasto requires a strong support. Don't work on thin paper or canvas if you plan to apply a pound of paint and modeling paste. Masonite or multimedia board is usually the right support for such paintings. These supports also provide protection against damage from the back. Layers of any kind of impasto may be executed in an upright position, but if you apply really thick paint or gesso, it's better to keep your support in a horizontal position until the substance has a chance to dry. Otherwise, there will be a sliding downward, which may ruin the planned effect. Especially in oil painting, and quick-drying white, the drying time is much longer than usual, if the material is heaped on.

In any case, impasto can be worked over and over again. You can make it thicker, or remove part of it, while it's wet. Once the impasto is dry, you cannot take it off, without probably damaging the support. Impasto may be absolutely realistic, abstract, semi-abstract, or nonobjective. The term "impasto" or "textural painting" refers only to a technique. The style as well as the subject is entirely up to you.

demonstration
of realistic
impasto

First, I made a realistic, but simple, sketch in color on a heavy, smooth multimedia board, 24 inches high and 18 inches wide. Showing only the top part of a clear glass vase, most of the support is taken up by the flowers, all in lifesize. I was more interested in having a variety of shapes and hues, different kinds of petals and leaves, than in painting a pretty picture. But you can hardly fail to create an attractive picture if your flowers are beautiful, and if you paint them well enough.

I painted the whole background quite dark, a mixture of ultramarine blue, alizarin crimson, Mars black, phthalo green, applied unevenly, to avoid the appearance of a sheet of dark paper. I did all this work in polymer. It could have been done in oils, but it would have taken much longer, because one has to wait for the colors to dry in oils.

I applied polymer modeling paste (extender) with a small trowel-shaped painting knife, always suggesting the respective petals and leaves. You can place a batch of extender on the support and spread it out, this way and that way, into round or pointed petals, pointed, flat leaves, round buttons in the flowers, or in any other shape you require. You can use the handle of a brush or a pencil to scratch a line between petals; you can depress a petal with your fingertip. I worked all over the flowers, a few strokes here, a few there. For heavier application, I went over certain blossoms four or five times, always allowing one application to dry before adding another one. At the end, the thickness of the paste ranged from a sixteenth of an inch to a quarter of an inch.

I gave the modeling paste a half hour to dry before applying colors, and I applied these in heavier than usual strokes, in order to give even more thickness to my flowers. The tips of many pointed petals now stick out perhaps half an inch from the background. I had the colors under complete control, applying light and dark shades in yellow, orange, red, green; I observed the gray-green shadows in the white flowers, the diversity of green shades in the leaves.

In some places, I worked with the knife; in others, with the proper brushes, small or big, according to shape and size of the forms. When the painting was finished, it looked astonishingly real. Not just realistic, but like the actual flowers, as the impasto strokes caught the light on one side, and cast shadows on the other side.

All this might have been executed in a different technique. I could have mixed the proper colors and shades with the modeling paste before applying them with knife

or brush. I might have painted some of the flowers flat, with brushes, and only a few in impasto. The first color layout could have been eliminated. But I found my method quite satisfactory and reliable. The basic sketch in color gave me a good idea of how much impasto to build up, and where. I had the whole picture in front of me, at all times, instead of groping around, making mistakes in sizes and proportions.

My background is quite dark. Many people would, no doubt, prefer a lighter, brighter backdrop. It could've been sky blue, as I had no blue blossoms in the picture. It could be violet, too, or a light gray. I selected the dark background because I just happen to like dark backgrounds, at least once in a while. But had I done the background in impasto, with a palette knife, the roughness and thickness of the paint all over the support would have diminished the effect of the flowers.

19 Collage in Flower Painting

Pictures have been cut out and pasted on walls, closet doors, cabinets, and other articles, for heaven only knows how many years. Picasso and Braque are, however, credited with having introduced the idea as a form of art. Collage, which rhymes with *garage*, is French for paste-up, and that's all it is: pasting actual, usually flat and thin, but occasionally thicker, odd-shaped objects or materials upon your support. Some parts of the support are painted by hand, as a rule. It's possible to create a full collage, without any hand-painted elements. A collage can be realistic or abstract, serious or whimsical, artistic or childish.

collage and flowers

Most flowers comprise more or less flat petals; their leaves are flat, too. Therefore, the idea of recreating them in various materials glued onto your support is not too far-fetched. As a matter of fact, with skill and quite a bit of patience, you might render completely realistic or fantastic, decorative floral pictures in collage. As in all fields, you have a choice of methods and materials or ingredients.

materials for collage

Besides various types of colored papers, you might work with velvet, silk, metallic foils, plastics in the petals and leaves; with real or artificial straw, wire, plastic tubes in the stems. Add rhinestones, beads, buttons, artificial gems (or real ones if you're rich enough), pins with big heads, pearls, peas, beans, whatever you can think of. Here's a technique in which you might as well let yourself go. Work on a strong enough panel, rather than paper or canvas, to be sure it will hold all the stuff you glue onto it.

work over a layout

The simplest, safest method is to prepare a drawing, cut the required pieces in the correct sizes, shapes, and colors from paper, textiles, plastics, or whatever suits your taste; then glue the pieces where they belong. Certain artists make a truly complete outline drawing, and do the cutting and pasting of pieces so carefully that the final result is a picture which looks exactly as if it had been painted by hand. Frankly, I question the validity of such a collage. A true collage ought to look like a collage, not like a painting. As long as you're going to take the trouble to make a collage, why not have it look like a collage?

spontaneous collage

Collage may be done without any advance planning. Have all imaginable materials on hand; dab a little paint or glue on the support, attach this and that; more paint or more glue, more this and that. The result may be interesting, clever, amazing or amusing. If you're a meticulous craftsman, you'll prefer a more systematic approach, with preliminary sketches and a full-scale layout.

three dimensional effect

In another method, the materials are allowed to stick out of the picture, instead of being pasted down flat. Thus, the work is actually three dimensional. Such an effect seems most appropriate in floral subjects, because a truly realistic appearance can be achieved. I might add that the best floral collage would be created if you purchased artificial flowers, separated their petals, leaves, and other parts, and pasted them onto your support. You might even add a real butterfly to the picture. But would this be creative art?

Personally, I like to start with a definite idea, but without tying myself down to a precise layout. I select, cut, fold, and arrange my materials in a recognizable manner, but avoid perfect realism.

selecting the proper glue

Polymer paints have a strong adhesive power; they glue almost anything to anything. It's better, though, to have some other glue as well for pasting items you don't want to smear with paint. A white, latex-based glue, in tube or squeeze bottle — such as Sobo or Elmer's — is easy to use. There are diverse cements in tubes. You need a fast-drying adhesive, which doesn't discolor the materials, and doesn't harm the skin on your fingers.

Read the labels on tubes or bottles, to find out which paste is good for the materials you're planning to incorporate in your collage. Certain glues won't stick to plastics or rubber; others are guaranteed to glue anything to anything.

use permanen materials

Museums and private collectors make a point of demanding permanent materials in a collage. Most kinds of paper and textiles are likely to fade, discolor, darken, or fall apart. Such ingredients ought not to be employed in a self-respecting collage. The paste, too, must be reliable. Imagine working with some temporary paste, used in offices or in commercial art paste-ups! Such temporary cements dry out, so that the things pasted with them soon fall apart, without even being touched. They also usually discolor whatever you touch with them. Generally speaking, if something is worth doing, it's worth doing well. You can spend hours, even days, on creating an artistic collage . . . why take a risk that it should fade away, or fall off the support?

protecting a collage

Another point is the protection of a collage. An impasto is solid material: paint, gesso, gel, modeling paste, underpainting white. It's as reliable as paint itself. In collage, however, some sections may be very high, stick out, inviting the clumsy, destructive fingers of curious spectators. Someone in your own home or studio may want to see what would happen if he touched the collage. Someone may want to dust it, just a little.

Depending upon the degree to which pieces stick out, or are otherwise vulnerable, cover the collage with a good sheet of plastic. If the collage is deeper, frame it in a shadowbox: a frame built like a shallow box, covered with glass. You might even have a narrow electric bulb in the box, to enhance the beauty and depth of your collage.

illumination for collage

A perfectly flat collage looks like a painting, and needs no special lighting. A three dimensional collage, on the other hand, looks more interesting if it's illuminated in such a fashion that one can see its technical features, its literally three dimensional characteristics. The best lighting comes from a source slightly in front of, and above, the upper left or right corner of the picture. You can attach a bracket-light to the frame, the same kind people use over paintings, but move the bracket off-center to provide a more interesting lighting effect.

is collage art?

In my opinion, it's more difficult to paint a picture than to paste things up. I don't want to imply, though, that collage is not art. A true artist turns everything he touches into art. As in all branches of art, you'll find good, bad, mediocre, attractive, interesting, absurd, ridiculous, foolish, and stunning creations in collage. A collage is neither good, nor bad, merely because it's a collage. Its artistic quality, or lack of artistry, depends upon the person who creates it.

I only wish to add, again in my opinion, that a collage ought to *look* like a collage, if it's going to stand on its own feet. If it looks like any old painting, and you have to scrutinize it from nearby before you realize it's composed of cutouts, you have the right to wonder whether such a collage is more than an exercise in pasting paper on a support. Almost anybody can cut flower pictures from a seed catalog and glue them on a support; but it takes talent, knowledge, and real effort to paint flowers of your own.

Making a collage undoubtedly has a therapeutic value, because it's absorbing and it enables anyone with fairly skillful fingers to produce something attractive. A collage may well become a conversation piece, even if it falls short of great art. You might enjoy making a collage or two, simply because it's truly great fun. Once you start working on a collage, you cannot stop. So why not try it? It can do you no harm.

demonstration of three dimensional collage

To be true to my own principle, I decided to make a collage which would never be taken for anything but a collage. (Turn to color section to see the end product.) I took a fine, heavy paperboard, 22 by 15 inches in size, and painted it with a mixture of burnt sienna, yellow ocher, and a little white polymer, just to have a background, in case some spots of it might remain visible between pasted-up pieces.

I had on hand sheets of first-rate, glossy colored paper: yellow, orange, red, blue, green, maroon, in several shades. Also, I had one of those stretch slippers the stewardess gives passengers on an overnight flight. I had some paper doilies, corrugated paper, odd pieces of textiles, a couple of plastic soda straws, a squeeze bottle of white glue, and a pair of sharp scissors.

First of all, I cut—or tore—squarish pieces of glossy paper in different colors, and folded them back, all round, wrinkling them, twisting them, bending them up, in order to make them look more three dimensional. I cut or tore them into petal-shapes, into leaf-shapes. I rolled and folded smaller pieces into diverse forms. Torn edges looked better than cut edges, because the white paper showing at the tear added to the feeling of thickness. I cut the stretch slipper into pieces, tore the corrugated paper into smaller segments, and tore up the paper doilies.

I started by pasting the stretch slipper pieces first. I took the pieces of corrugated paper and pasted them next to each other, like a cluster of petals. I continued pasting pieces next to, and on top of, each other, interested only in selecting harmonious colors. Instead of gluing each piece down completely, I only squeezed a couple of drops of paste in the center, on the back, pressed the "flower" down, and bent the rest of the paper up, in order to achieve a stronger three dimensional effect.

I added leaves, in various tones of green, wrinkling and twisting the pieces. Some of the flowers consist of three or four pieces, including a section from a paper doily. I added a few soda straws to indicate stems. The entire work was done within a short time, as I was interested in color and pattern, rather than in details. I considered this an exercise in taste, in using vivid colors, in creating a novel effect, not in trying to achieve absolute lifelikeness. As a matter of fact, nothing was farther from me than the idea of creating realistic flowers.

I now had a vignette; that is, a picture not filling the entire support, but leaving the corners empty. I found the brown corners of the board somewhat distressingly barren, so I decided to paste a border on the picture. I cut a dark maroon paper into four-inch strips, and tore these along the center, in a very uneven, zig-zaggy fashion. I pasted these pieces along the borders, with the uneven tear on the inside. Thus,

the flowers appear to be seen through a sheet of paper whose center had been torn out. I signed the collage, and considered it finished.

Note that, in most cases, there are several flowers of the same kind in this collage. My idea was that you wouldn't assemble a bouquet of all different kinds of flowers. A collage, too, ought to have some repetition, even though my flowers are entirely personal, and could never be found in any botanical book, or in any flower seed catalog. This unreal realism, so to speak, is what made my collage worth doing, in my own estimation. Like practically every idea, this one is open to argument.

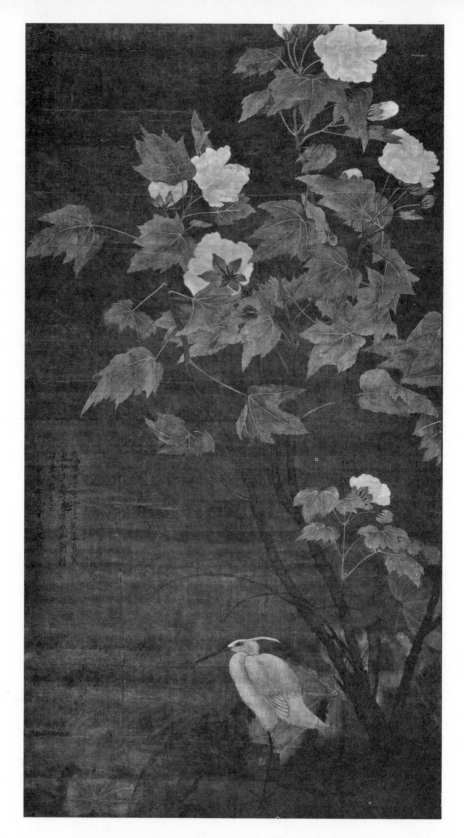

Flowering hibiscus by Chao Tze Ku, Chinese, Sung Dynasty, 960-1279, silk, framed, 44½ x 23¾ inches. Done with great delicacy, on the basis of the keenest observation, this painting has a minimum of spatial relationship: the bush is clearly depicted; one can sense, if not actually see, the soil from which it grows. The soil is also indicated by the lovely bird standing on one leg. Even without light and shadow, the picture creates an illusion of three dimensionality. The Metropolitan Museum of Art, New York.

20 Decorative, Stylized, and Abstract Florals

What comes first: realism or abstraction? This is almost the same as the question: what comes first, the chicken or the egg? Most primitive art is some sort of abstraction, even though, in all likelihood, such art was intended to be realistic, but turned out to be childlike. Children aren't as discerning as experienced adults; they notice main forms, rather than details. Children accept abstract toys, figures of humans and animals made of simple sections, such as balls, sticks, cylinders.

what is decorative?

All art is decorative, insofar as it's not utilitarian in the popularly accepted meaning of the word. A great many people think that art is not absolutely necessary, but merely attractive, at least for those who care for that kind of stuff.

The only real purpose of art, therefore, is to serve as a decoration, in a more or less sophisticated fashion. Art historians, psychologists, and anthropologists maintain that, originally, art served very definite purposes, such as giving power to man over beasts and over the dangers of nature, and assuring protection against evil, or against the restless spirits of the dead. They also agree that magic, and thus utilitarian features of art, became matters of habit, and grew into what we now call decorations.

what is stylized?

As I mentioned in Chapter 2, stylizing means to represent objects in a simplified, conventionalized manner. Stylized articles are easily recognizable. The simplification involved in such renderings is often due entirely to the materials and tools with which the work is done. For instance, the size of mosaic chips used in Byzantine (Early Christian) art was too large to permit tiny details. Figures as well as flowers and plants in those mosaics had to be stylized. Yet, they seemed fully realistic for the illiterate population of the period.

what is abstraction?

Abstraction, in man's handiwork, is the reduction of realistic forms and features into simple, basic elements, recognizable to all people living in the same community, and — usually, but not invariably — to other human beings as well. The thin figures of animals and humans painted on the walls of prehistoric caves undoubtedly meant real figures to the cave-dwellers. We find very thin, tall statuettes in ancient Rome, resembling, to an astonishing degree, the elongated statues made by the late Swiss sculptor, Giacometti. Before drawing realistic figures, art students are often taught to draw figures entirely in basic lines, what we call stick figures. This is also a reduction of a realistic form to an abstract shape.

Abstract art, manifestly, isn't new, but it was introduced on an impressive scale early in the twentieth century. In true abstraction, we still recognize objects or articles but, in present-day art, abstraction means a whole concept, not merely a figure or two.

what's the difference between stylizing and abstraction?

Stylizing implies a kind of flat design, whether in outlines only or in color. Any object can be stylized, but each stylized form serves its own decorative purpose. You can stencil a stylized floral ornament on your wall or on a piece of furniture. You can use stylized patterns on neckties, curtains, dresses, and so forth. An abstraction, on the other hand, serves an entirely different purpose.

In the fine arts, a good abstraction is a good picture. Its goal is to express a different artistic taste and style, without losing its pictorial power and cohesion. An abstract painting is executed with the same tools and materials employed in realistic painting, and the technical possibilities are equally vast.

how to stylize flowers

Flowers are a natural for stylizing; that is, to turn into designs in which the outward, most commonly known shapes of flowers, buds, stems, and leaves can be immediately recognized.

Many flowers, such as daisies, are comparatively flat when viewed from the top. They're also quite symmetrical, with petals growing out of a central, button-shaped organ, called a disk. (Such petals, by the way, are called rays or ray-florets.) The daisy is practically a flat design created by mother nature. (It might surprise city folks to learn that the daisy is a weed to the farmer, wasteful and dangerous, because it exhausts the soil and, for whatever reason, is not eaten by any animal.) In stylizing a daisy, you merely make it more exactly symmetrical than it really is.

rose, tulip, lotus, and lily

The rose, the most universally celebrated of all flowers, has a rich, yet fundamentally simple design from the top view. Its bud is best known from the side. So are the lily and the tulip. The lotus, equally beautiful from above and from the side, has been admired, even worshipped, in Egypt and the Far East, since the most ancient times. Egyptian artists often depicted lotus flowers from the side; the flowers were held by elegant ladies and gentlemen at parties. In India, the cross section of the lotus, which resembles a wheel, has become identified with the concept of eternity: a circle or wheel, with no beginning and no end. The lotus is rendered in sculpture as well as in painting all over the Far East, in diverse degrees of stylization.

In a designed form, the rose is usually shown as a rosette, a round design resembling a rose, with the petals indicated as a perfectly symmetrical pattern. Rows of such rosettes, or rosettes alternating with humans and animals, were frequently used to decorate the facades of palaces and temples in Babylonia and Assyria. They were also a natural in jewelry, on crowns, scepters, belts, and so forth. They were employed in the painted decorations of Crete, Greece, and Rome. Byzantine mosaics often used rosettes or other floral designs as a framework, because the natural shapes and hues of flowers lent themselves so easily to decorative purposes.

The lily, a symbol of purity and elegance, has become a sign of royalty. It's often employed in heraldic and other designs. The tulip, one of the most admired of all flowers, plays an important role in Muslim art of every sort. Its great variety and brilliance of colors, its tall, straight stem, and graceful, long leaves make the tulip a favorite flower for design.

leaves and stems

Leaves curl, bend, or twist but, fundamentally, they're flat and symmetrical. They come in countless designs, and any experienced person can identify a flower by its leaf, because the main shape of every leaf of the same species is always the same. Disregard the small individual differences between leaves of the same kind, and you have a nature-made design ready to be carved, incised in stone or marble, painted as a decorative frieze, or employed as a charming pin. The stems of plants and flowers are lovely by nature, easily adaptable to decorative projects.

Soft-edge abstraction is a free pictorial technique, with shading, and often a very fine blending of hues.

Hard-edge abstraction comprises geometric, or semi-geometric forms, executed in sharp lines and colors.

There's no limit to possibilities of stylizing or conventionalizing flowers, leaves, and their arrangements. The stylizing may be geometric, or free, depending upon the purpose of the design and the material in which it's executed.

Egyptian lotus and lotus bud,
as they really are.

Lotus from top, as might be
shown in Indian painting.

Lotus from side, as might be
shown in Indian painting.

Indian lotus, as it really is.

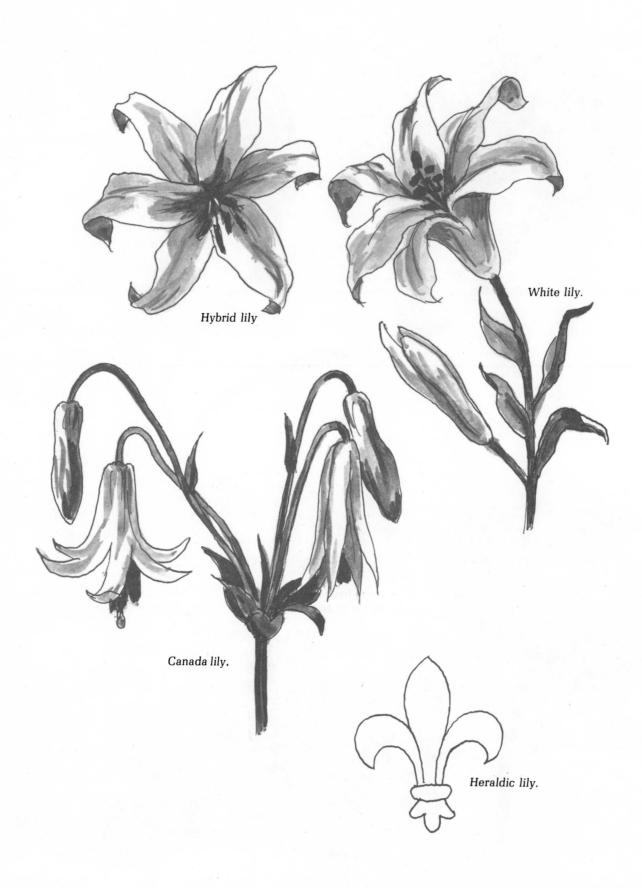

Hybrid lily

White lily.

Canada lily.

Heraldic lily.

Lotus as depicted in Egyptian art.

Stylized flowers as depicted in Egyptian art.

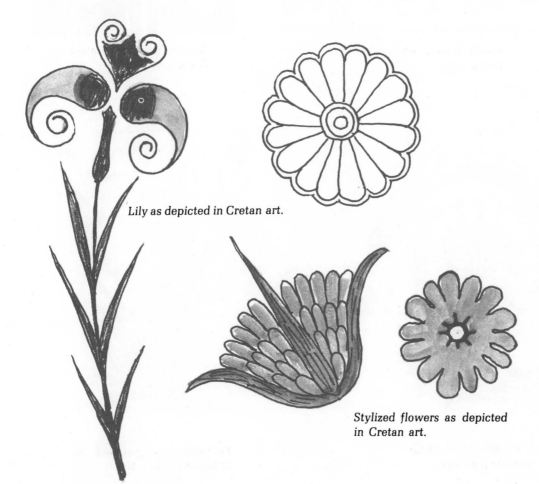

Lily as depicted in Cretan art.

Stylized flowers as depicted in Cretan art.

Stylized frieze in Greek art.

Floral design on ceiling:
Greek art.

Stylized wall decoration in
Greek art.

Roman marble relief, done
with supreme precision.

Pompeiian wall painting, in
impressionistic style.

Lotus in relief sculpture:
Indian art.

Realistic flowers in painting:
Indian art.

Typical floral motifs, highly
stylized: Persian art.

Stylized, organically con-
nected, but different flowers
and leaves on the same stem:
Chinese art.

Textile design, in which flow-
ers are intermixed with
herons and turtles in the
same size and shape as the
flowers: Japanese art.

Realistic flowers formed into
ribbon design: Japanese art.

Realistic daisy.

Stylized daisy.

Realistic tulip.

Stylized tulip.

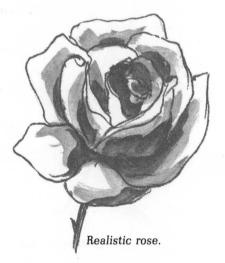

Realistic rose.

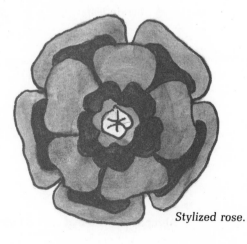

Stylized rose.

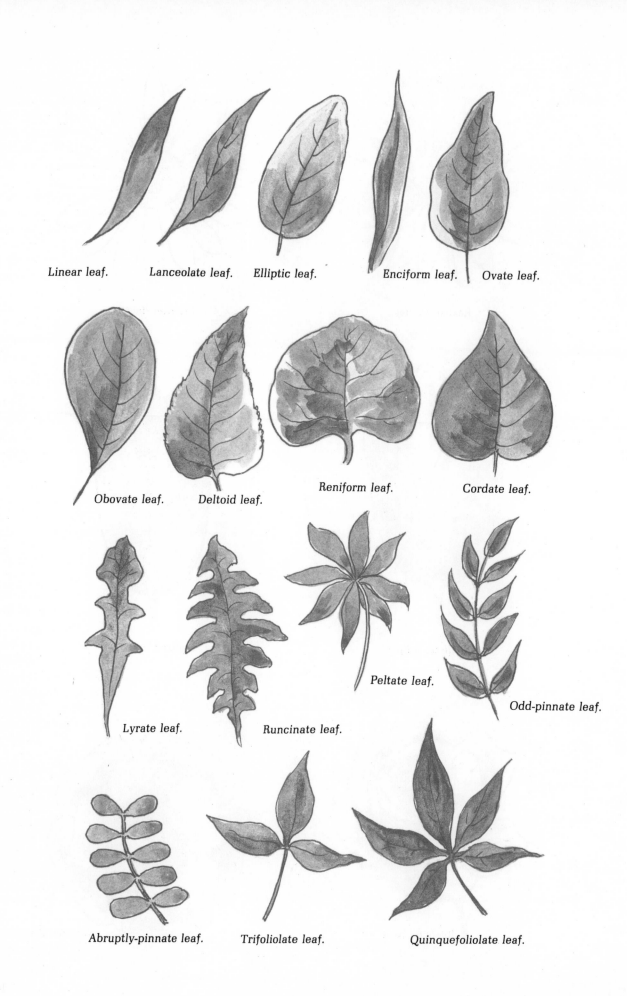

Linear leaf. Lanceolate leaf. Elliptic leaf. Enciform leaf. Ovate leaf.

Obovate leaf. Deltoid leaf. Reniform leaf. Cordate leaf.

Lyrate leaf. Runcinate leaf. Peltate leaf. Odd-pinnate leaf.

Abruptly-pinnate leaf. Trifoliolate leaf. Quinquefoliolate leaf.

To abstract a flower subject, here's what I do. I make a charcoal or pencil sketch, as if I were about to do a realistic painting. I place the same emphasis on composition, no matter what my subject, style, or medium may be. When I consider the layout satisfactory, I have a choice of two techniques. One is to go ahead and paint everything in the usual manner, but without going into small detail, either in form, or in color. The other is to actually complete the painting in all details, then to eliminate more and more small items.

First, I pull together, into simplified forms and simplified hues, the bigger flowers. I then enhance the darkest and the lightest parts of my subject by making darks even darker, lights even lighter than they really are, but without shading and blending. I step back from my easel every now and then to observe the effect. I often look at my painting in a small mirror, which I hold in such a manner that I only see my painting in it. This gives me a clearer view than when I look at my work surrounded by other items in my studio.

Eventually, I reduce the picture to an abstraction based on factual observation. It's always up to the artist to decide just how far he wishes to go in any direction. I may make an abstract painting almost unrecognizable for the casual onlooker. But I believe that my most complete abstractions can be understood by anyone looking at them with care and interest.

dramatic colors

Dramatic color combinations, considerably different from the actual hues, may be developed by employing striking contrasts between darks and lights, cool and warm colors. Three dimensional effects may be abandoned or retained, according to your taste. Many abstractionists enhance the feeling of depth. Others prefer a flattish design. One artist may use the flowers as a kind of foundation which he eventually abandons. Another artist may try to render the spirit of the flowers, their essential wealth in color and natural design, disregarding actual sizes, shapes, and proportions. Still another painter might concentrate on glowing hues against a dark or mysterious backdrop.

**just think
of flowers**

Many abstract artists don't want to have any model while working. They just *think* of flowers, vase, accessories, backdrop, and so forth. You may pass a few florists' windows and you may want to do a painting from memory, and/or from imagination, without the vaguest desire of making your painting recognizable. Nobody will prevent you from allowing your imagination to run as it will. Paint hues and shapes you like, soft-edged, hard-edged, overlapping, slashed-on, dripped, geometric, free, or nondescript shapes. There's no limit to abstract possibilities, but, the moment you cross the borderline of a definite idea, you become a nonobjective artist. The colors of flowers may still be your source of inspiration, but nonobjective painting must have no relationship to anything, real or imaginary.

**demonstration
of floral
abstraction**

The last picture in the color section is a floral abstraction. I covered a first-rate paperboard, 15 inches high by 22 inches wide, with polymer colors: cobalt blue, phthalo green, titanium white, Mars black, all mixed in various shades. Then I began to pour polymer colors, the most vivid, unmixed hues, on the board, directly from the jars. I added squirts from tubes. I used some very liquid paint which splashed a little as it hit the support. After a few minutes' pause, to give the thick paint time to dry, I applied more paint with brush, painting knife, a couple of tongue depressors, with which I ladled some of the paint out of small jars. I also used my fingertips to give certain batches of paint a swirl, a spiral appearance.

I allowed colors to become mixed into each other the way chocolate marble cakes look. As the paint dried, I'd go across the whole picture with a tongue depressor

Poppies, *school of Sotatsu, Japanese, 1603-1716, Tokugawa Period, 1603-1867, colors on gold paper, 34½ x 14⅝ inches. The Japanese artist rendered poppies and their leaves realistically, from diverse angles. Every petal, every vein is shown. This realism is totally different from Western realism: there's no light, no shadow, only lovely colors. There's no indication of where the flowers are. Yet they are pleasing to the eye. The Metropolitan Museum of Art, Bequest of Mrs. H. O. Havemeyer, 1929, New York.*

dipped into cadmium red medium, or titanium white, and let the paint drip over the rest. I suggested a basket for the flowers, and at no time did I forget that I was doing an abstraction of a floral subject. I don't think anyone would fail to recognize the subject matter. But I daresay there isn't a flower in the whole wide world that's like my flowers in this picture are.

Although I did a great deal of dripping, and pouring, the entire work remained under my strict esthetic control. It was not a so-called automatic, or abstract-expressionist work at all. I knew exactly what I was doing, and I made many changes and corrections. In some sections, flowers next to each other happened to be too similar in shape, design, and color. In other spots, the contrasts were ugly, jumpy. Here and there, I enriched certain forms by skipping over the ridges with another color. All in all, I enjoyed doing this work. I found it just as exhilarating, just as serious as if I had been doing a perfectly realistic painting.

should we paint abstractions?

Students often ask me questions like: "Is it a good idea to do abstractions?" or "Do sane people paint abstractions?" The answer is that the more experience you have, the more techniques, and styles you try, the sooner you'll find yourself. It's true that we have certain contemporary styles that even the proverbial child or grandchild can do. But the fact is that a real artist can throw, squirt, or pour paint on the support in an attractive manner. Ultimately, it isn't the art that's good or bad, it's the artist.

The studying and practicing of diverse techniques is a great help, provided that your aim is to learn, to find out what style and technique can do for you. If you try everything, you'll surely discover what form of art harmonizes best with your temperament; which one gives you the greatest satisfaction, esthetically; which one gives you a feeling of true achievement; which one is the true "you" in art.

the value of abstraction

Abstraction, in any medium, helps you see major forms and colors, rather than tiny details, a feature of representational painting that so often leads the student astray by making him believe he knows a great deal. "Aren't these flowers beautiful?" he exclaims (perhaps only to himself), not realizing that the details are there, to be sure, but in the wrong places, in the wrong colors, wrong sizes, and so forth. Abstraction teaches you how to put less into your painting than you'd at first consider necessary. In a forest, you have to see the forest, not just the trees. In a flower painting, don't let the petals and pistils obscure the flowers themselves.

individuality versus commonplace

Does all this sound as if flower still lifes could be based on commonplace skill, and cheap cliches? Don't forget that every subject has been used by thousands of artists tens of thousands of times. There's no landscape, cityscape, seascape, nude, or figure subject that has never been done before you came on the art scene. Innumerable artists, good, bad, mediocre, and great, have painted the same saints and biblical themes during the Renaissance in Italy. Yet, we recognize their brush strokes, their general approach. We won't take a Tintoretto for a Raffaello. The artist's individuality comes out in all his works.

Nobody can possibly tell you just exactly what would, or will, make your paintings individual, recognizable as your work. It's up to you to evolve your individuality. The best instructor, the greatest book, can only give you technical information and esthetic advice. The rest is in you by nature, and will become visible as you grow in experience, in skill, and in human stature.

21 Advice to Artists

Nobody can become a real artist without sufficient, natural talent, but talent must be developed, no matter how much of it you may have. Study, either by going to art school, or art classes, or by looking at art books. You can learn a great deal by talking, and, especially, by listening, to accomplished artists. All artists know how to express themselves in their chosen fields.

teachers or books?

I can only state my conviction that a good, articulate, and dedicated teacher is the best source of information. Such teachers are rare. Lacking this kind of teacher, you can turn to the excellent how-to-books, from which you can learn a great deal, if you add your own, careful observation, and serious experimentation to the fundamental understanding you'd gathered from books.

technical knowledge

It took the Western world over twenty-five hundred years to reach its present level of artistry. Nobody can live long enough to discover all the ramifications of this knowledge by himself. There's nothing humiliating in learning from others. I'm always mystified when a student exclaims: "Please . . . don't tell me anything. I'll figure it out by myself!" I wonder why such students wear clothes invented, woven, and sewn by others.

I have given a good deal of technical advice in this book. Now, I'd like to reiterate, and perhaps elaborate upon, some of the advice.

retouch varnish

This varnish is employed only in oil painting, because oil colors have a tendency to sink-in, to become dull, grayish. A small amount of retouch varnish, sprayed — not brushed — on the painting, brings all colors back to their original brilliance. You cannot possibly match sunk-in colors without first applying retouch varnish. Keep the painting in a flat position when applying retouch varnish. Otherwise, the colors are likely to run downwards.

final varnish

Oil paintings shouldn't be coated with a final varnish for at least a year after they're finished. It's better to wait two years. Varnish applied to a fully dry painting can be removed, years later, for cleaning. Since varnish dries fast, it causes paintings to crack if the varnishing is done on an insufficiently dry picture. Furthermore, the paint, or some of it, is likely to be removed together with the varnish, when the cleaning occurs. Read directions on varnish containers with great care.

Casein and polymer paintings may be varnished immediately, with matte or glossy polymer varnish. Varnish makes these paintings more contrasty. Test the effect of varnish on watermedia by applying it to colors brushed on the same kind of support, in the same medium you use in your painting. The effect of the varnish is different on diverse kinds of supports.

Aquarelle can also be varnished with a special watercolor varnish. Most synthetic varnishes work on watercolor. But varnishing robs aquarelle of its crisp, fresh, airy appearance. Consider, therefore, whether you prefer to varnish a watercolor or to protect it with glass or with a sheet of plastic.

There are special fixatives for pastels. Do the spraying lightly; wait a few minutes; then apply another coat of spray. Usually, you'll have to do some additional work between sprays. No matter how well you spray pastels, they still require glass for protection, or a heavy sheet of plastic which you should attach to the pastel in such a manner that the painting and the plastic won't shift.

matting

Aquamedia and pastels are matted, as a rule. The mat, normally about three inches wide all round, or a half inch wider at the bottom, should be neatly cut. Most exhibitions require white, off-white, cream, or gray mats. Mat-cutting equipment is available at modest enough prices in art supply stores. This will save you much money, and effort, if you need many mats. Always place a heavy matboard under the mat you're cutting, so that the knife blade won't be ruined as you work with it on a hard table.

When placing a picture in a mat, don't paste it into the hole. Rather, make a backing by hinging a sheet of clean, white board to the mat with gummed paper across the top. Mark the opening on this backing, and attach the pictures to the back. Use a small piece of gummed paper in the upper left and right corners. If the picture is wide, add a third piece of gummed tape in the center. Make sure the tape adheres; it's most disagreeable to find that the picture falls down while the painting hangs on the wall. The frame has to be opened, the picture has to be reattached, by you or by someone else.

framing

The finest frame cannot make a masterpiece of a poor painting. A bad frame, however, causes real damage to even the best painting. I've seen juries of selection reject good paintings because of their inappropriate framing. Expensive frames are not recommended for exhibiting purposes. Most societies request good, but simple frames. An inexpensive rawwood frame can be turned into a satisfactory one by finishing it with polymer extender, or gesso, painting it with colors that go well with the picture. Such colors can be rubbed into the frame with a rag, in polymer or oils. The idea is to use colors in the frame which predominate in the picture. A coat of self-polishing wax gives your frame a nice finish.

sizes of paintings

Work on a few sizes, rather than all different ones. You may need four or five different shapes and sizes for support. Buy a good frame for each size. It's easy enough to take a painting out of a good frame, and put another picture in the same frame.

exhibiting

Exhibitions usually don't go to you; you have to go to them. Read the Exhibition Opportunities columns of art magazines. Write to the secretaries of art societies, asking them to put your name on the mailing lists. Read the circulars and entry forms of art organizations with care, and act according to their respective rules. Don't take it for granted that you can guess the rules. Even the same society might change certain rules from one year to the next. You have only yourself to blame if you fail to follow instructions. Such failure usually means a waste of money and effort.

**suppose
your work
is rejected**

This isn't a far-fetched supposition. Most artists, if not all of them, have gone through disappointments. Juries consist of human beings; they have their own tastes, prejudices, or preferences. You needn't be upset or heartbroken if your entry isn't accepted. Try again. If you're good, your work will be accepted, sooner or later. Visit exhibitions before entering your works, if at all possible. You might get an idea of what paintings they accept, although there's no definite criterion for taste, and next year's jury may be totally different from this year's.

**membership
in art societies**

No big art society elects members simply to obtain dues. The dues are only a few dollars a year, not as in a club, where a few new members may mean a great deal of extra income. It costs you only a letter or a postcard to find out what the rules of membership are in any society. If you have an opportunity to become a member of an art society, grab it. I've known many artists who refused membership in newly organized societies and found out, years later, what they had missed. By then, it was too late.

**don't broadcast
your lack of
success**

Don't tell every member of your family, every friend, and every acquaintance that you had been rejected by a society, even though you had submitted your latest masterpiece to the jury. People, including members of your family and your best friends, are likely to come to the conclusion that your entry wasn't good enough. Keep quiet. Suffer in privacy. Can you imagine a physician or a surgeon telling all the world about the patients he hadn't cured? Can you imagine a lawyer telling right and left about the case he had lost?

**don't push
too hard**

Publicity is important for an artist, but don't push yourself too hard. You might push yourself overboard. If you're too modest, nobody will know about you, that's true, but if you ring your own bell too loudly, and all the time, people will avoid you like the plague. Self-confidence is absolutely necessary, but bragging will get you nowhere. Self-confidence must be based on knowledge, on your ability to learn even more than you already know, and, in the final analysis, it must be based on provable achievement. Most great people, in any field, started at the bottom. Naturally, it must be wonderful to rise to the top at once. I haven't had that great experience . . . but I sincerely hope you will.

Edited by Susan E. Meyer
Designed by James Craig
Composed in ten point Melior by Noera-Rayns Studio Inc.
Printed and bound in Japan by Toppan Printing Company, Ltd.